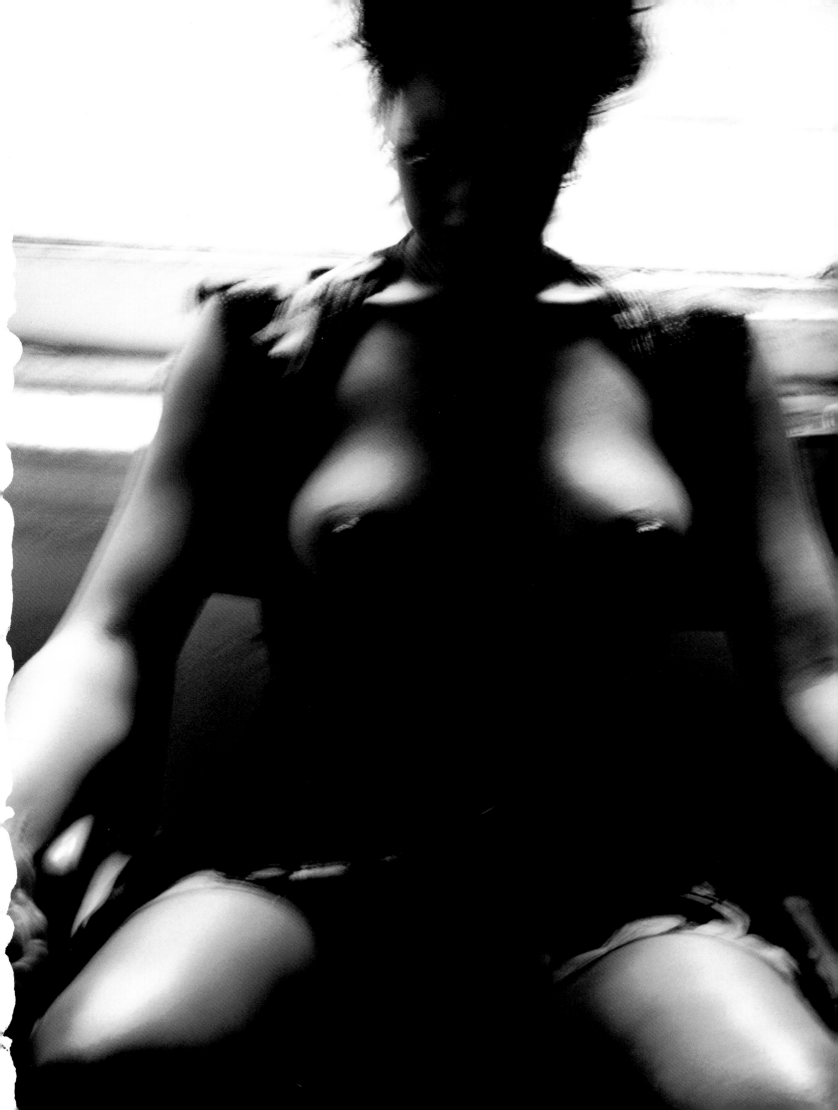

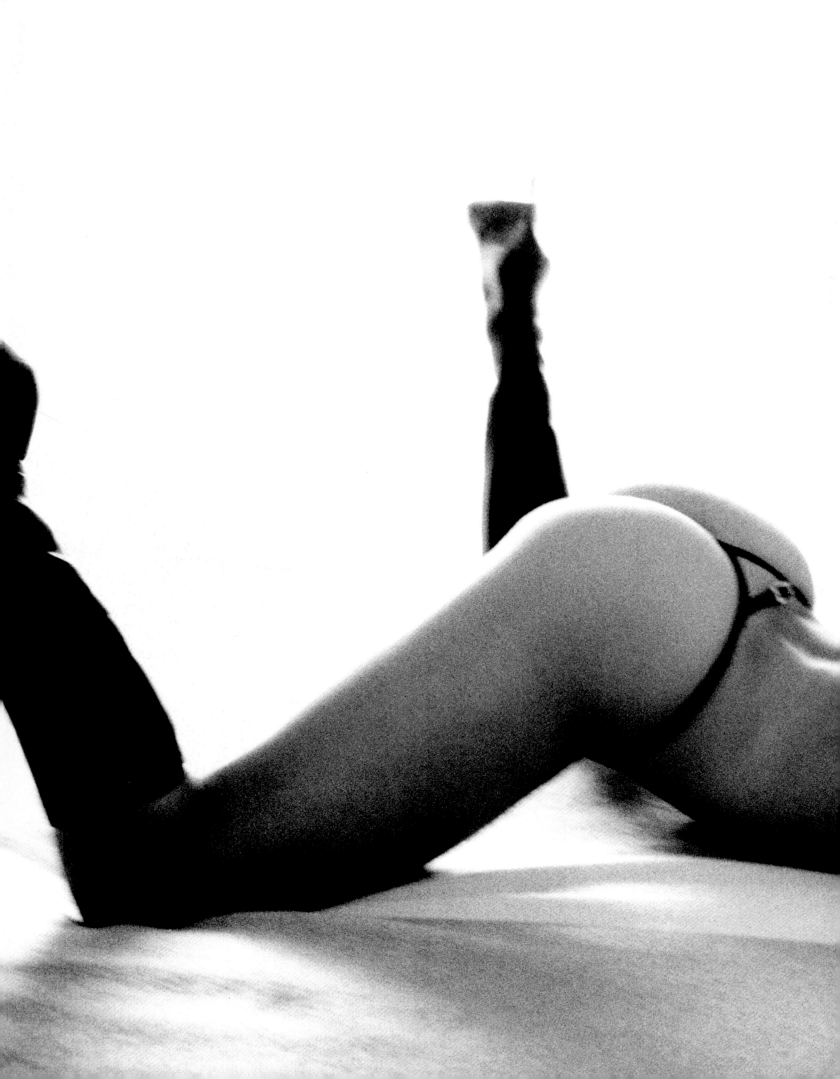

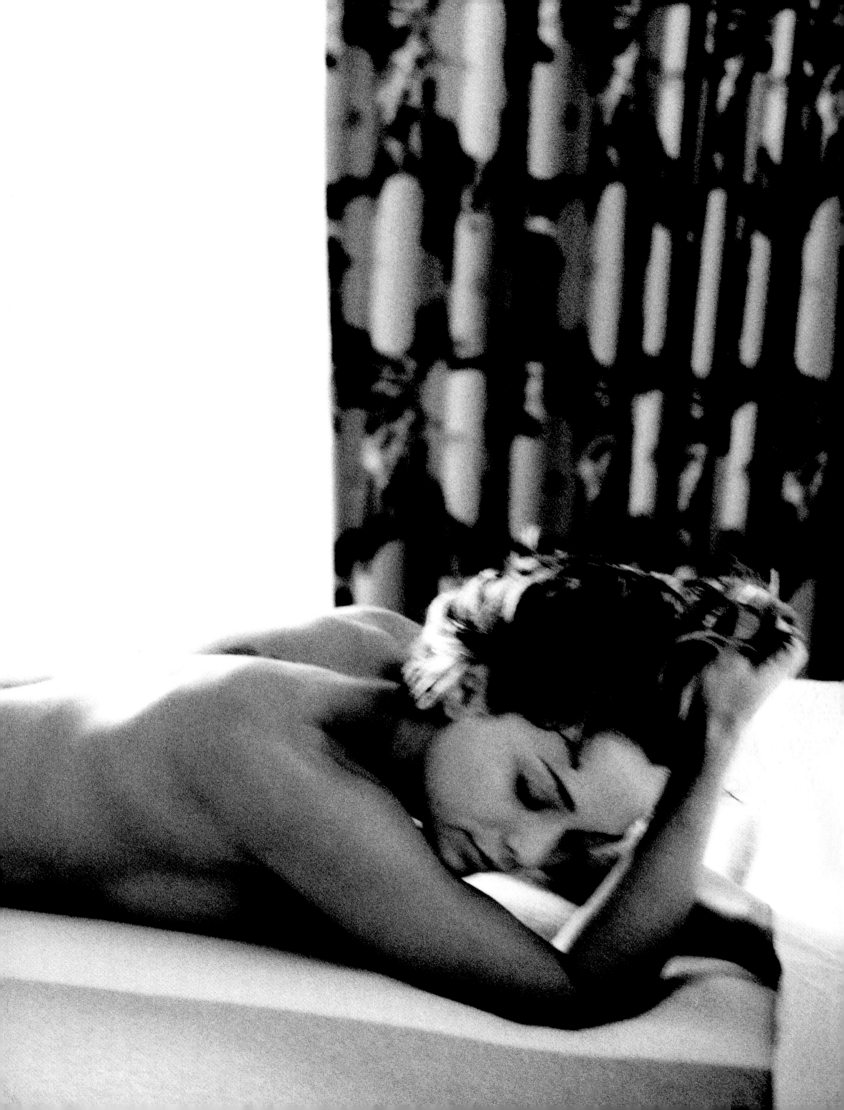

intim

nate

NUDES BY MARC BAPTISTE

UNIVERSE

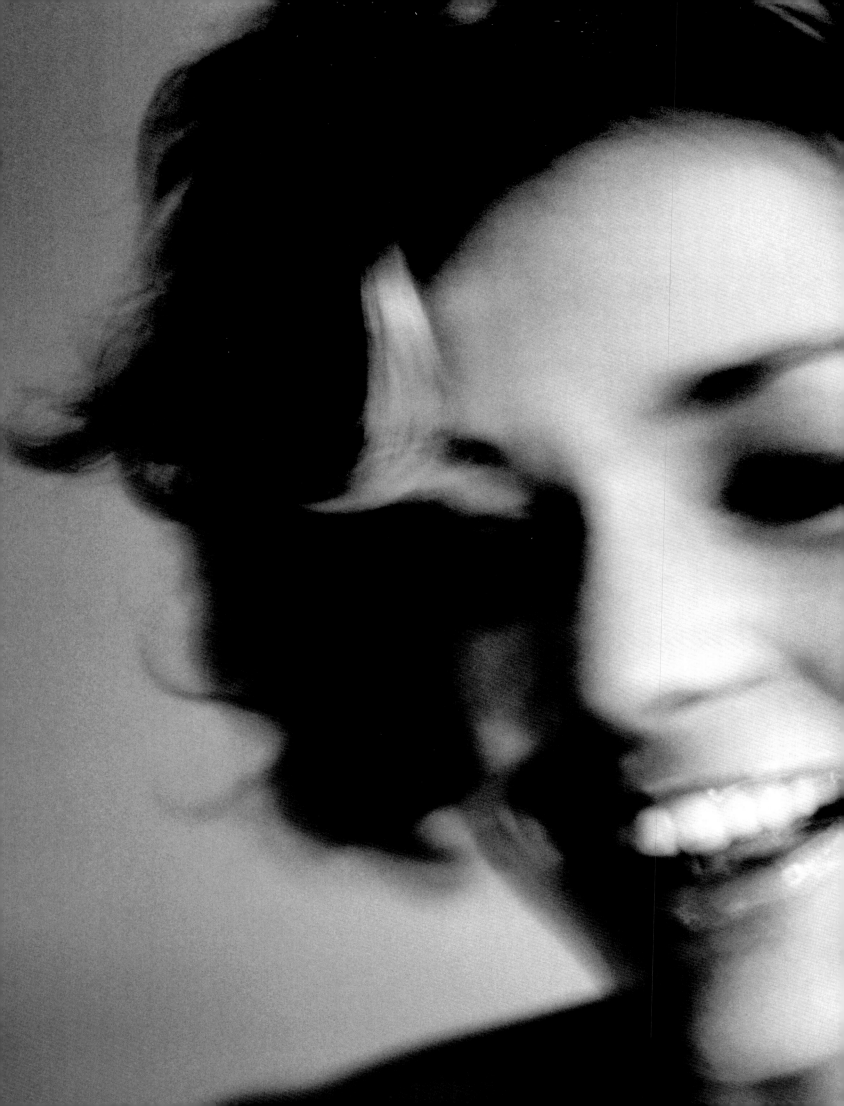

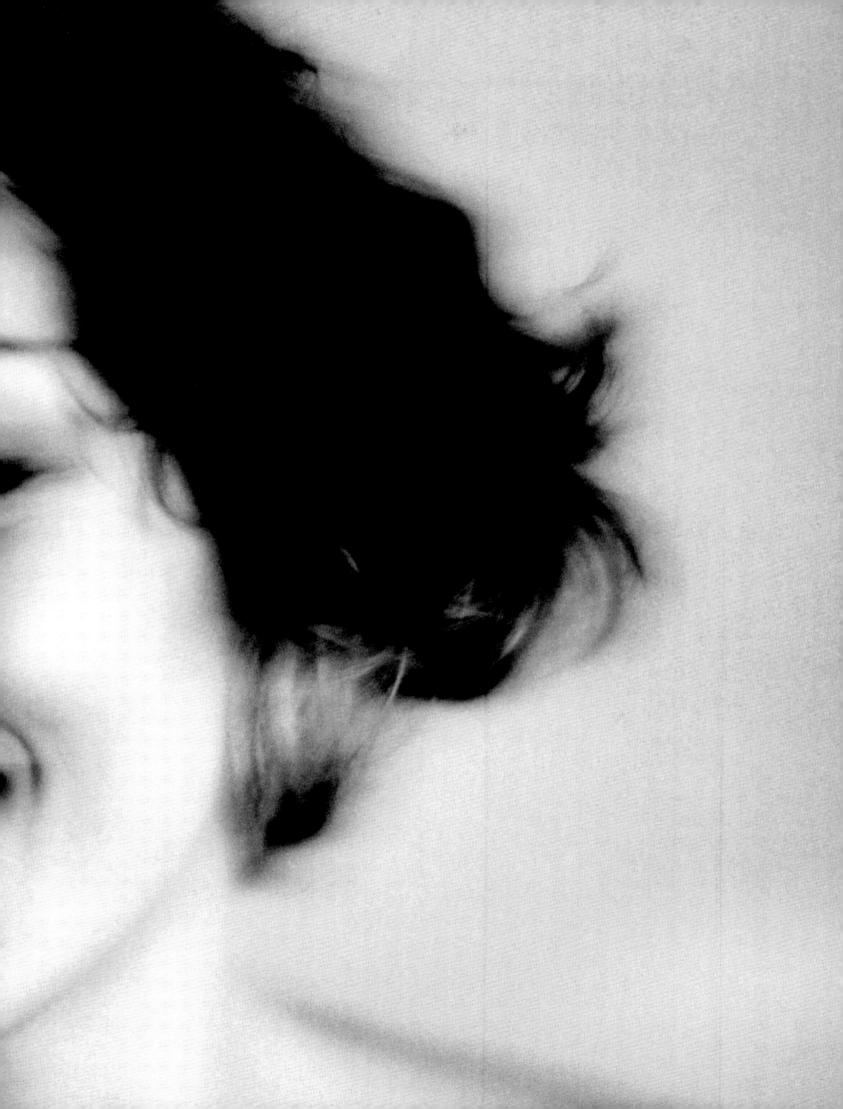

FOR JENNY

First published in the United States of America in 2003
by UNIVERSE PUBLISHING
A Division of Rizzoli International Publications, Inc.
300 Park Avenue South
New York, NY 10010

2003 2004 2005 2006 2007 2008 / 10 9 8 7 6 5 4 3 2 1

ISBN: 0-7893-0994-7

Library of Congress Control Number: 2003104740

Printed in Italy

Designer: Siung Tjia
Universe Editor: Jessica Fuller

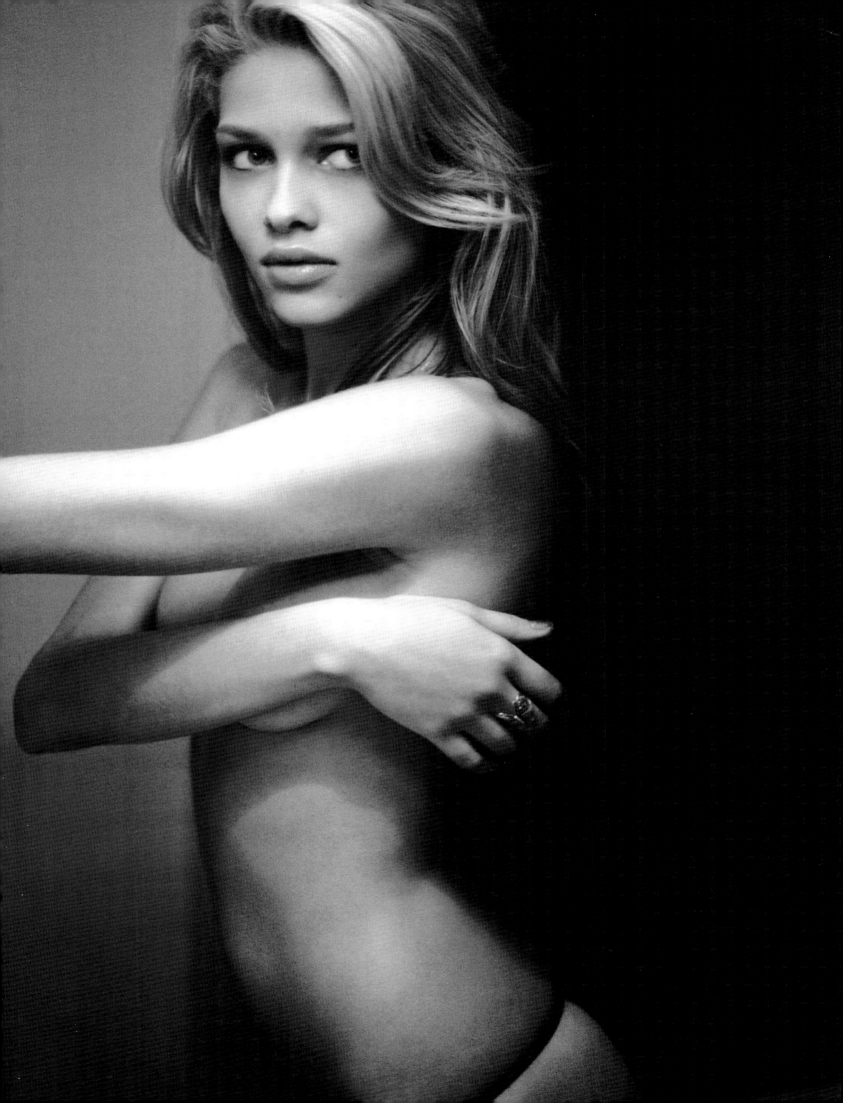

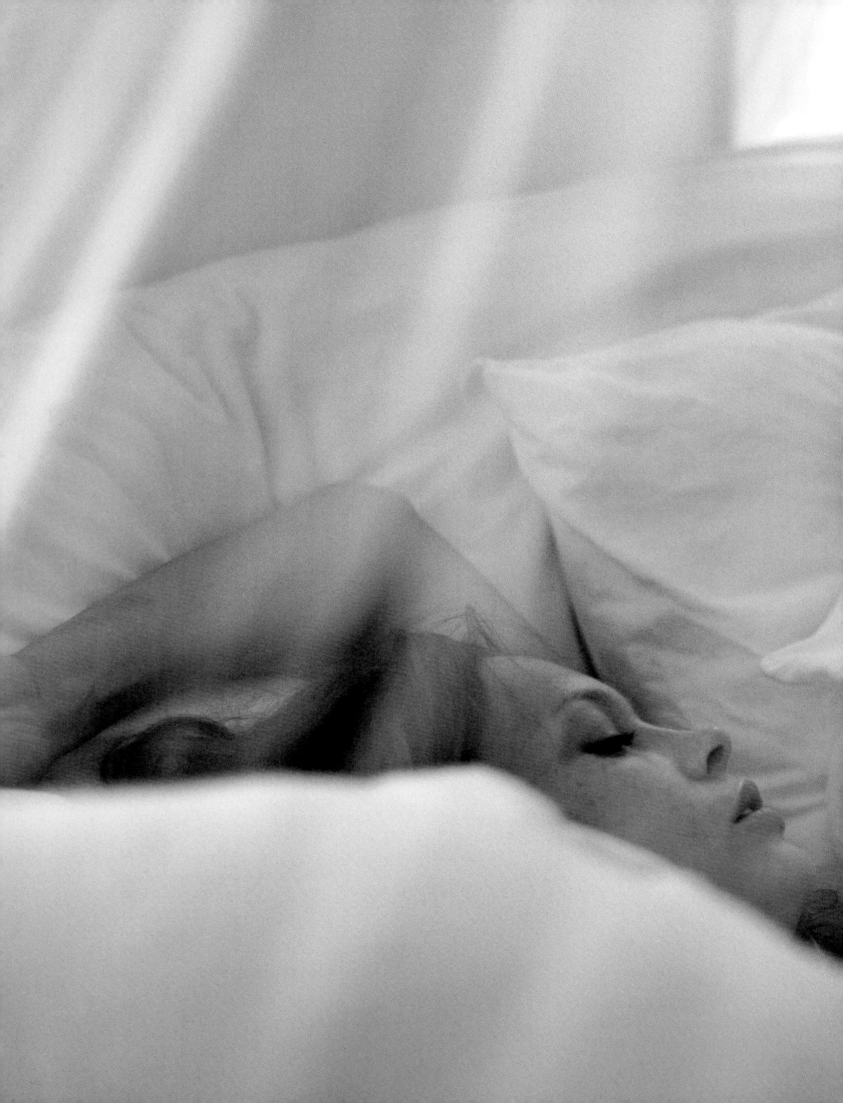

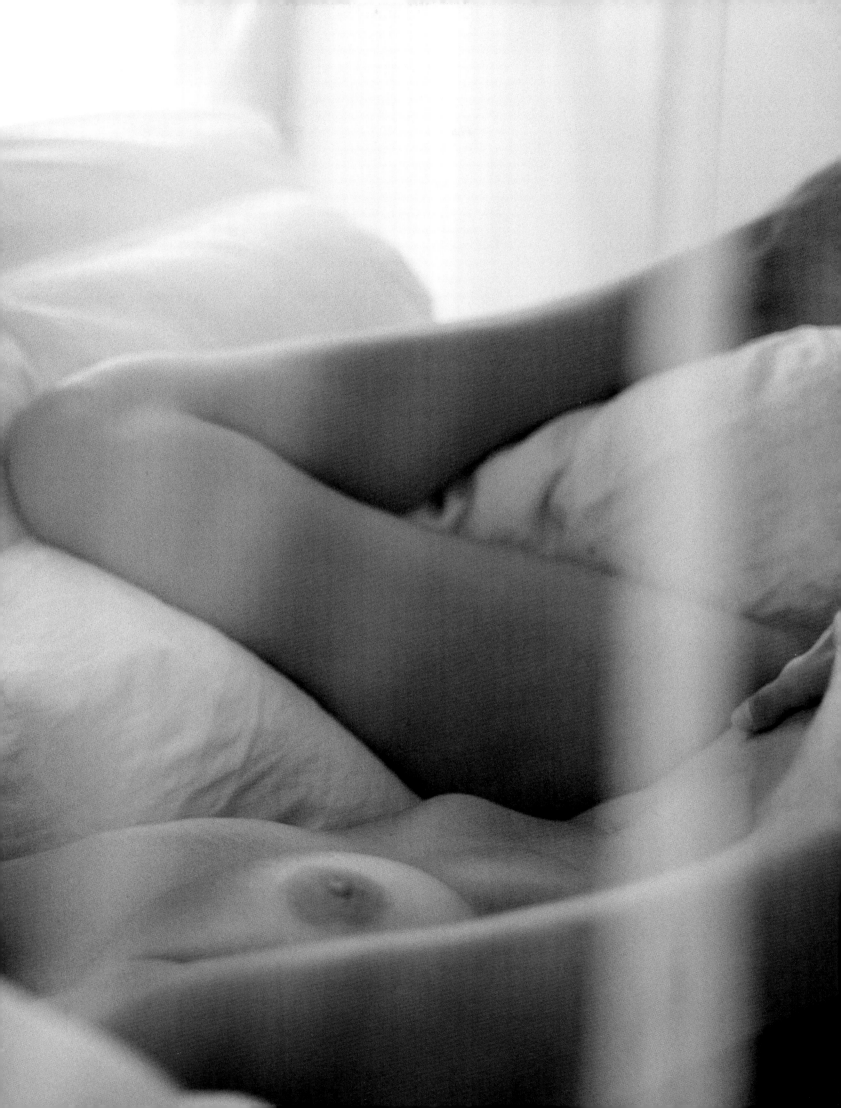

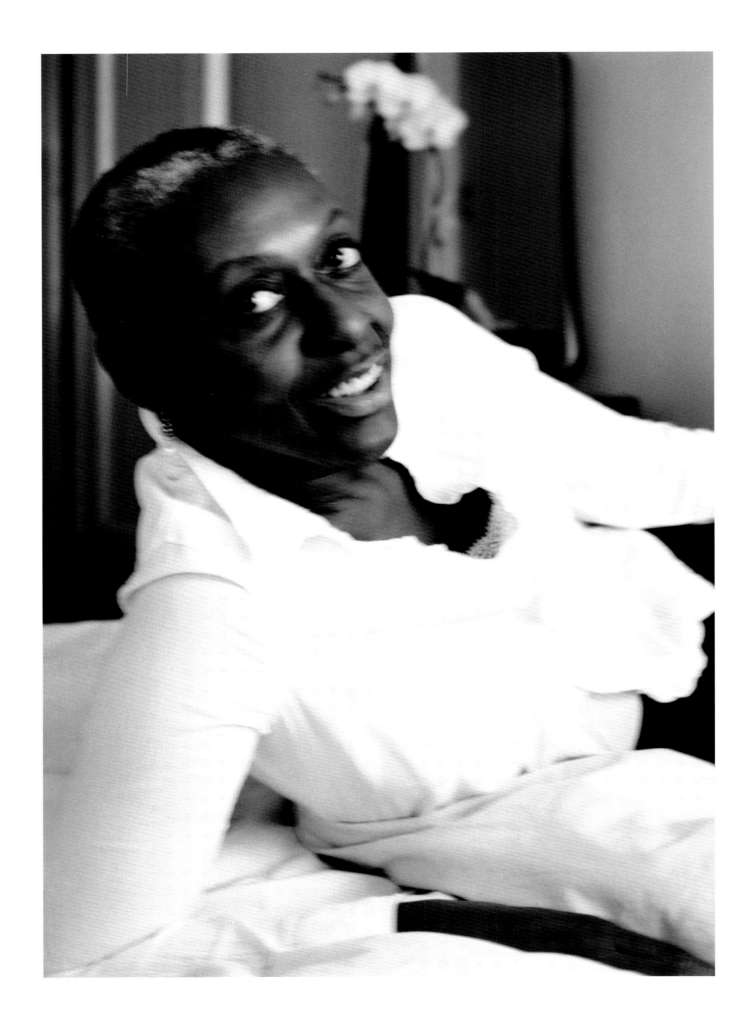

BY BETHANN HARDISON

WHEN MARC came to me to discuss this book, and he said it would be titled *Intimate*, I literally swooned. It sounded so perfect after *Beautiful*, and a wonderful way to follow up. I loved the idea that with his first book, Marc used his vision to explore women's beauty, and now he would go a step further, open it up, and investigate intimacy through nudes.

I, LIKE MOST PEOPLE, I am sure, don't often run through the exercise of visualizing an abstract concept like intimacy. An artist with enough sensitivity and guts like Marc has the ability to think about an abstract concept, and then with images express the spirit of that concept. However, I can free-associate about the word *intimate*: various quiet conversations; a specific person, place, or thing that makes me dream or smile; being alone with my body; or an activity that helps me find peace. I even think savoring a shopping excursion can rank as being *intimate*. I find that Marc has the ability to approach the human subject with a sense of gentleness, and extends a confidence that allows him to get so close and reveal a person that the subject no longer seems aware of why either of them are there.

THINKING ABOUT Marc's project led me to an impromptu self-analysis. I began to appreciate my internal debate about what is or isn't *intimate* to me. I thought about the word intimacy and how, where, and when it applies to people. Clearly, many things can embody intimacy. *Webster's Dictionary* defines *intimate* as "intrinsic, essential; belonging to or characterizing one's deepest nature; marked by very close association, contact, or familiarity; marked by a warm friendship developing through long association; suggesting informal warmth or privacy; of a very personal or private nature." I love that idea of "characterizing one's deepest nature"; it has so much depth. How often does a person go that far within one's self to discover what would or could be hiding "in there?" Intimacy is truly a moment in time, a place, a thought, an action, privacy, quietness, sexuality, and so on. The word opened up a world of concepts for me. Upon recently traveling to my home in Mexico with my newfound ideas about

intimacy, I commented to a young American female friend about my search for a definition of intimacy. She retorted, "You are questioning intimacy with all those Mexican men you have around you?" Well there it is—the obvious belief that sex corresponds with intimacy for so many people. I can't deny that sex can be a big part of intimacy; however, I was searching for a different facet of intimacy, one that involved me alone.

LET ME GIVE a small example of how I began to speculate about what could or couldn't be *intimate*. On a recent trip I met a beautiful young Latina girl, really quite attractive, and who appeared to love her body (my conclusion). She was wearing barely anything at all, and her skin-tight clothes definitely accentuated her assets—she had a magnificent derriere. I thought about intimacy in relation to the girl; my initial judgment was that this young beauty wasn't by obvious character someone who understood intimacy. How could she, this extroverted girl? After thinking about her a little more, I questioned my initial reaction. I had reserved my vision of intimacy to being private, closed, whether with someone or alone. Who am I to decide whether another person understands or has experienced intimacy for himself or herself?

SO, I THOUGHT more about my own life. I was an only child. Selfishness can be a primary characteristic of only children; it can also cultivate a wonderful internal understanding of one's self. Of course there are other things besides being an only child that provide that sense of self—self-awareness, esteem, confidence, or a natural sense of security. The intimacy with one's self could involve a letting go, a release, and in the process of release becoming both more and less yourself. Like being nude in front of an uninvolved person and being OK with who you really are. You without any clothes, and being comfortable in your own skin. A sense of self becomes most important; without it, how can you achieve true intimacy with anyone else? With age comes wisdom, and the most meaningful characteristic of intimacy, to me, is having a romance with yourself. You must

have that understanding of yourself, which allows better understanding and acceptance of one another.

I HAVE LEARNED over the many decades that intimacy with one's self can be more comforting than intimacy with another. First, let's not confuse this with masturbation—intimacy not as a sexually driven idea, but as an idea of self-involvement. An intimacy that is born out of sheer pleasure or simple enjoyment. Let me say, surely, I've always been so happy to experience intimate sexual moments with others, and I still do. Unfortunately—or fortunately—it requires an energy that, as time and life goes by, I prefer little by little to reserve for myself so that I can quietly spend time alone tending to things that help put my life in order and bring me calm.

LET ME SHARE with you something that my mother Sophie told me when I was a young girl. The statement went something like this: "If I have to buy me a young man to be with me as I get older that's what I'll do I ain't never gonna be lonely." I don't remember what brought that conversation on, but the statement was one that I will always remember. Sophie had a wonderful way of expressing herself. Not only did she have personal style—she was a one-time Savoy Bopper (jitterbug dancer)—but she also had a personality that allowed her to get away with saying anything. Sophie at the age of sixty-seven had a wonderful "boyfriend" named Michael, who was about twenty-eight years old. She was quite happy to have me meet him. At the time I was only a little older than Michael was. They seemed to have a very special intimacy with each other; I don't know if it was sexual; perhaps I am being naive, but Michael appeared to have adored her.

SOPHIE DIED at the age of sixty-nine. She died alone. Maybe she was lonely, maybe she wasn't. It didn't seem so. She truly talked the talk and walked the walk. She left behind a memory of strong character. A woman unto her own.

AND, AS LIFE would have it, the apple doesn't fall far from the tree. I guess that's how many people see me as well. Although I haven't pursued the idea of being lonely, or the thought of buying a young man to keep the body warm, it naturally finds its way and there I am living what seems natural to me.

AS I AM NOW approaching that decade, I too have my "Michaels." And as Sophie always had what was attractive and what was attracted to her around her, I do too. I don't ever think she worried about the age of a man. Nor do I. Age does have its distinct advantage. What, who, and why they choose the woman that they do. It says much more about the younger man than it does about the older woman. Imagine that's intimacy. The more I share myself with others, the

more I believe it is possible to maintain intimacy alone. Ironically, the best thing to me regarding shared intimacy is the opportunity to be alone.

WHAT I MOST enjoy about it is that I am never ever lonely. It is so important not to confuse being alone with loneliness. As life continues to go by it amazes me how many people you meet or know who cannot imagine venturing off alone. They always need to be with others: that is their security.

TO APPRECIATE the joy of being alone is truly a gift: the contentment of self. I realize now I do get carried away with my sense of intimacy. I travel alone, far away, sometimes to unknown places. I can—and do—go to cinemas, the theater, restaurants, or concerts alone. I actually prefer to go to social parties and dance parties solo. It allows me to determine my own space as well as not be forced to be vocal on demand. My latest discovery is exercising alone for an hour at home with my video fitness trainer. It fits comfortably into my lifestyle—no more rushing to the gym with less time to spare for other things. Aloneness is truly sublime when you're comfortable with yourself.

I THINK right about now I most desire solitude. I steal time for myself because I have so little of it. My life is totally involved with people—and well, yes, I am also popular. When you spend your entire life being the belle of the ball you just get worn out. I feel it's important to explain that I am not a natural recluse or hermit, but that it is a state that I continue to seek out.

BUT STILL I DO wonder about those who do not long to be alone. What is their sense of intimacy, those who long to be with others? Or conversely, how about those like me who long most to be alone. Do they recognize the intimate moments while they happen? Is there enough solitude or interaction for them to know the difference? Oh, who am I to judge? Only with this project have I really begun to think about this concept of intimacy, of myself, both by myself and with others.

WELL, IT'S TIME to consider the image for my portrait by this artist who can have an idea, then reveal that idea visually, thus exposing and educating us about ourselves in the process. I don't need to be in the nude to feel my sense of intimacy. For me there are other choices. Still, I want it to reveal my acceptance—an acceptance of myself that might reveal a flaw, a secret, or a possible rite of passage.

WHATEVER the moment becomes, I have faith that Marc will capture and execute something wonderful: an image that will embody our closely shared moment of intimacy.

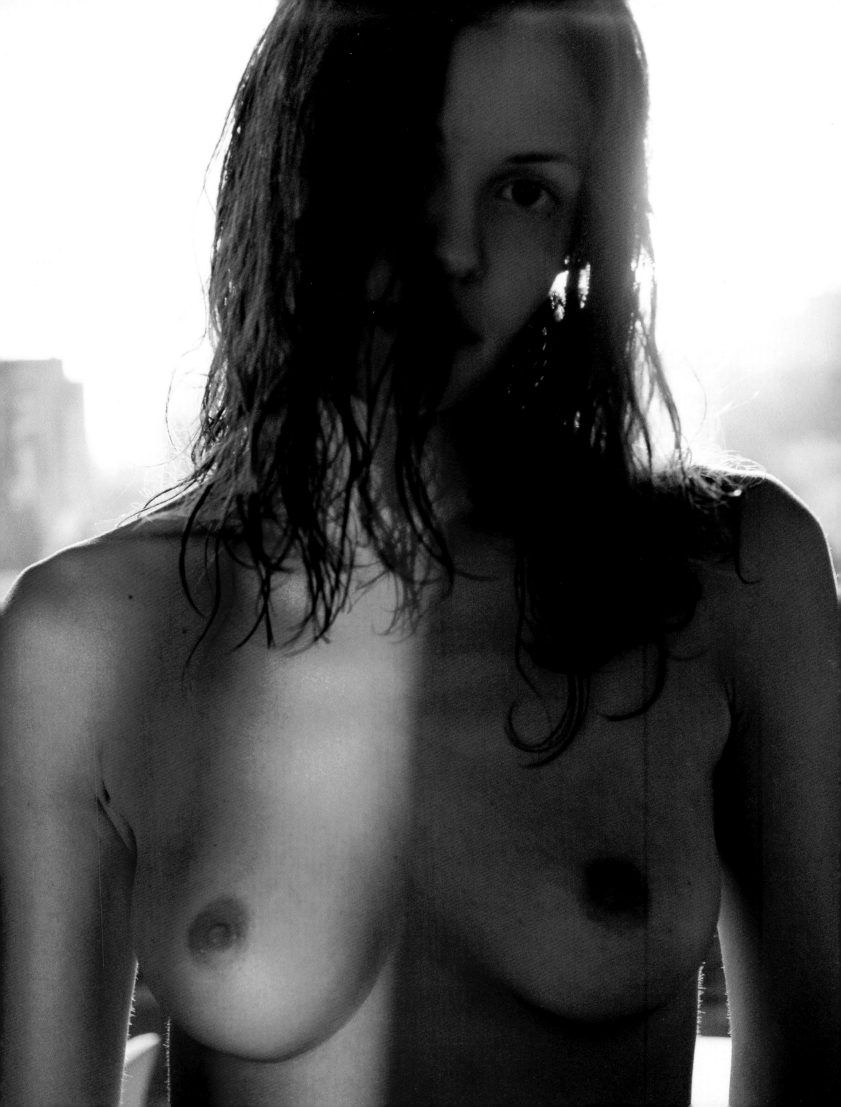

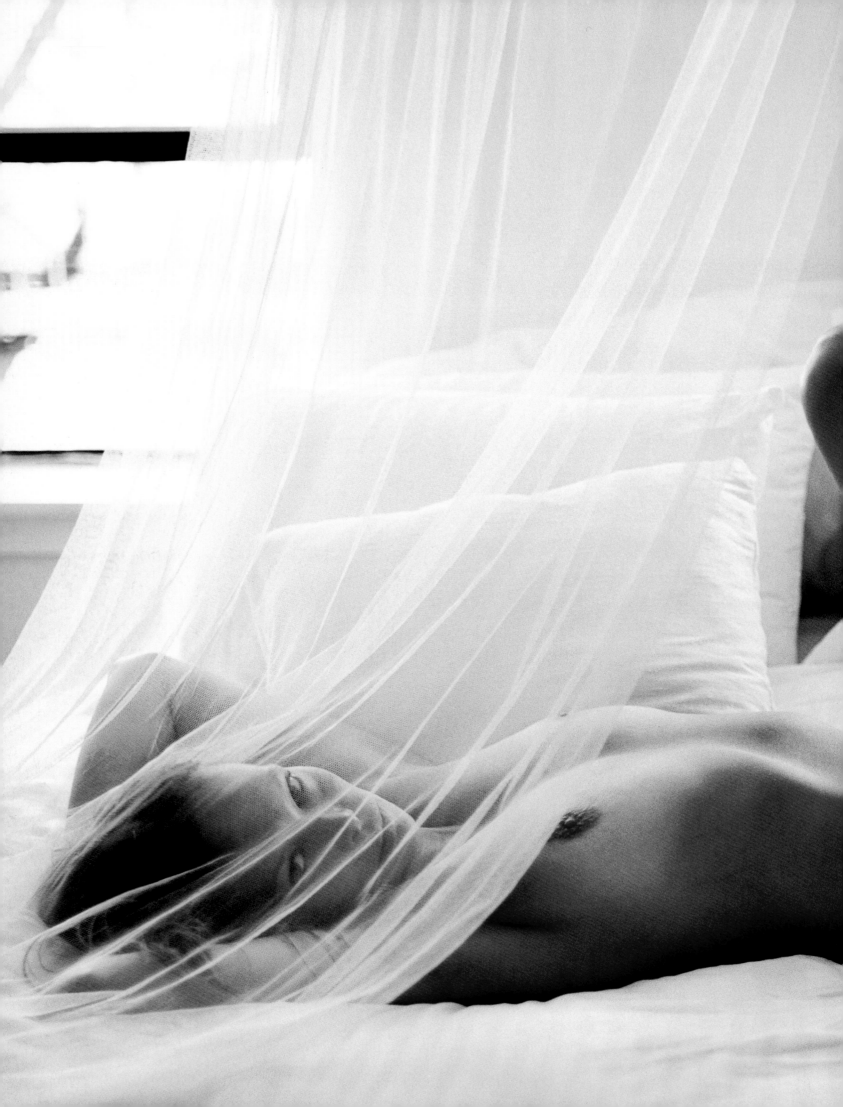

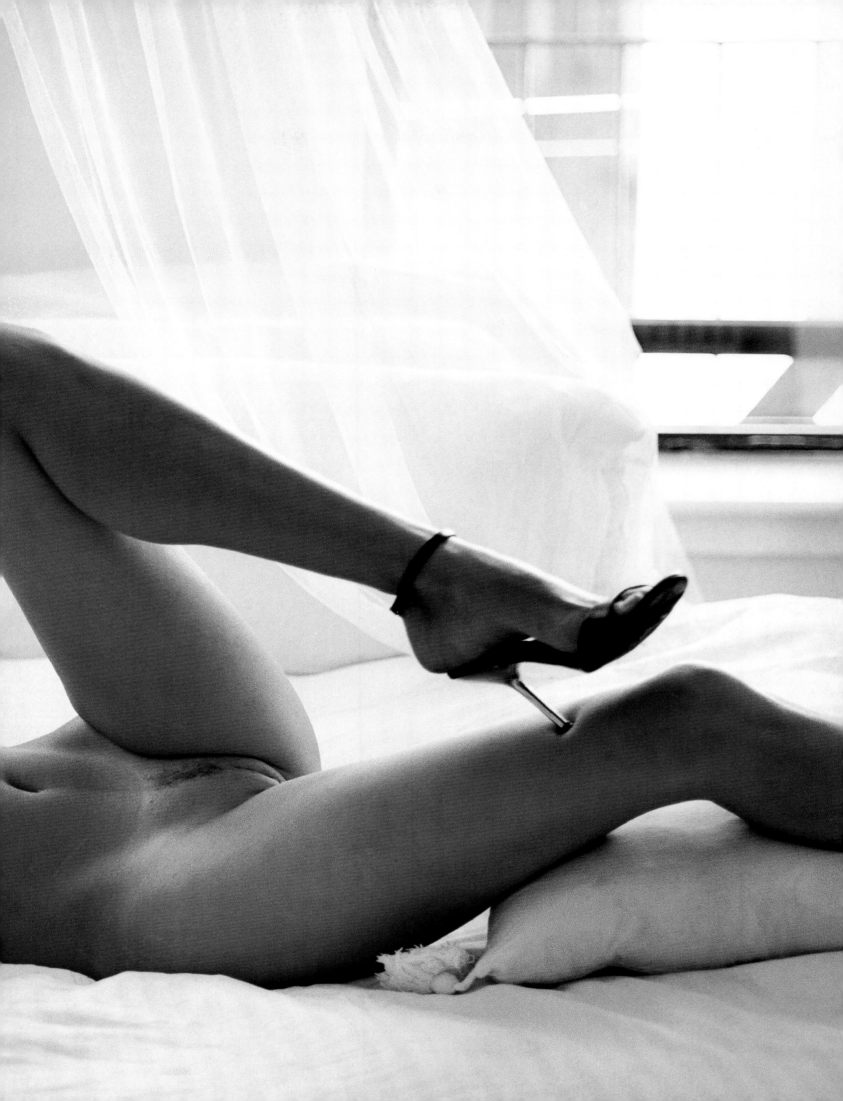

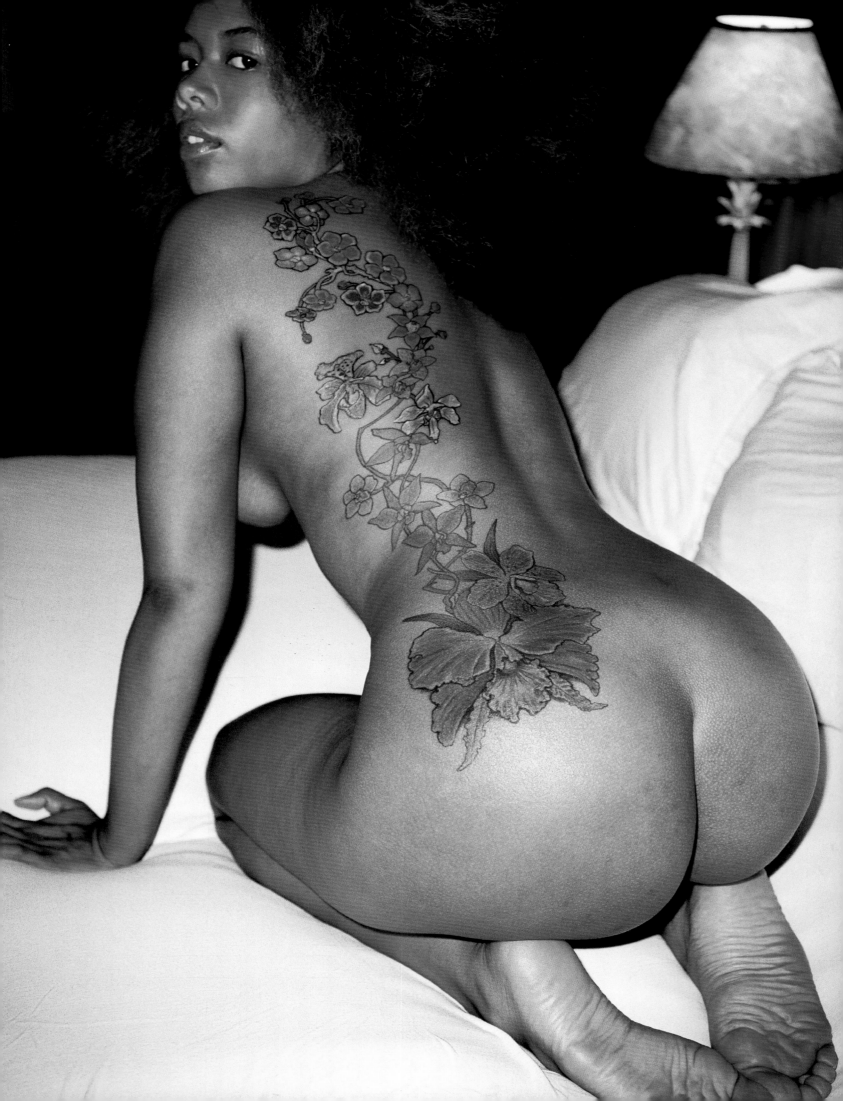

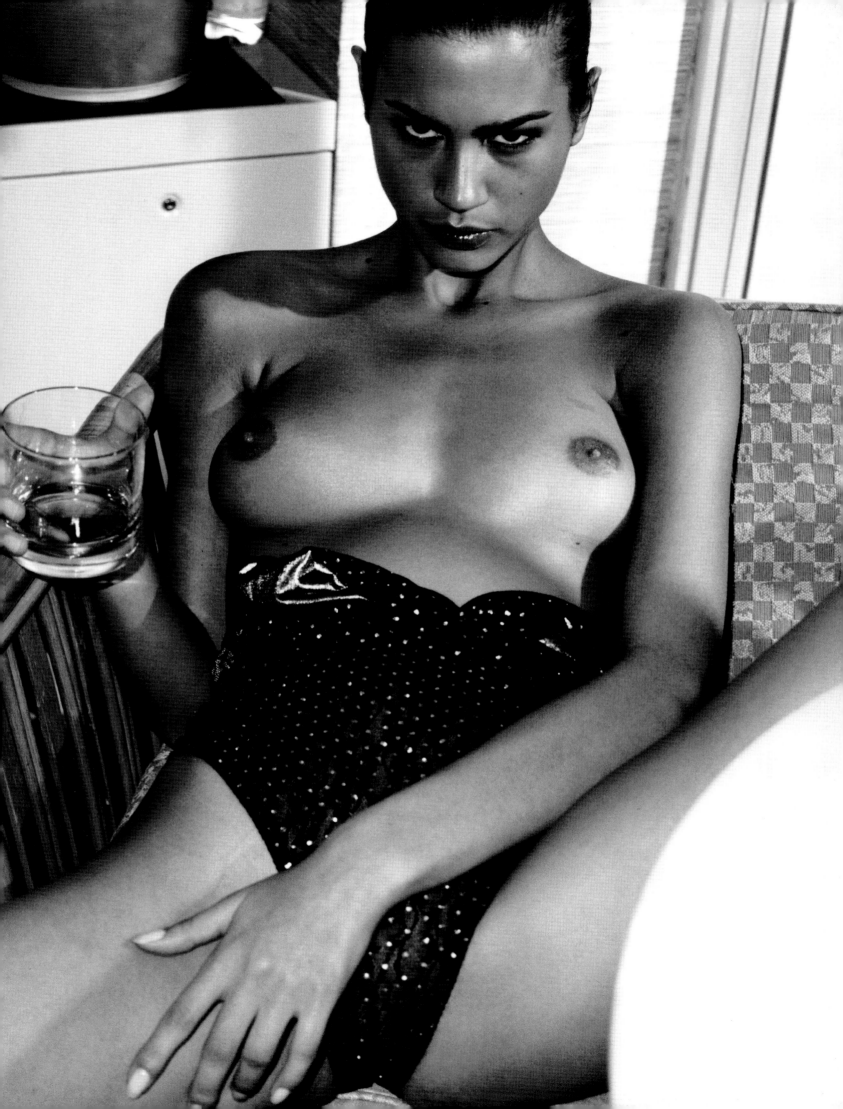

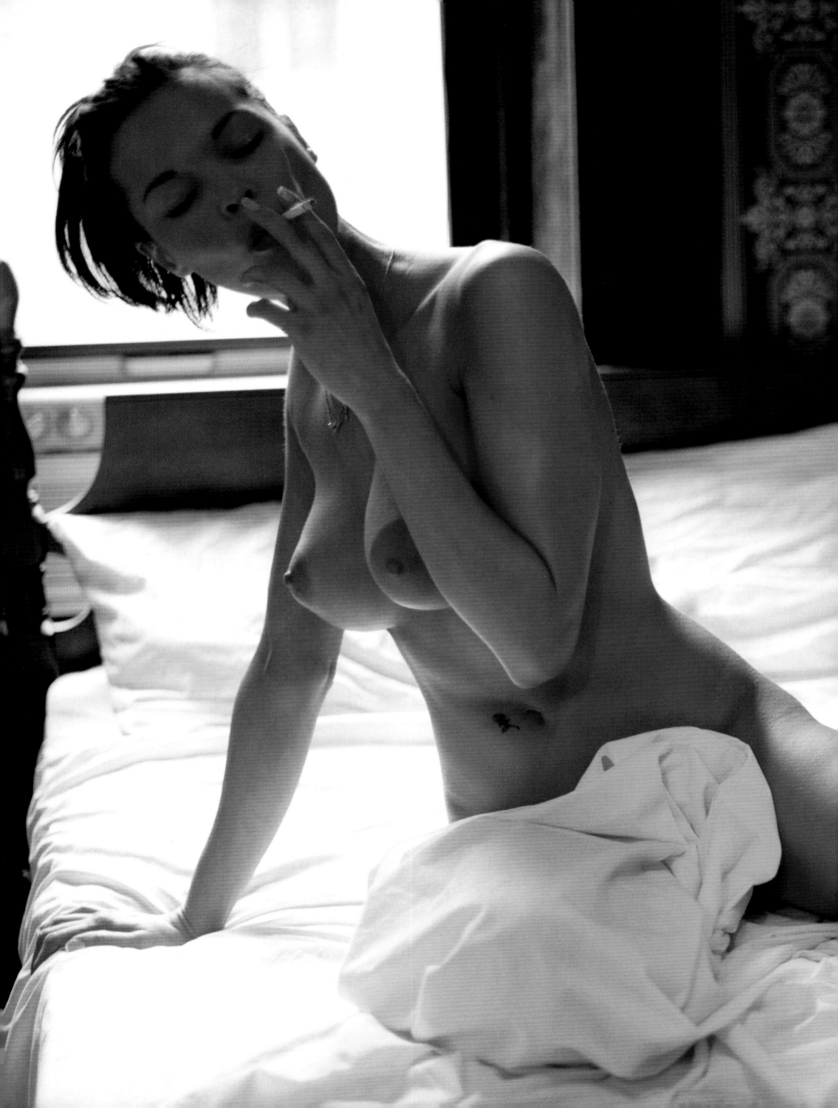

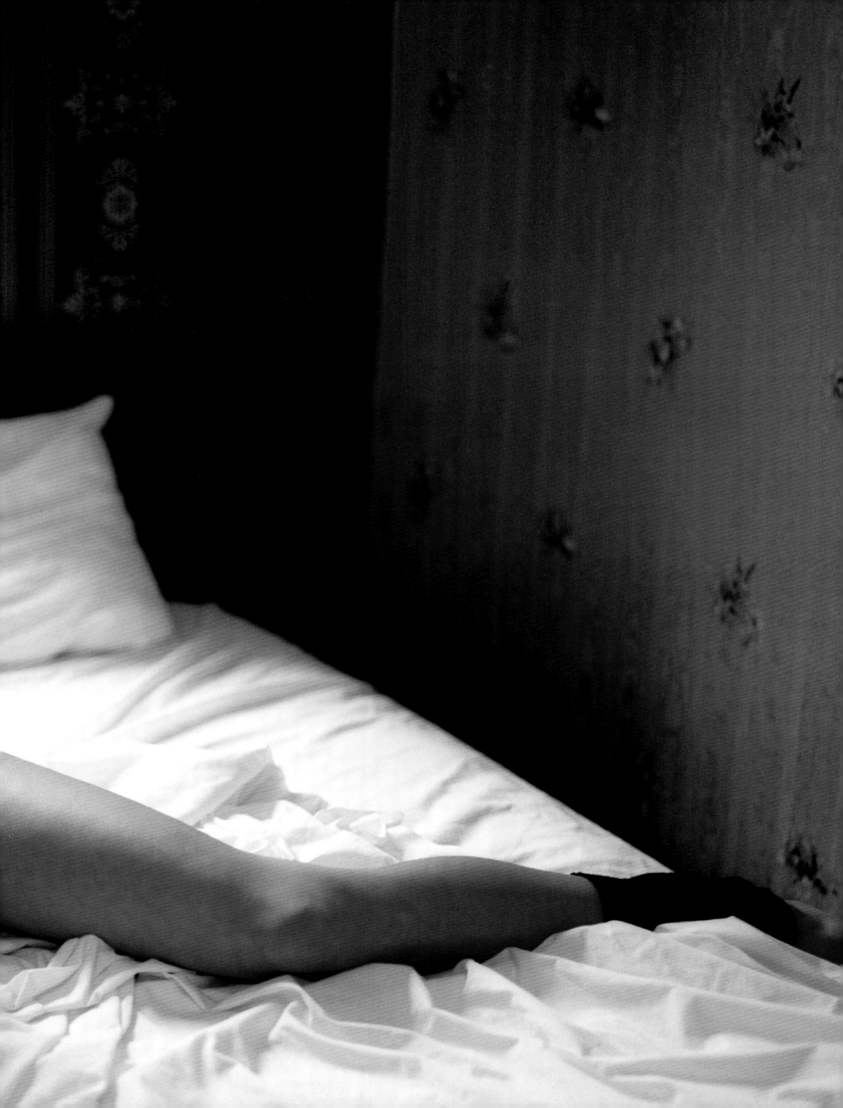

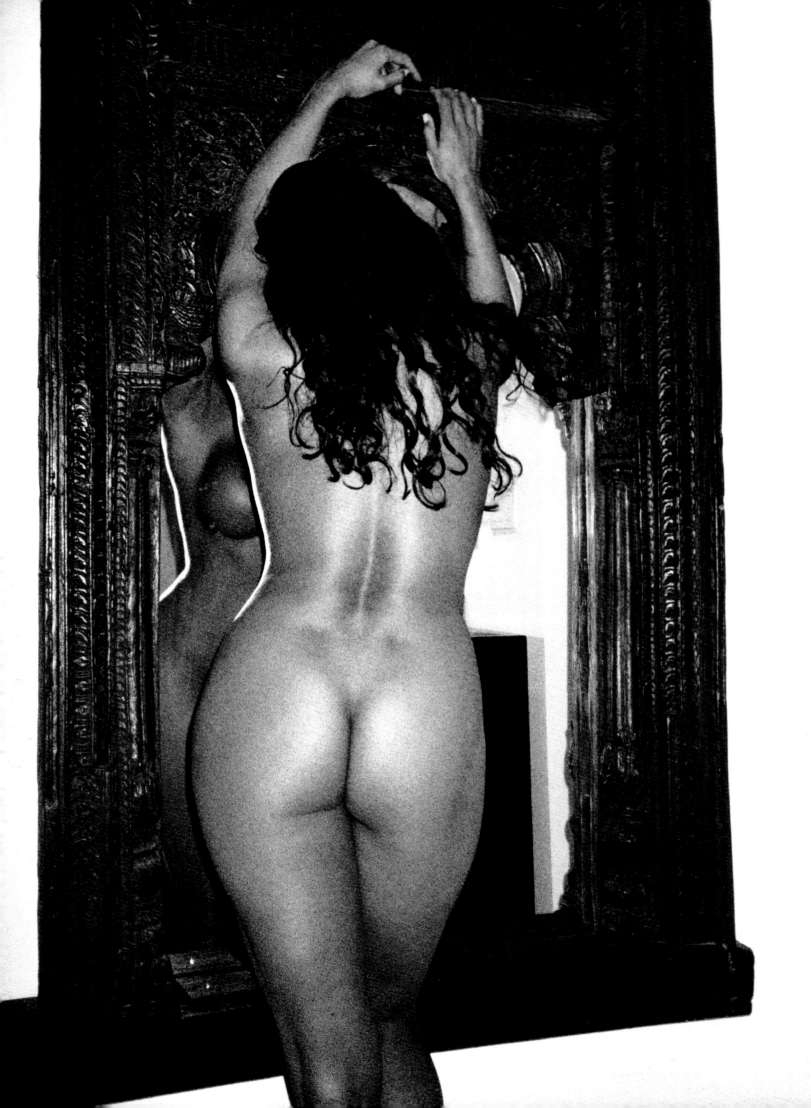

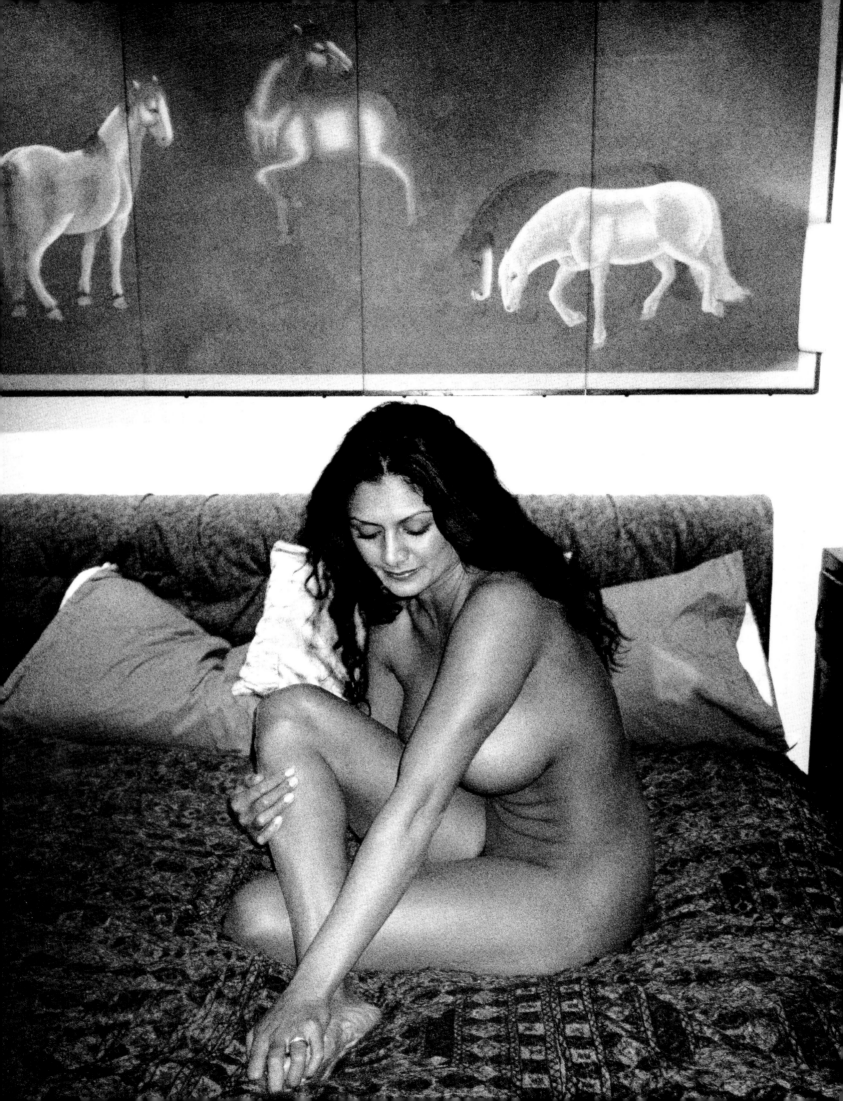

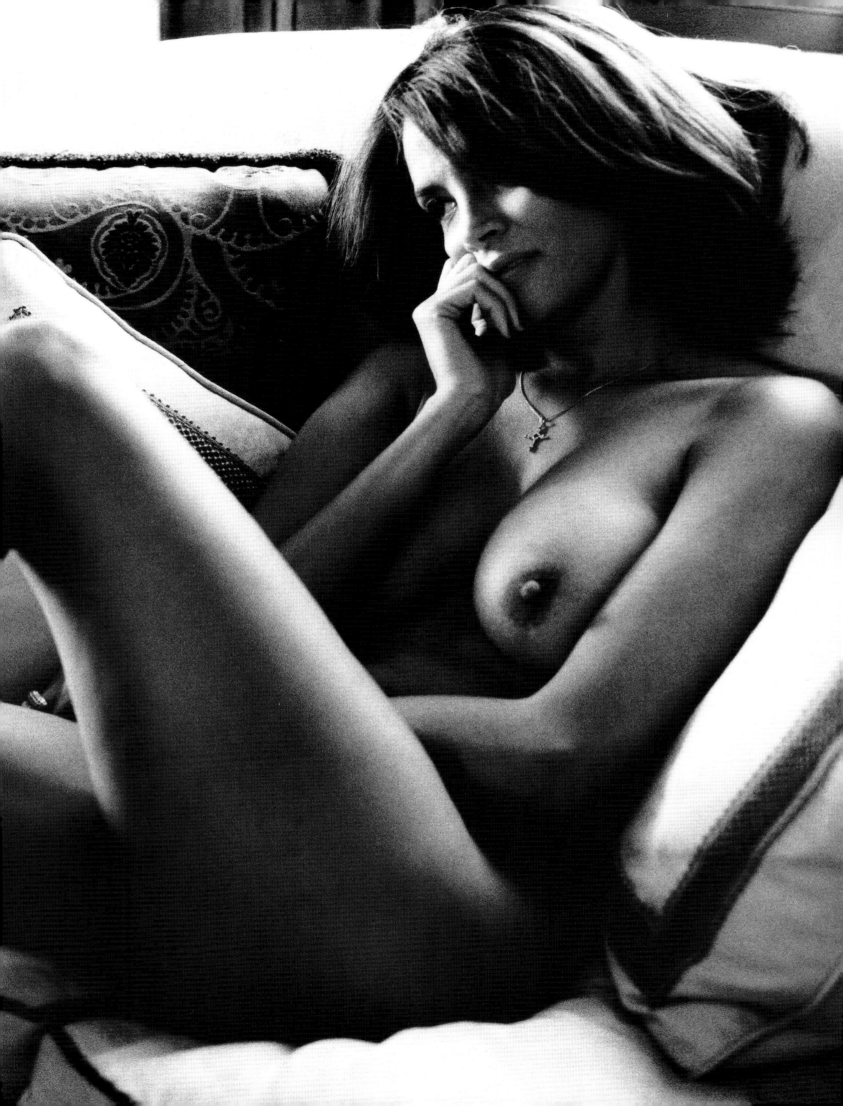

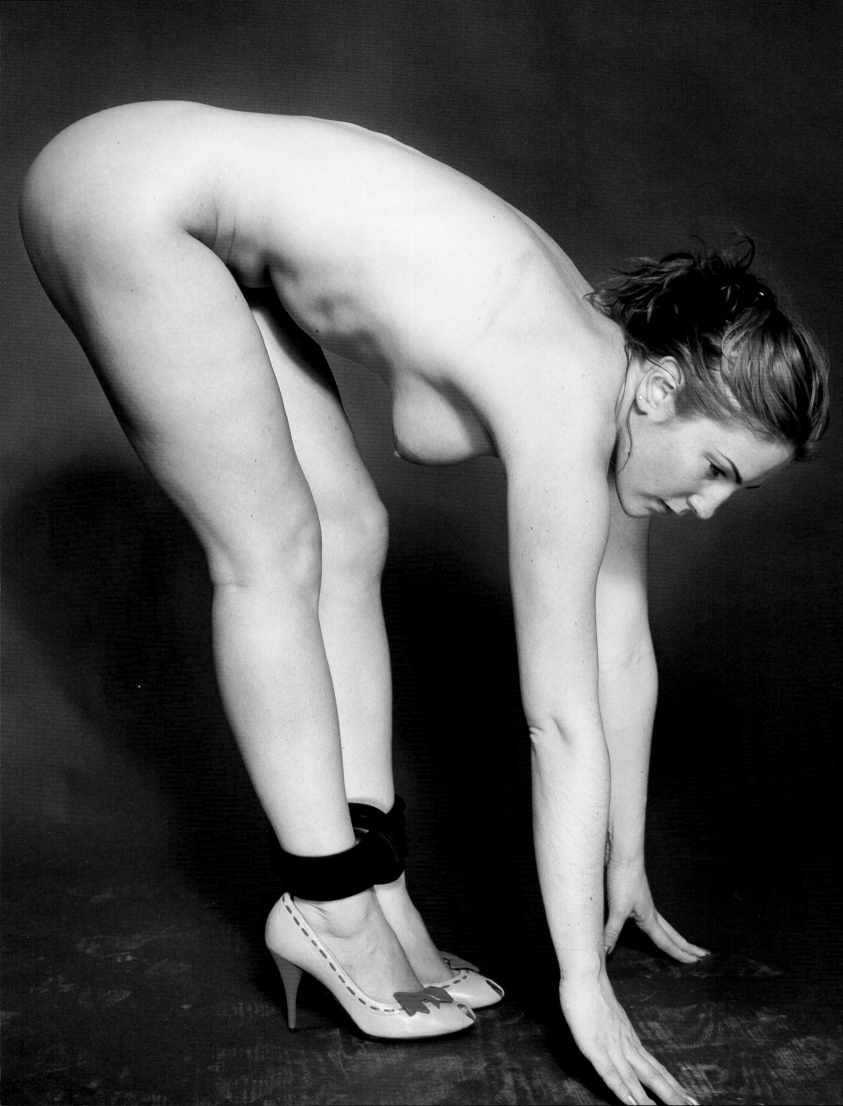

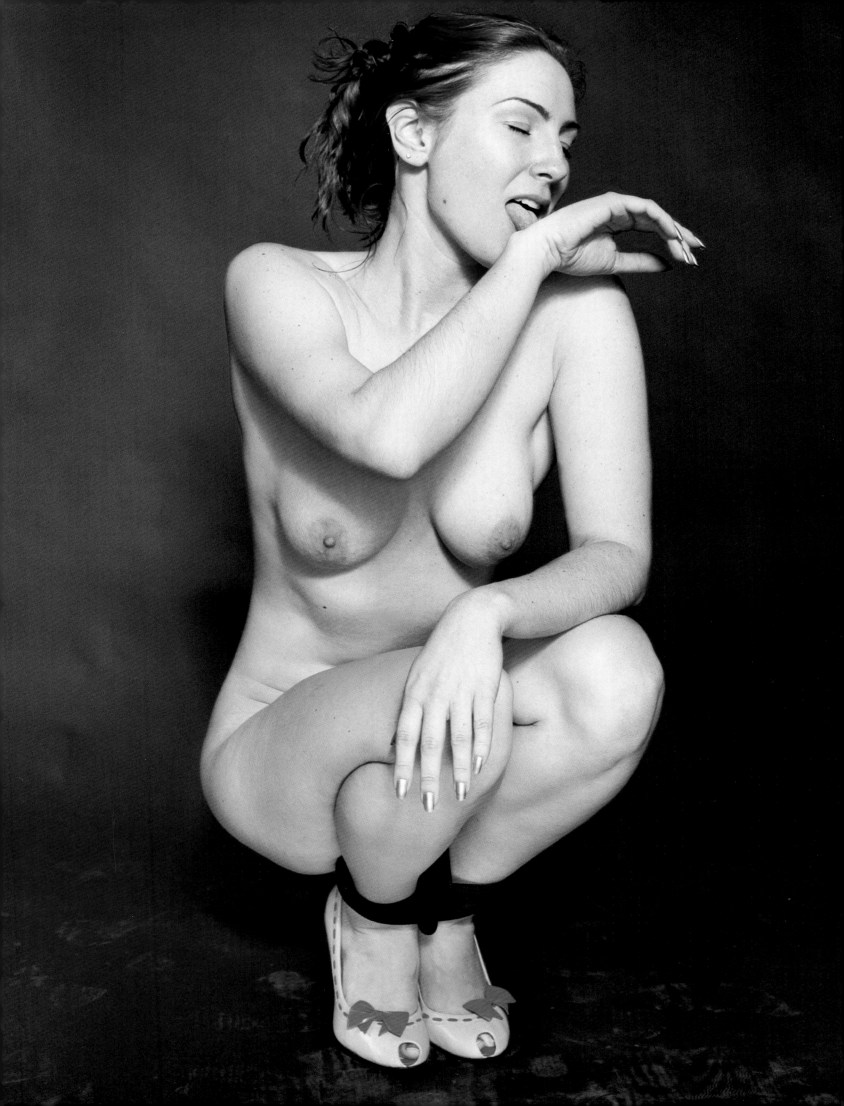

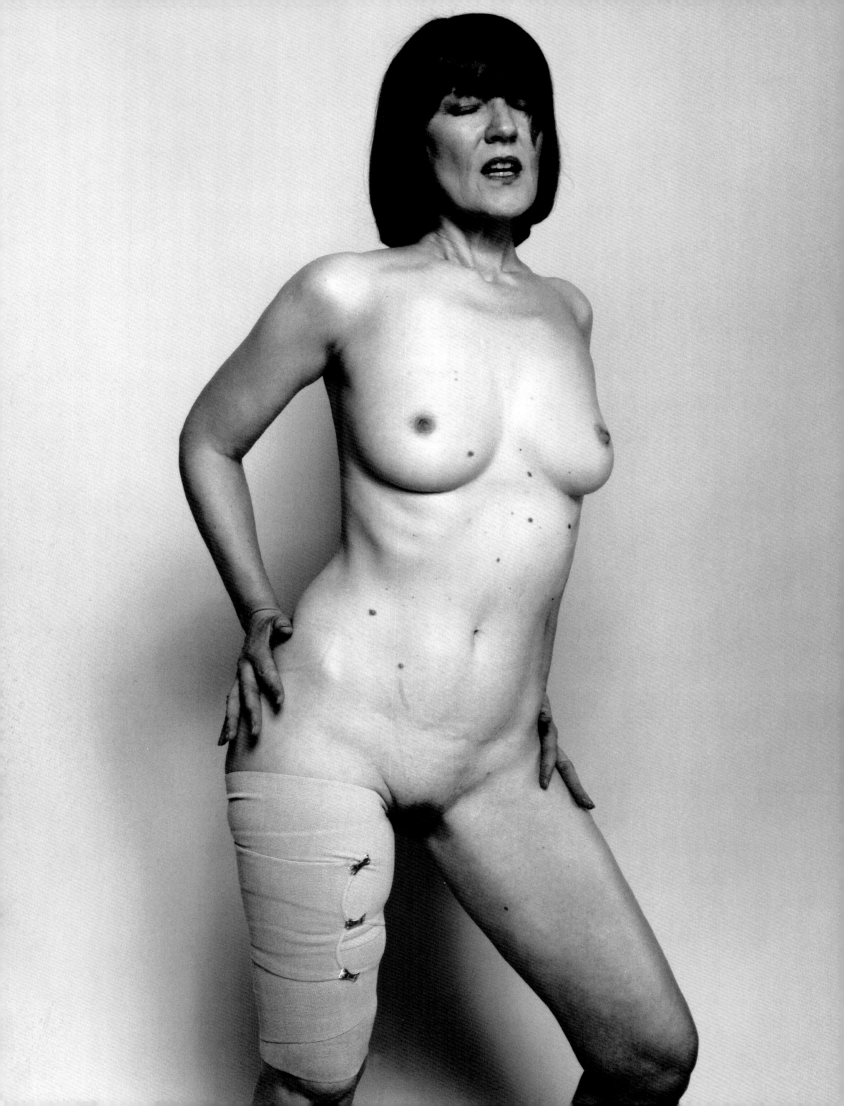

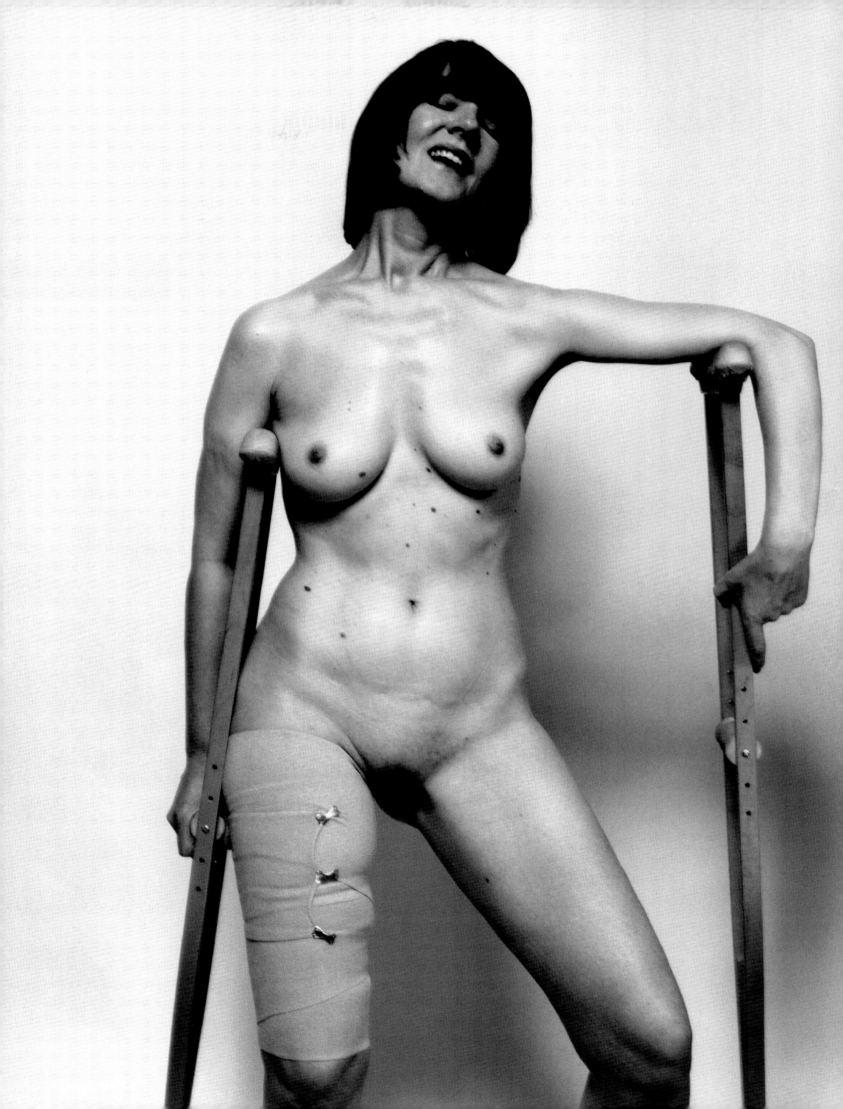

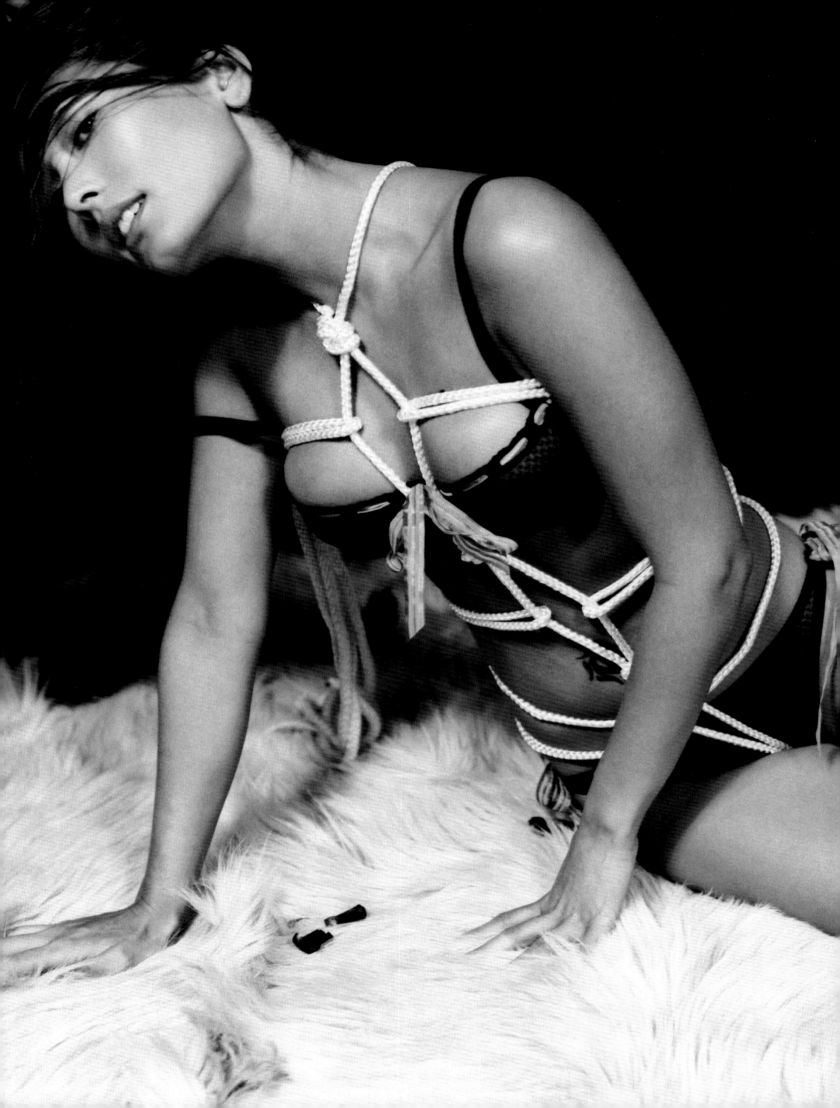

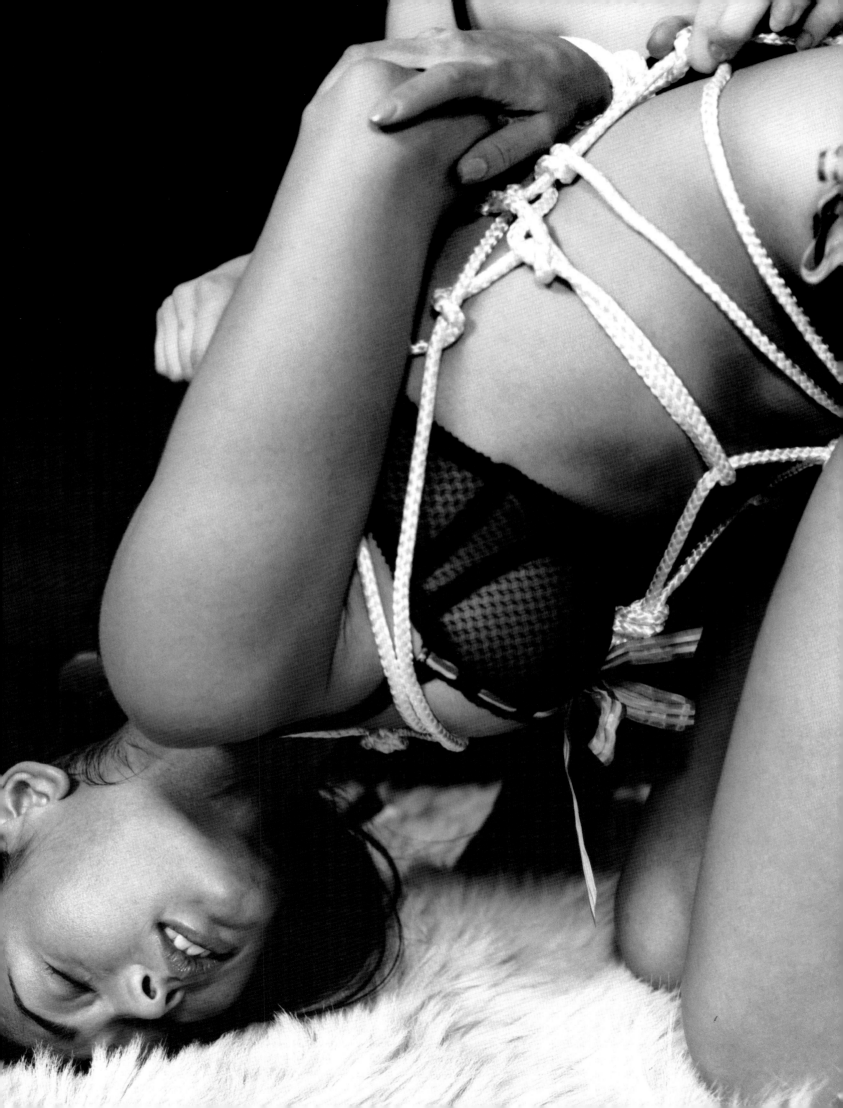

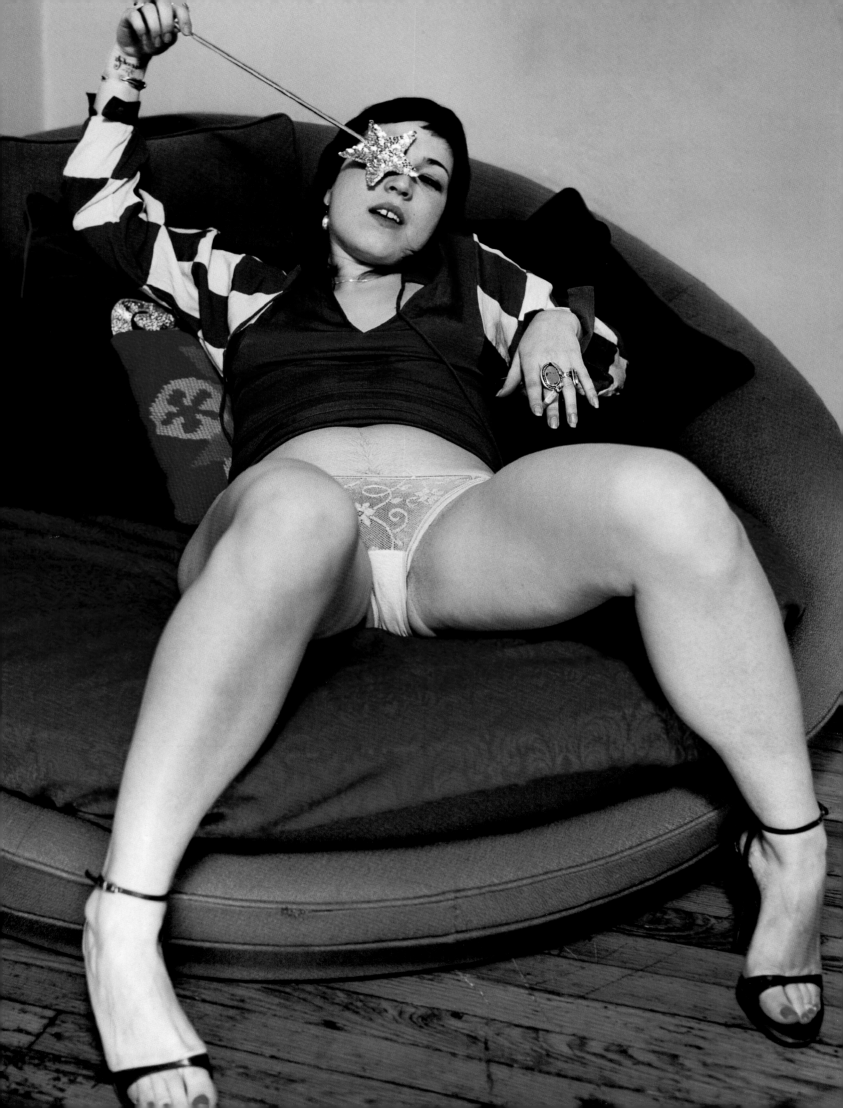

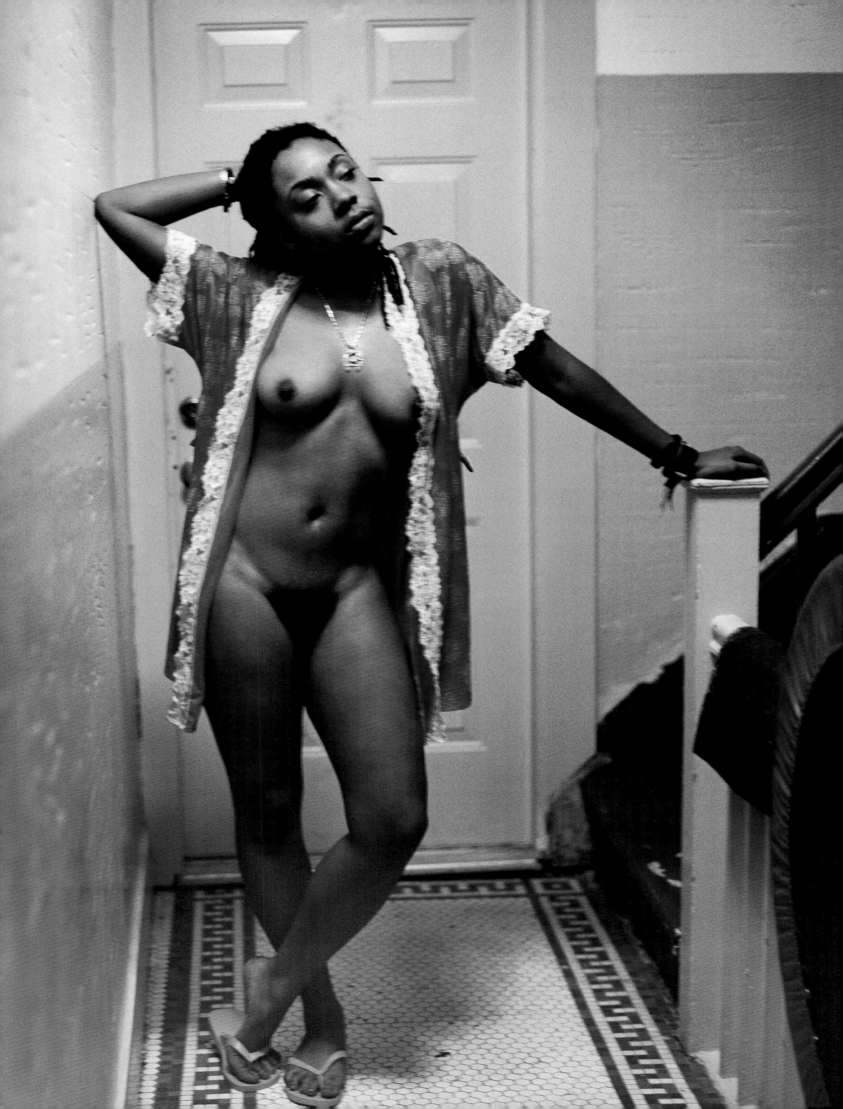

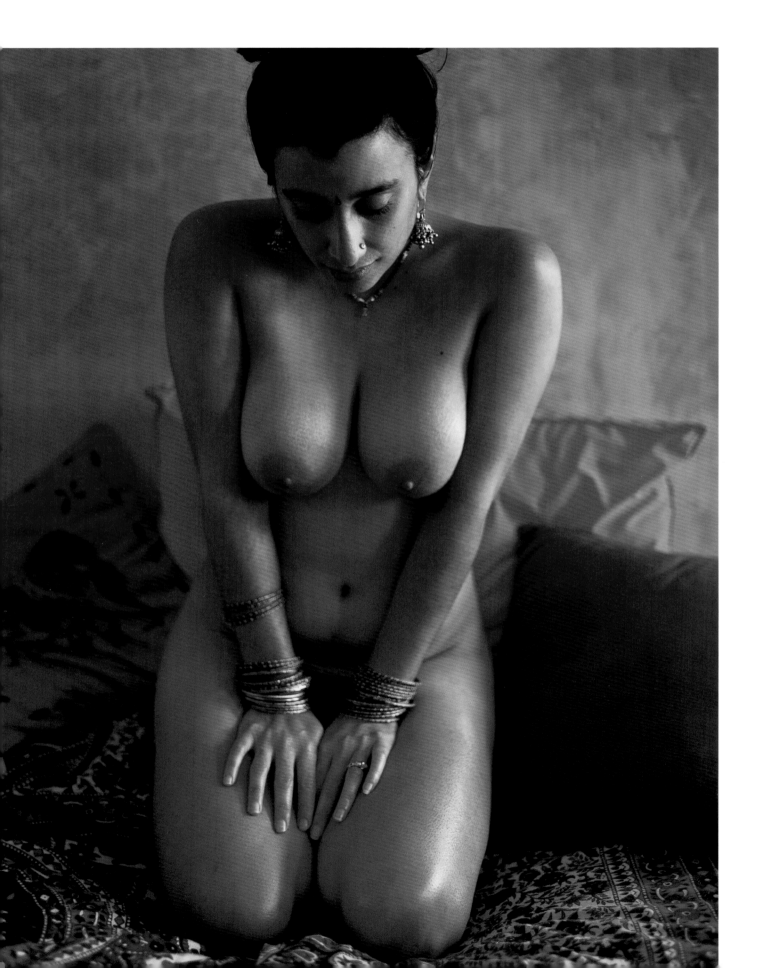

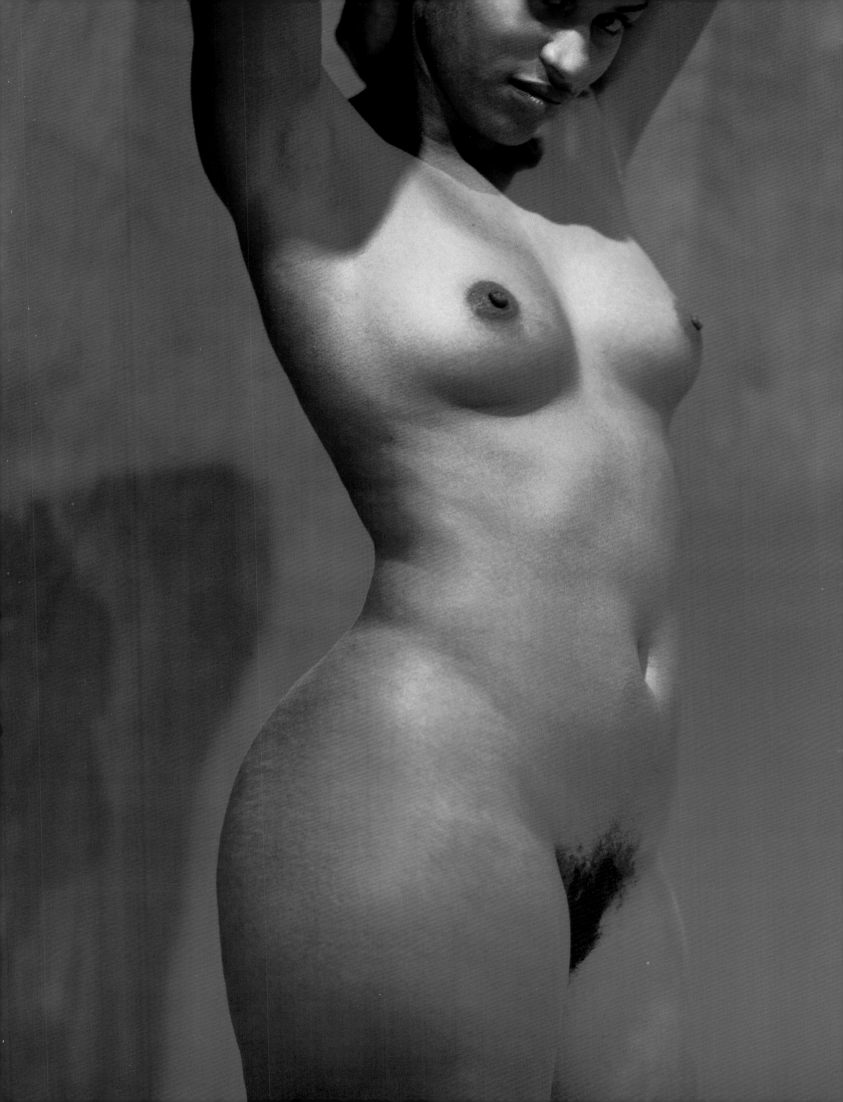

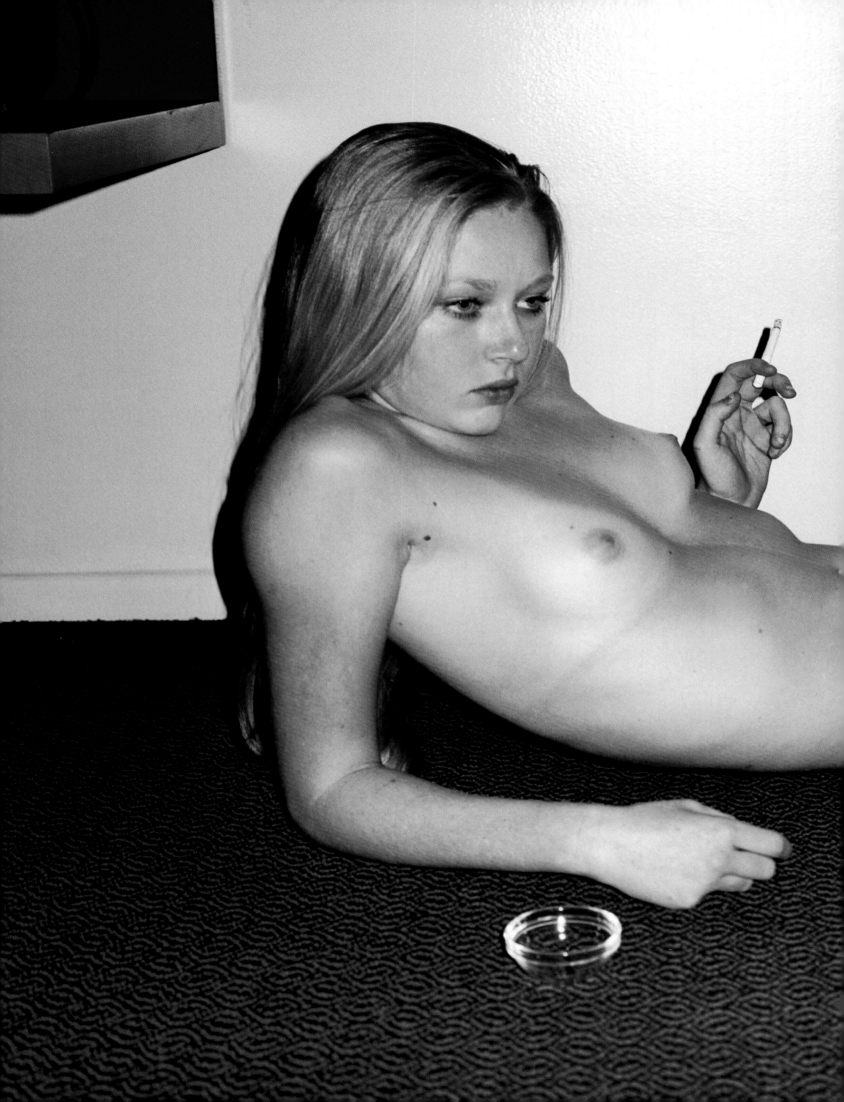

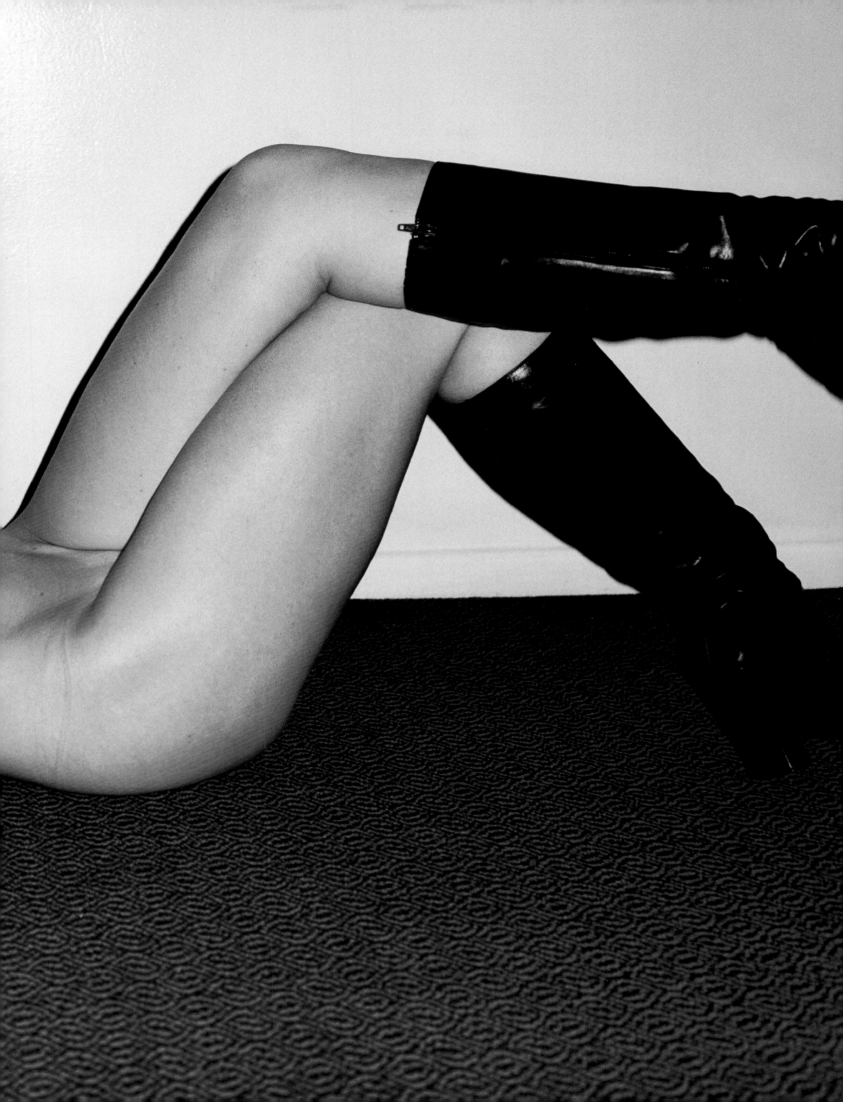

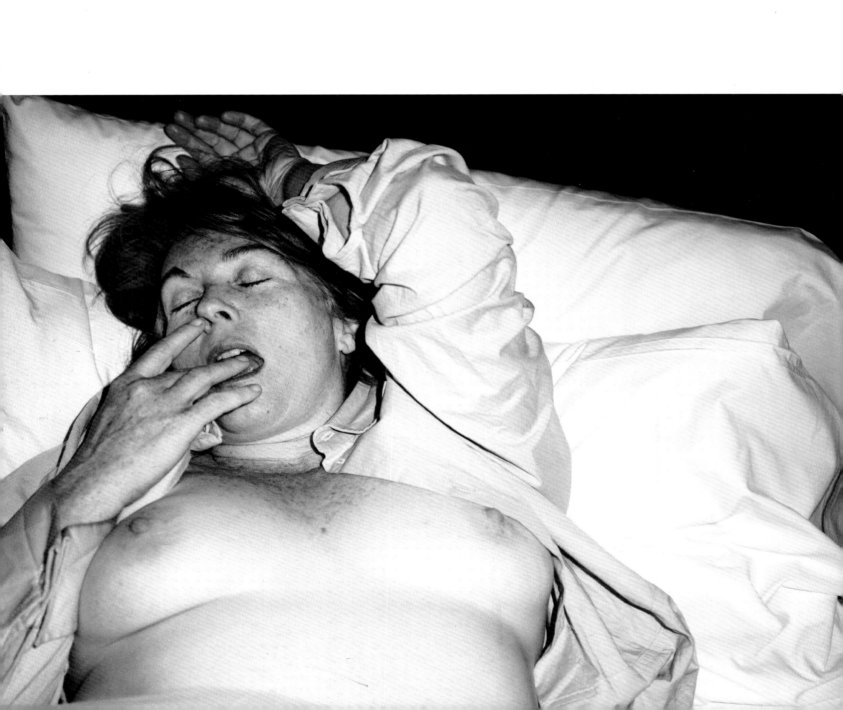

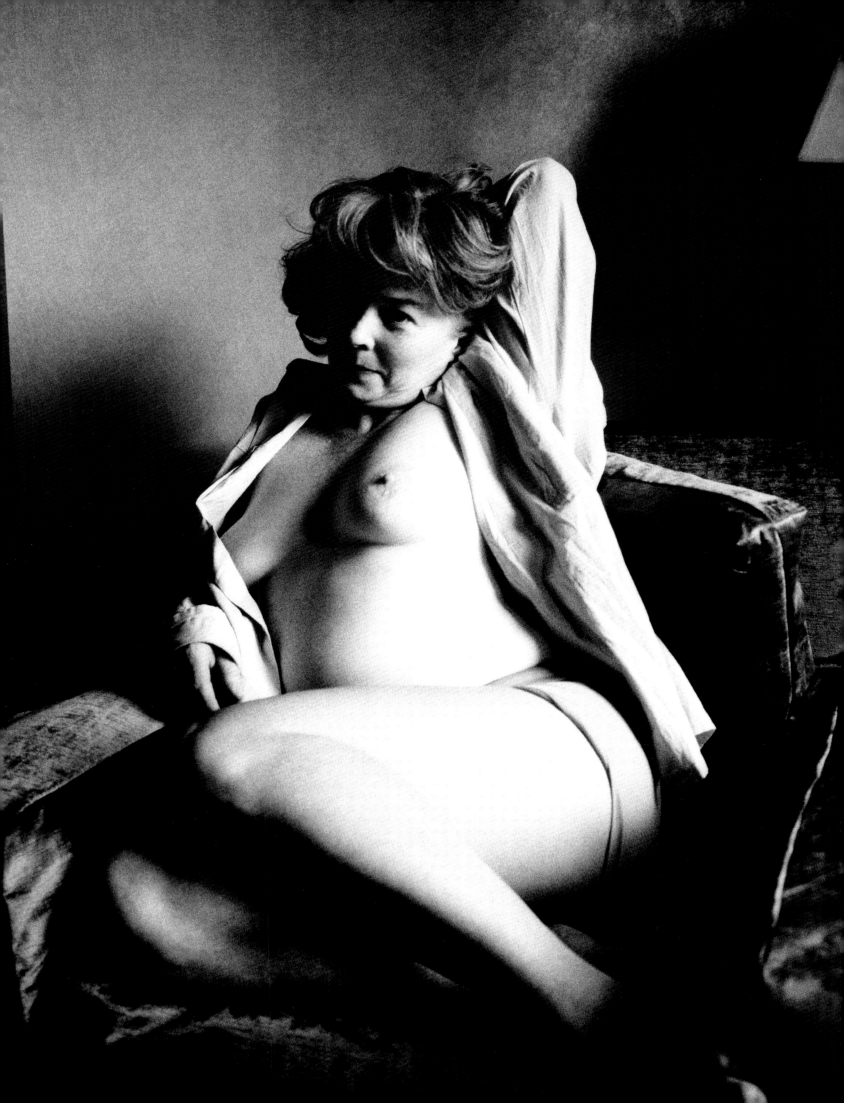

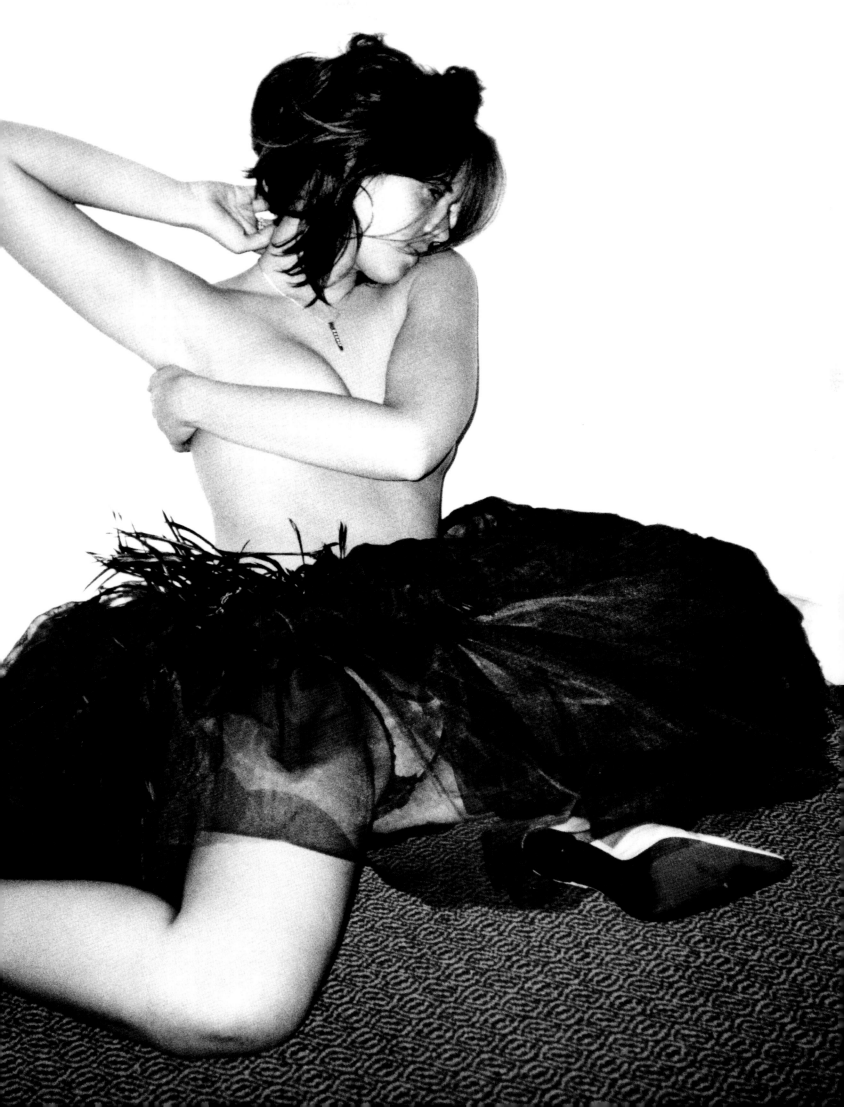

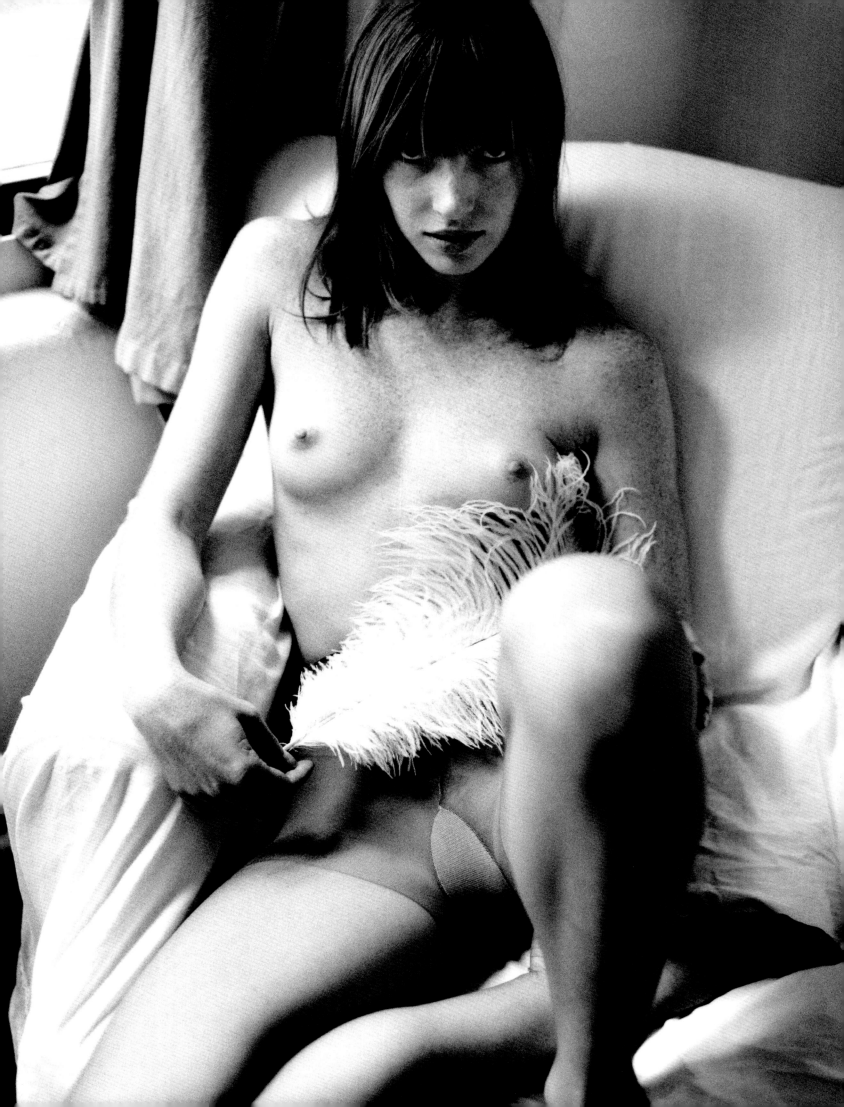

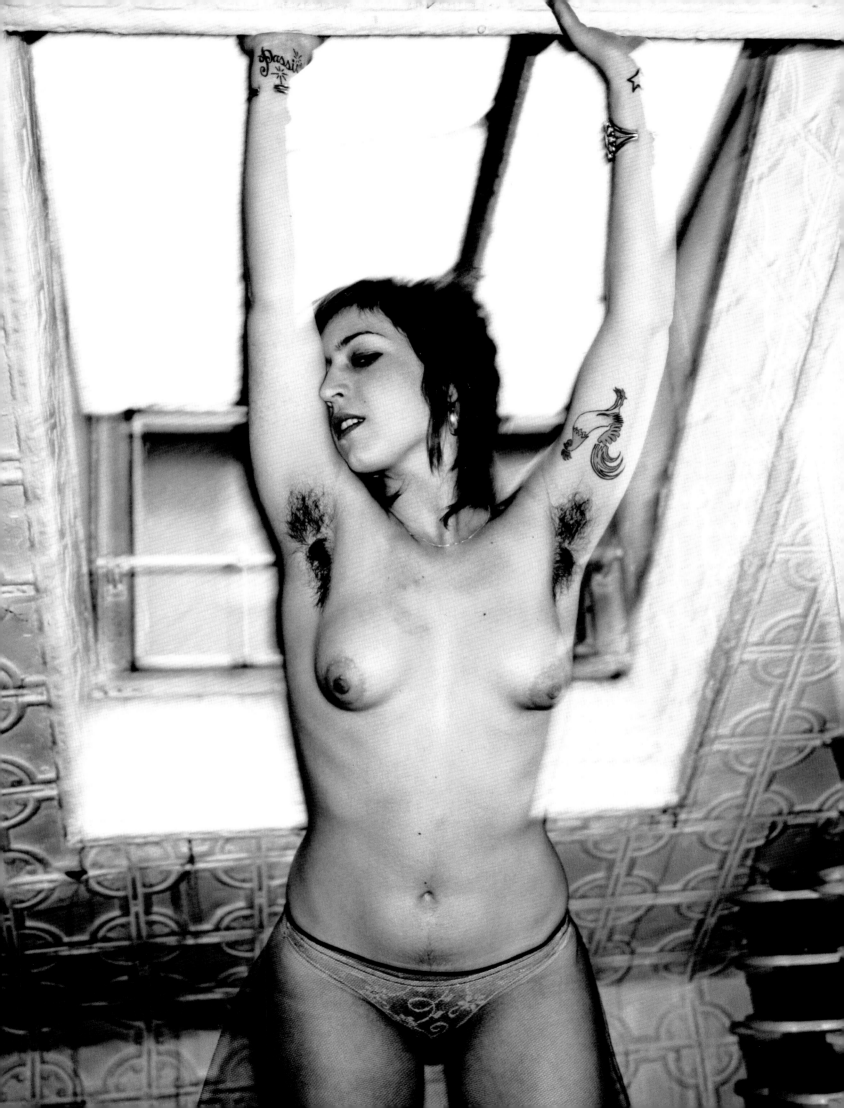

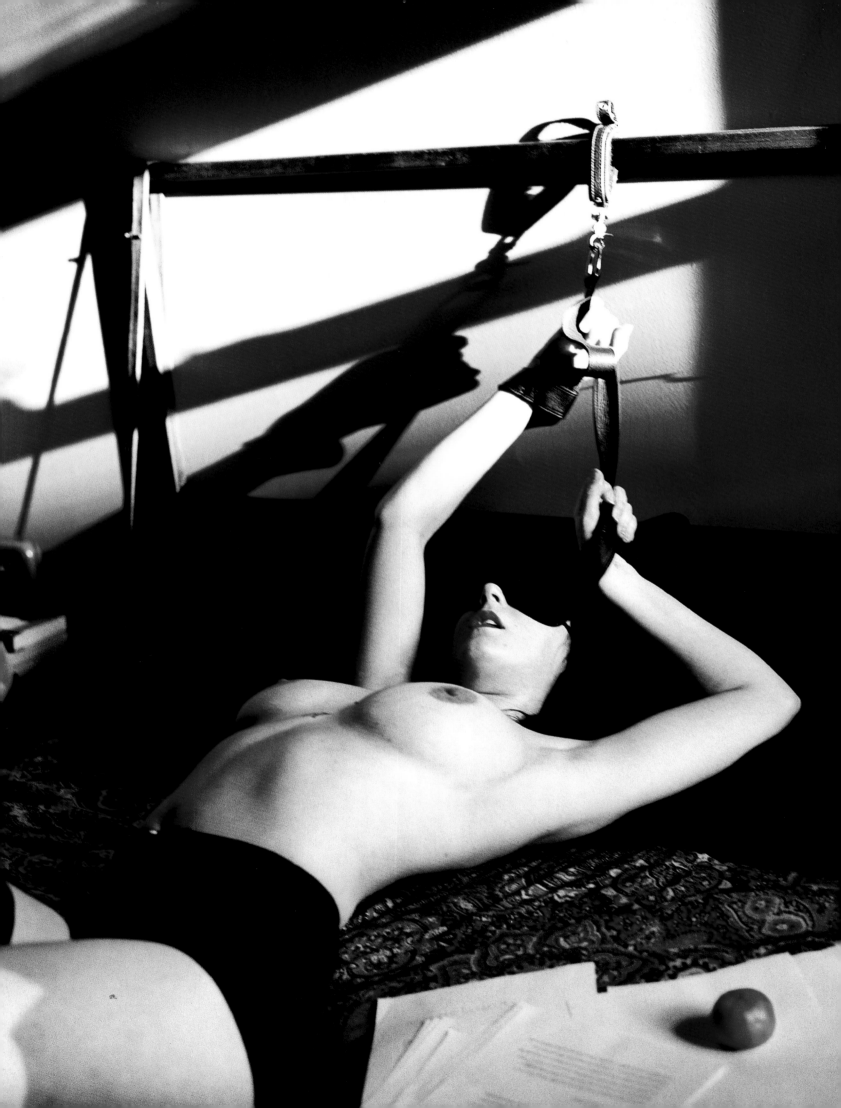

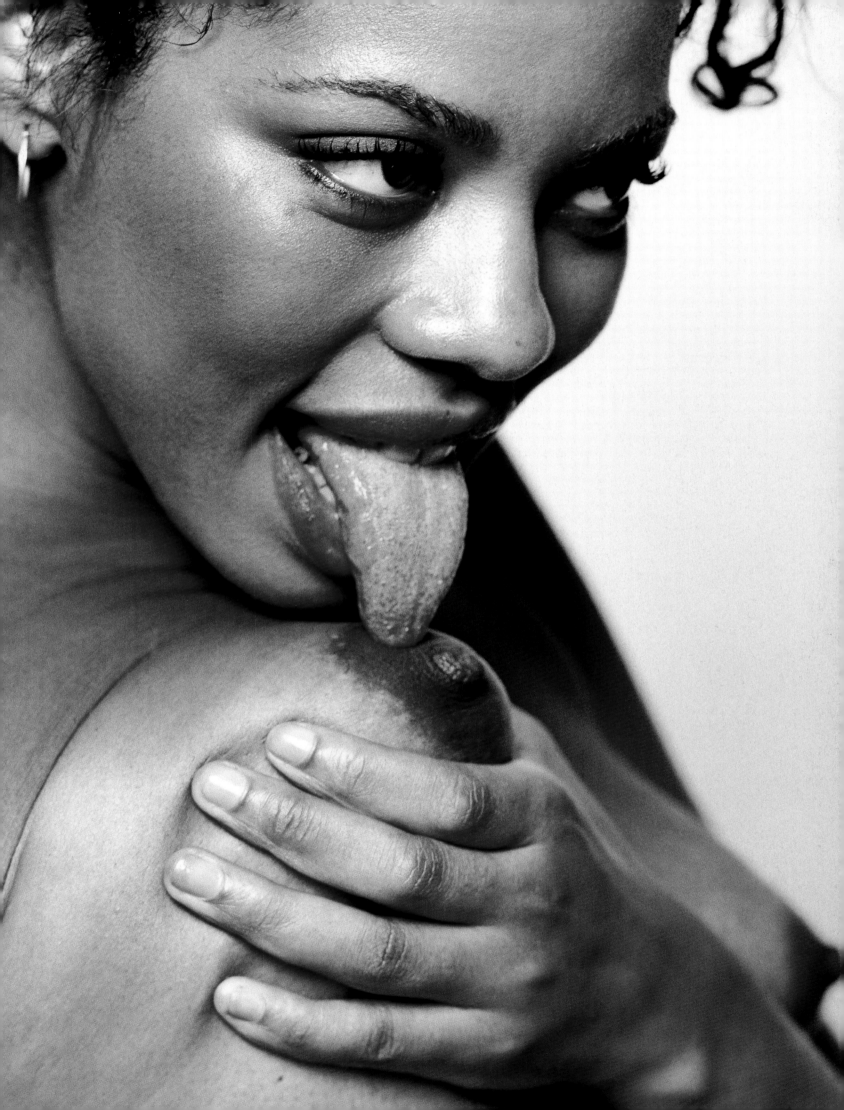

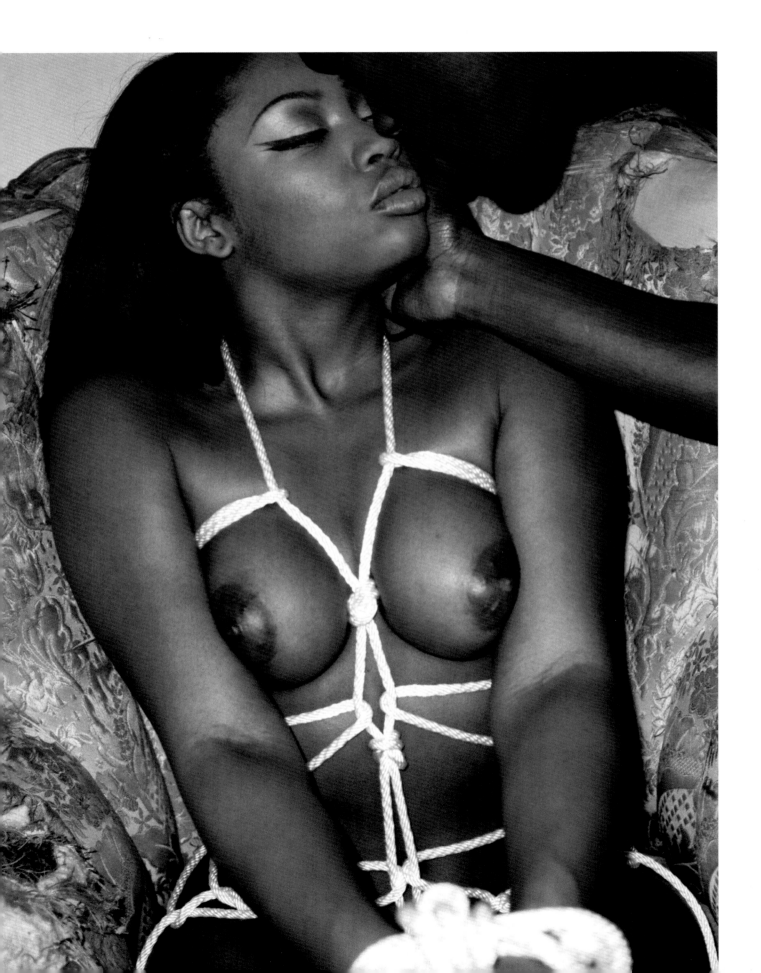

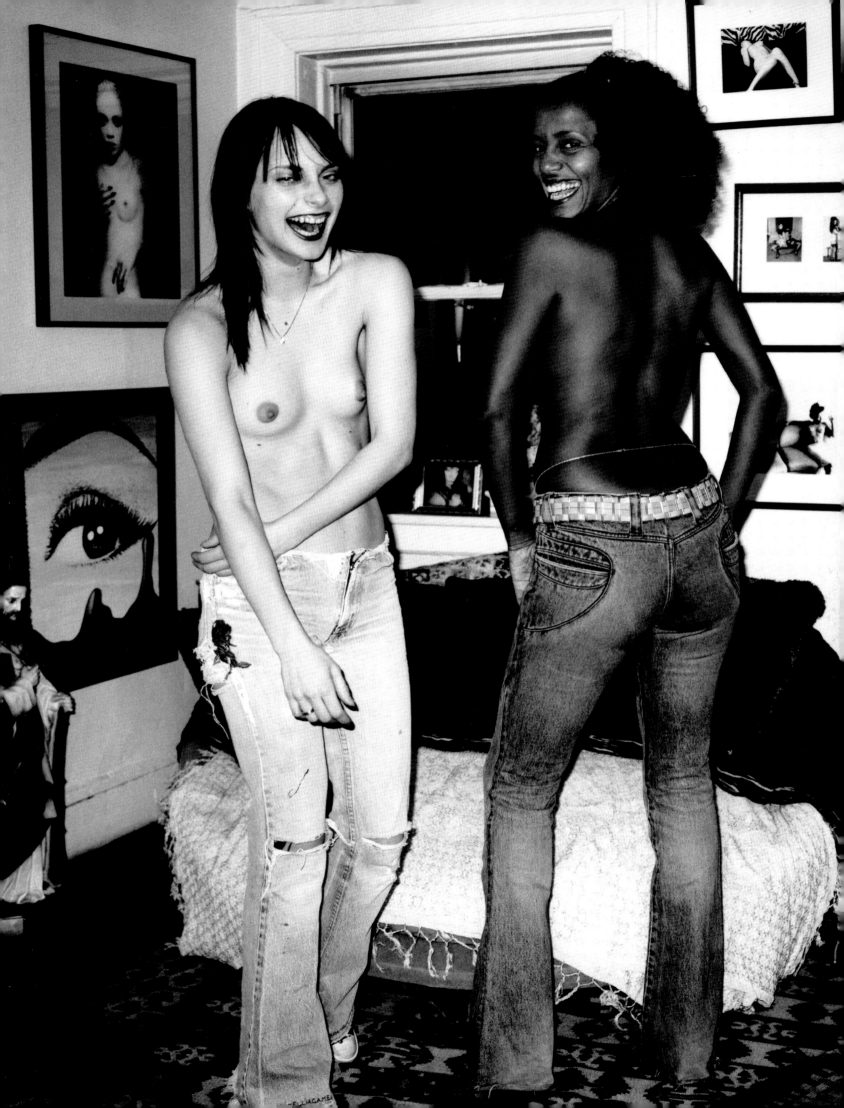

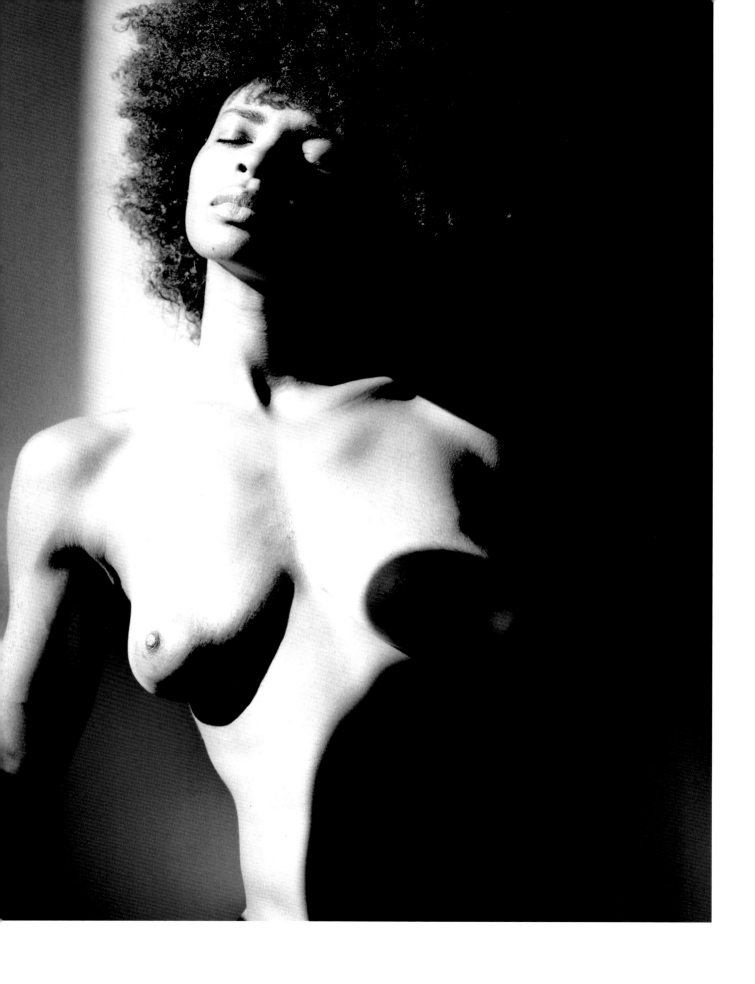

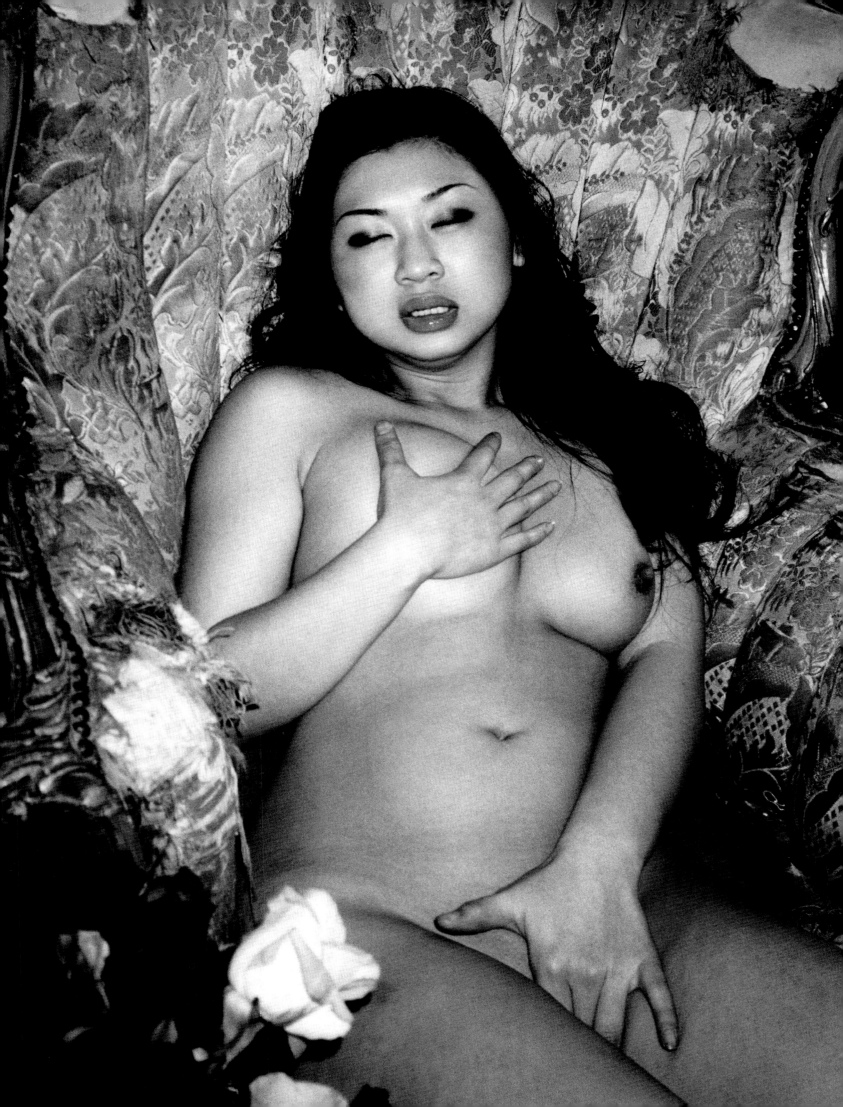

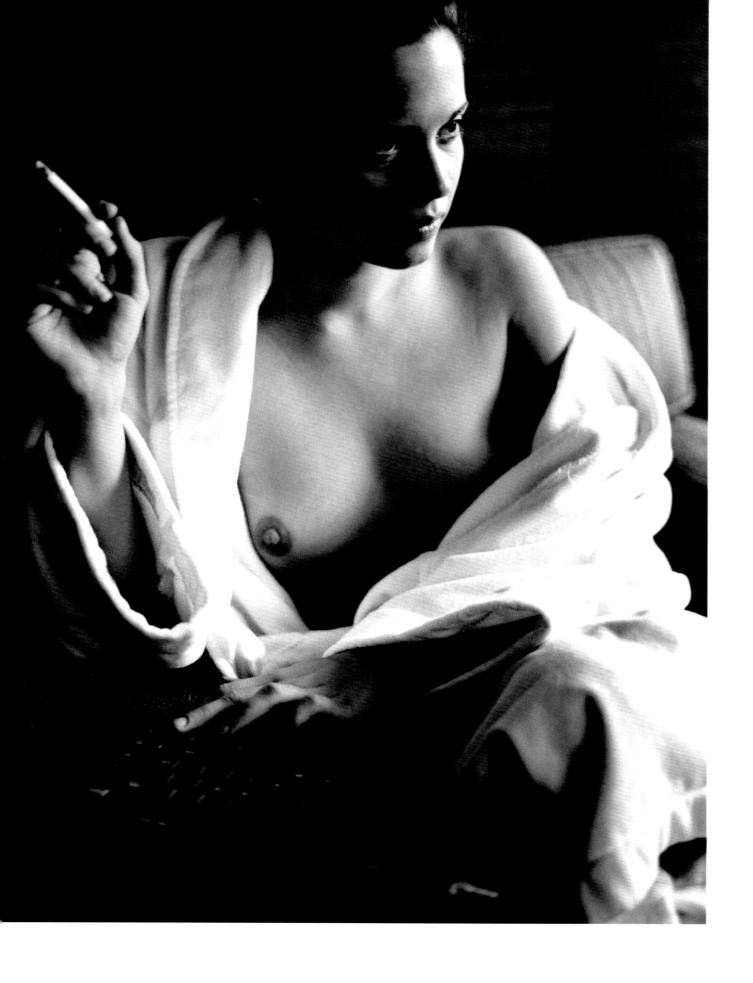

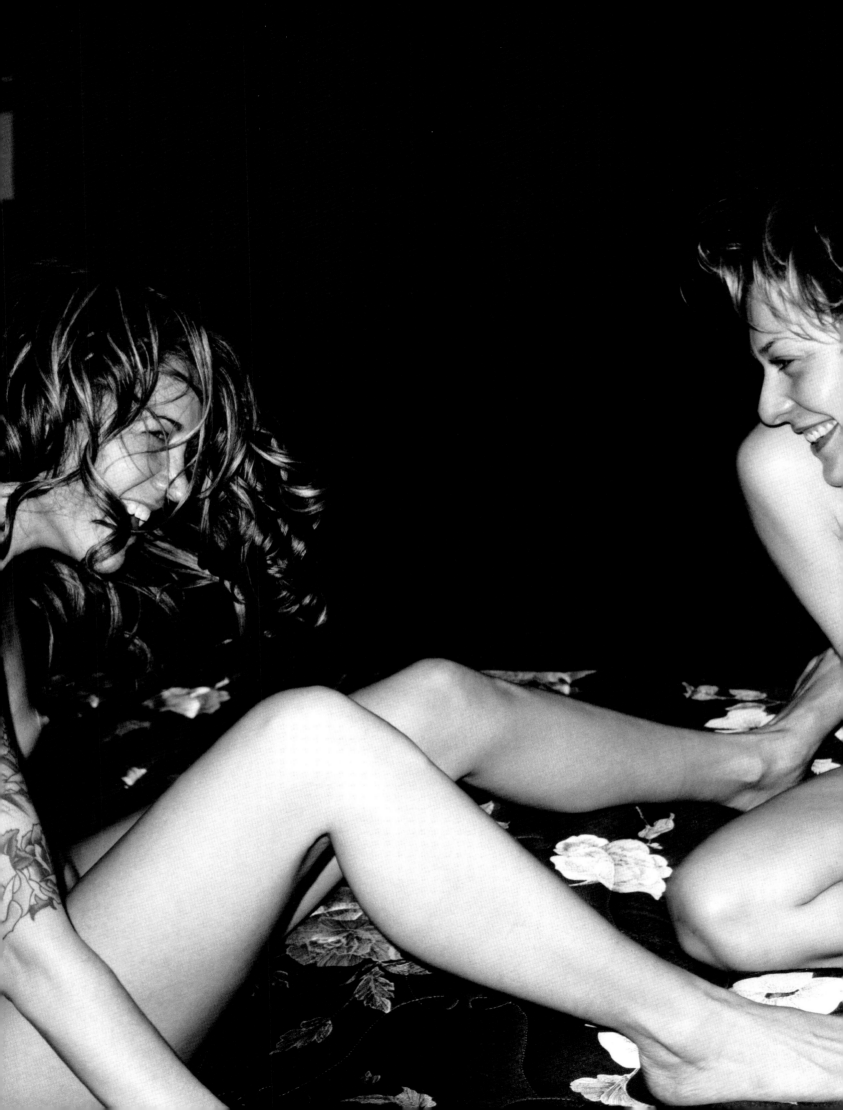

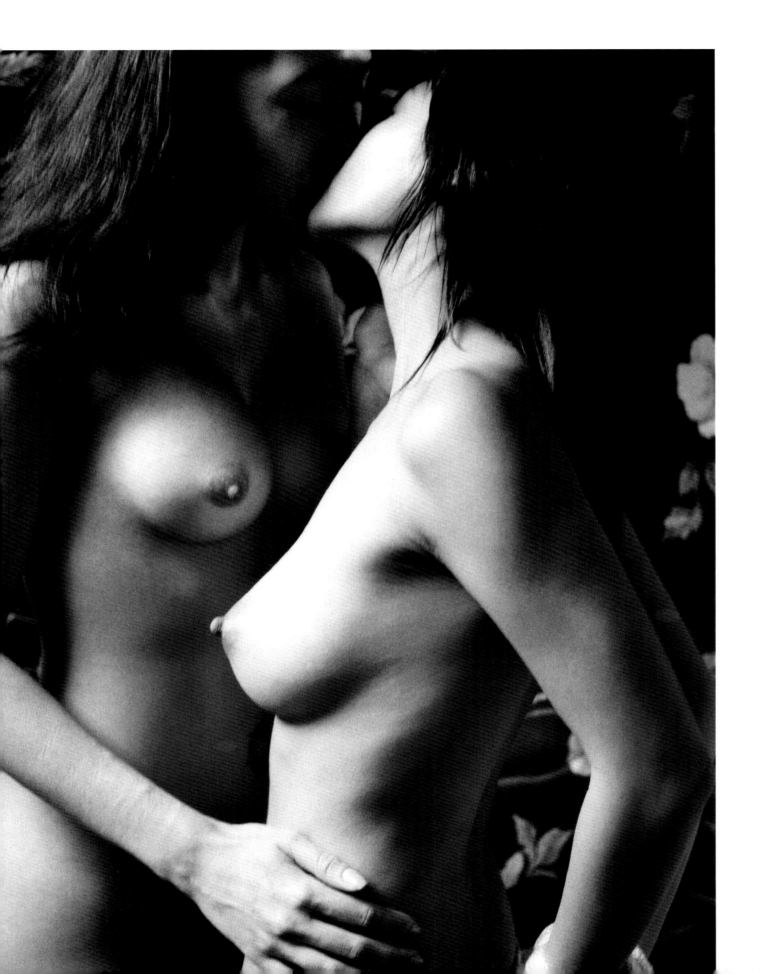

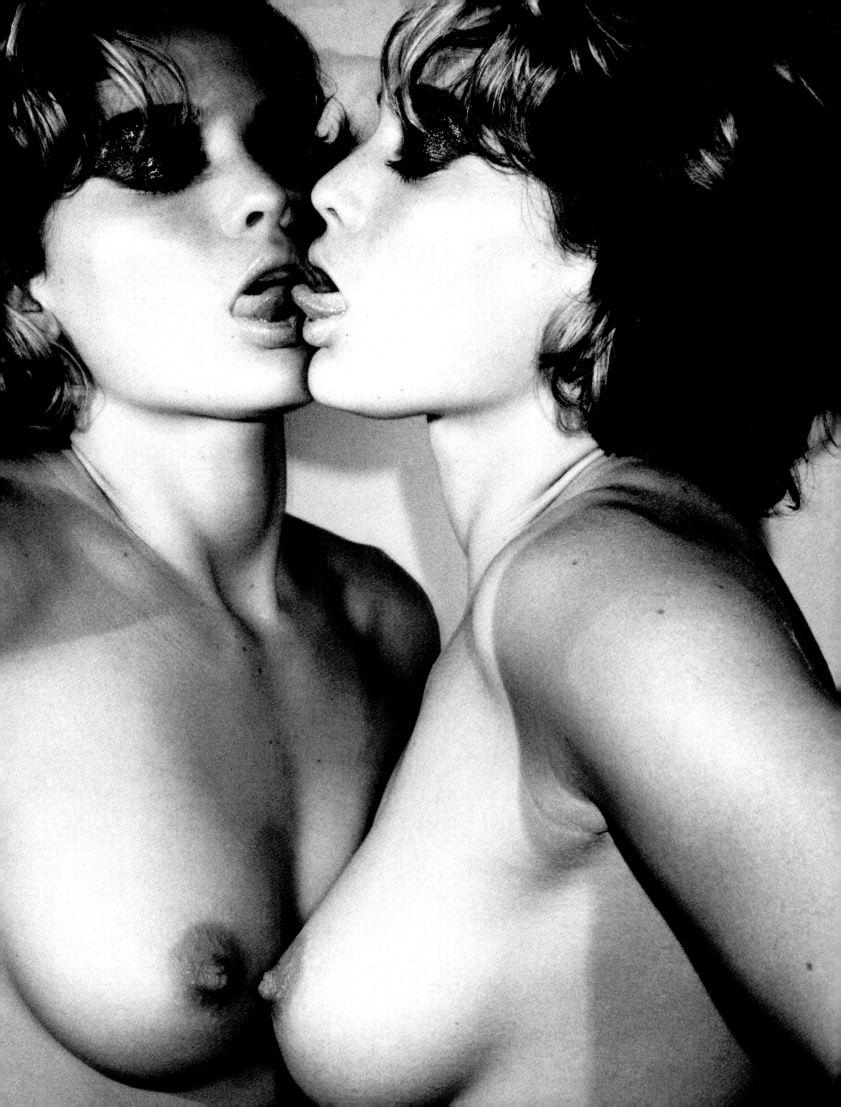

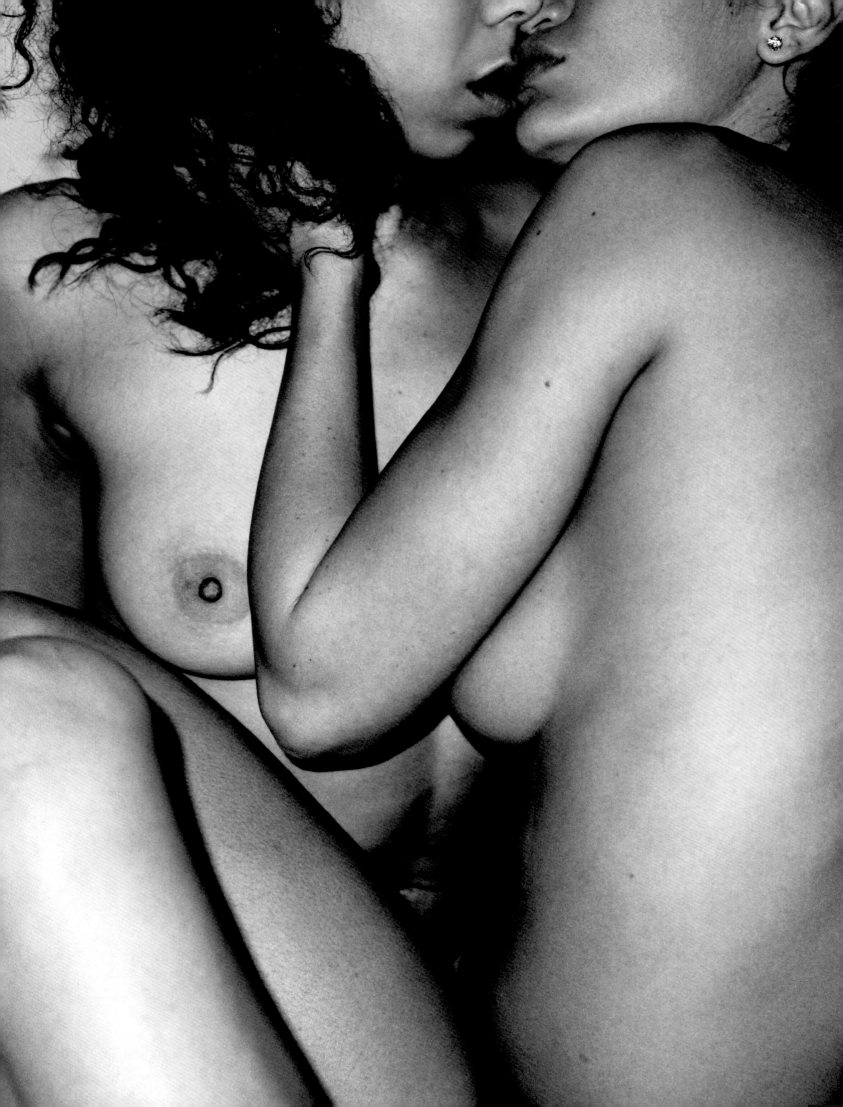

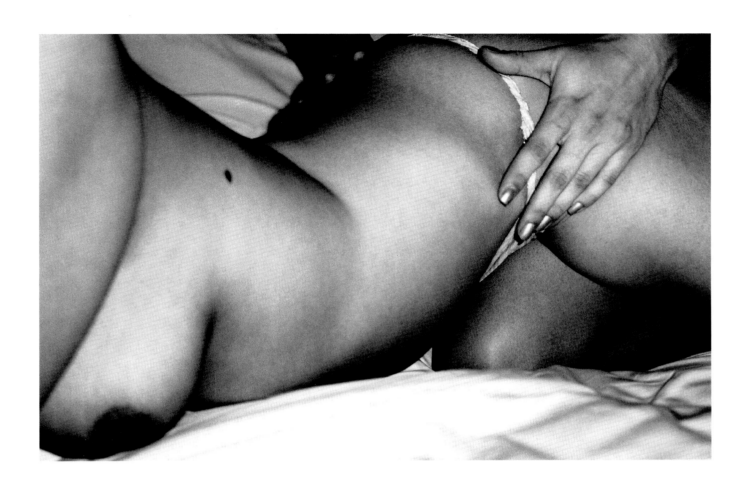

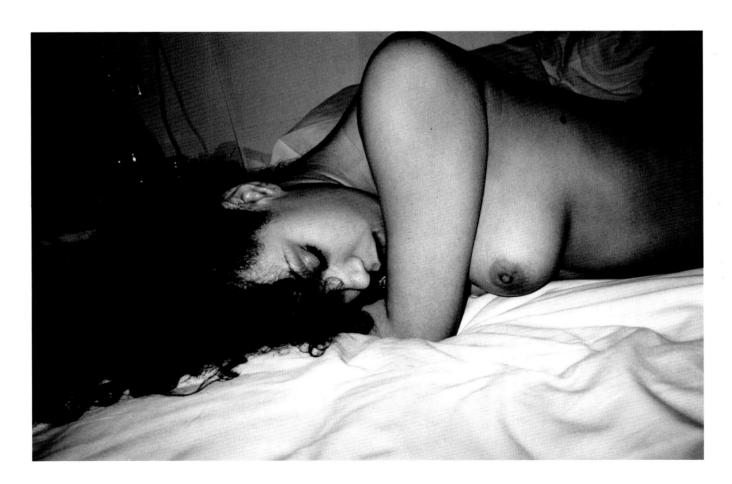

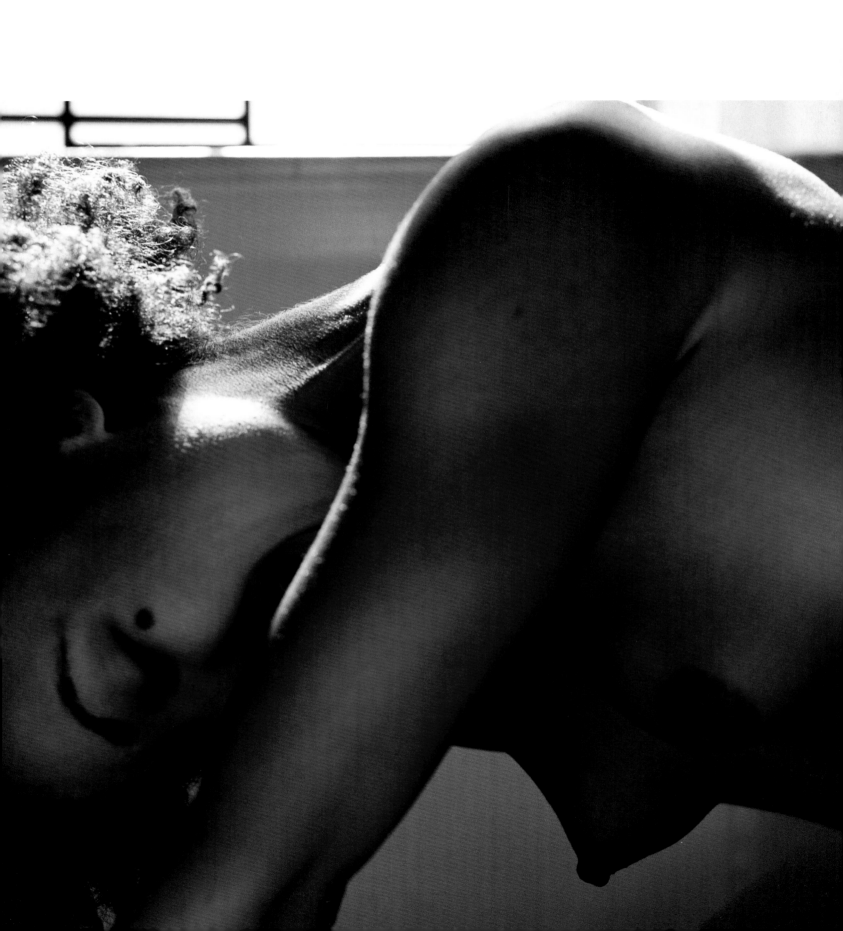

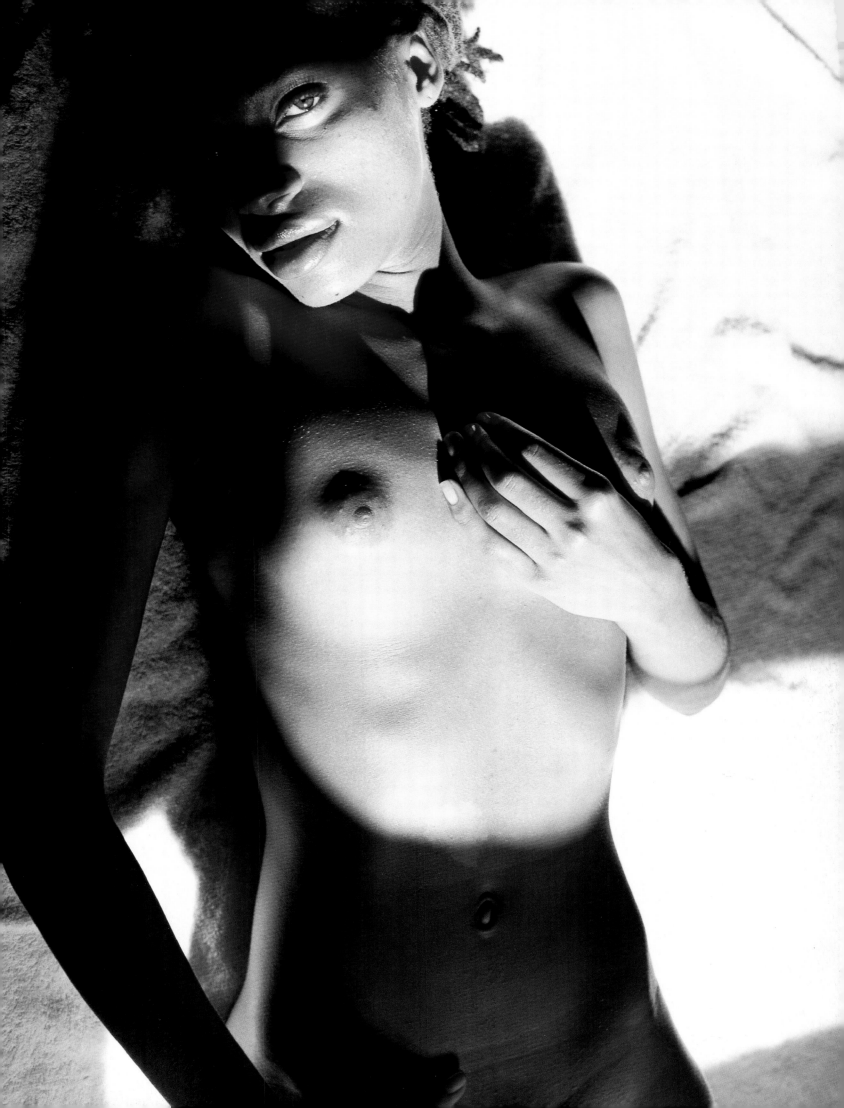

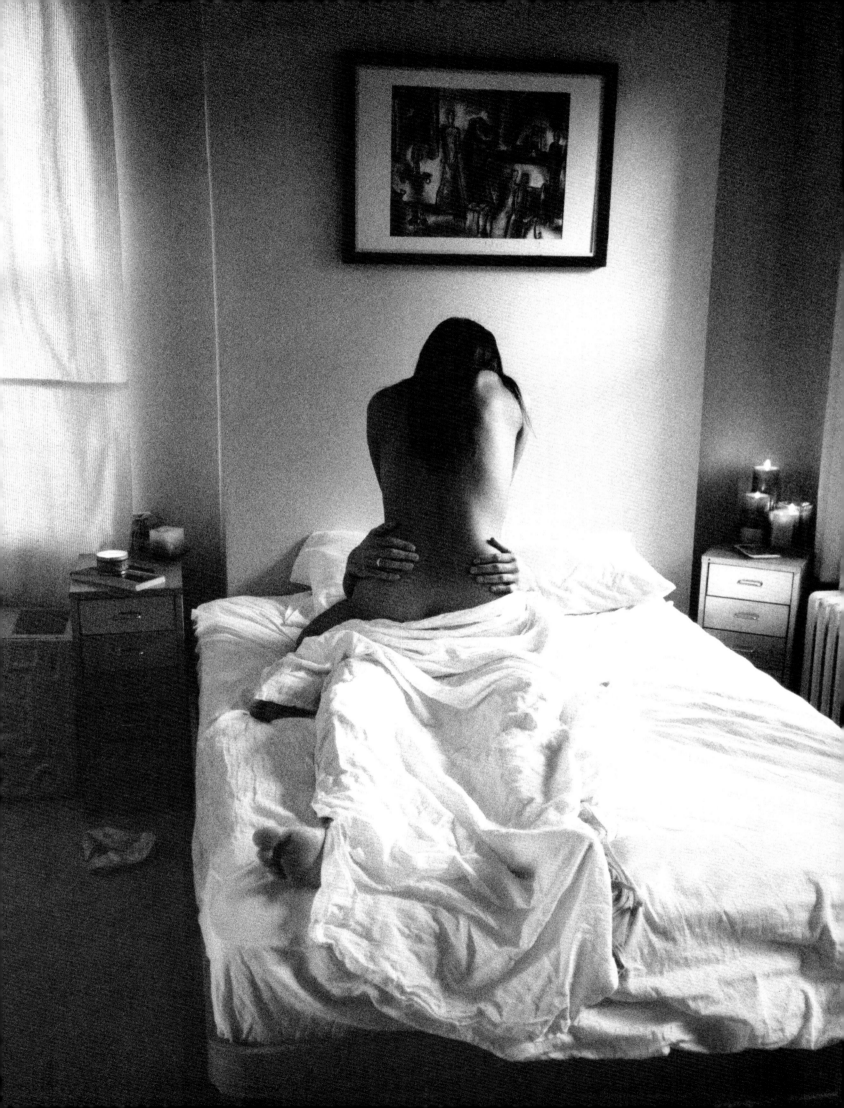

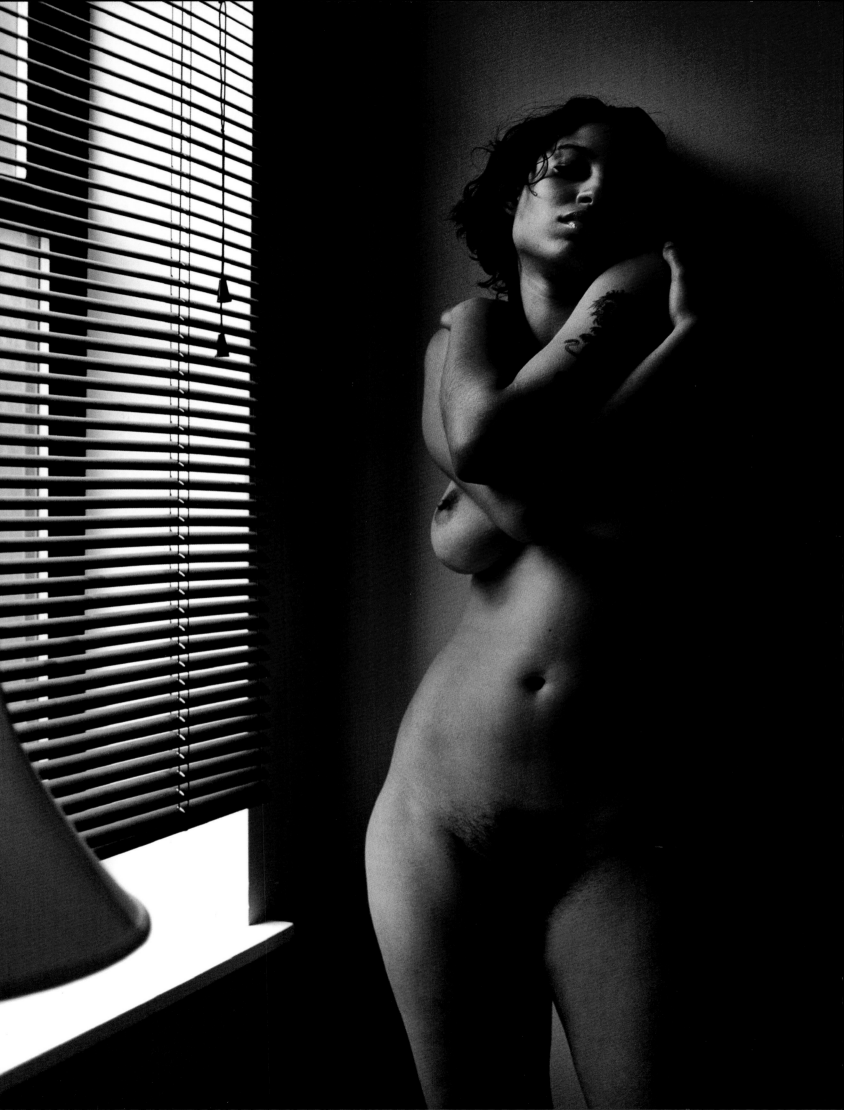

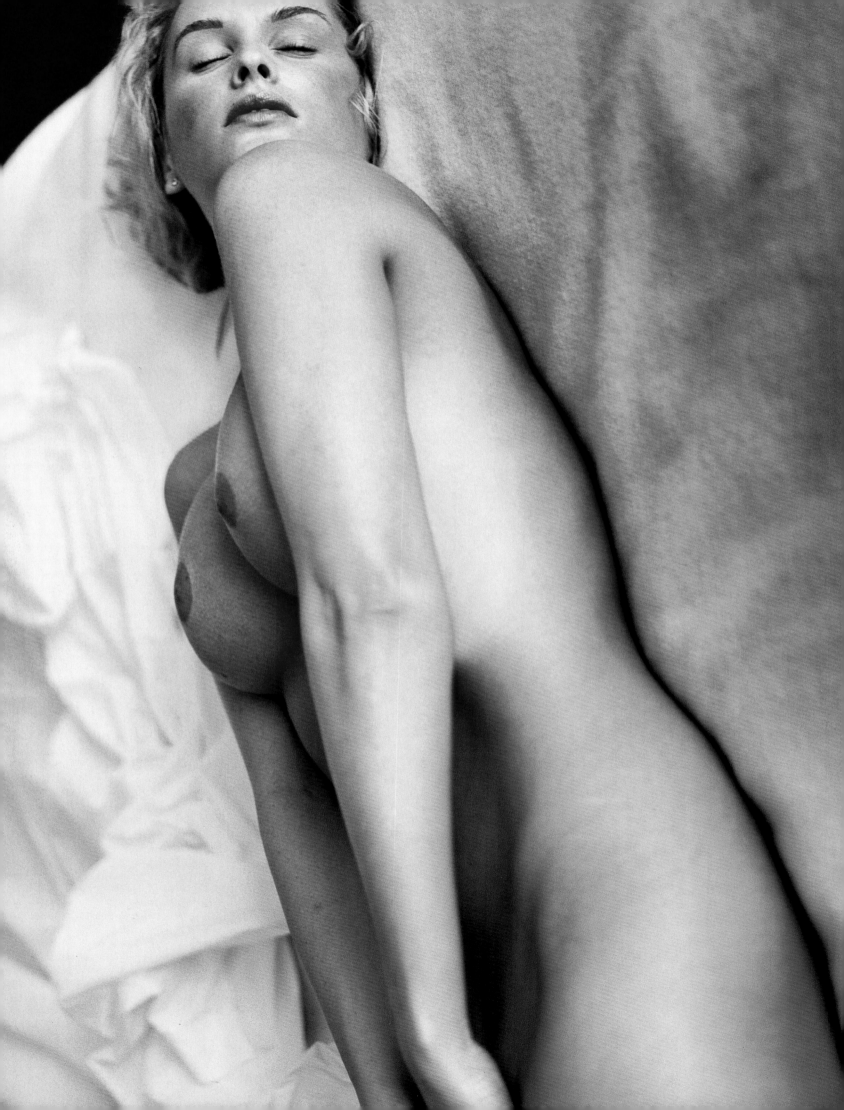

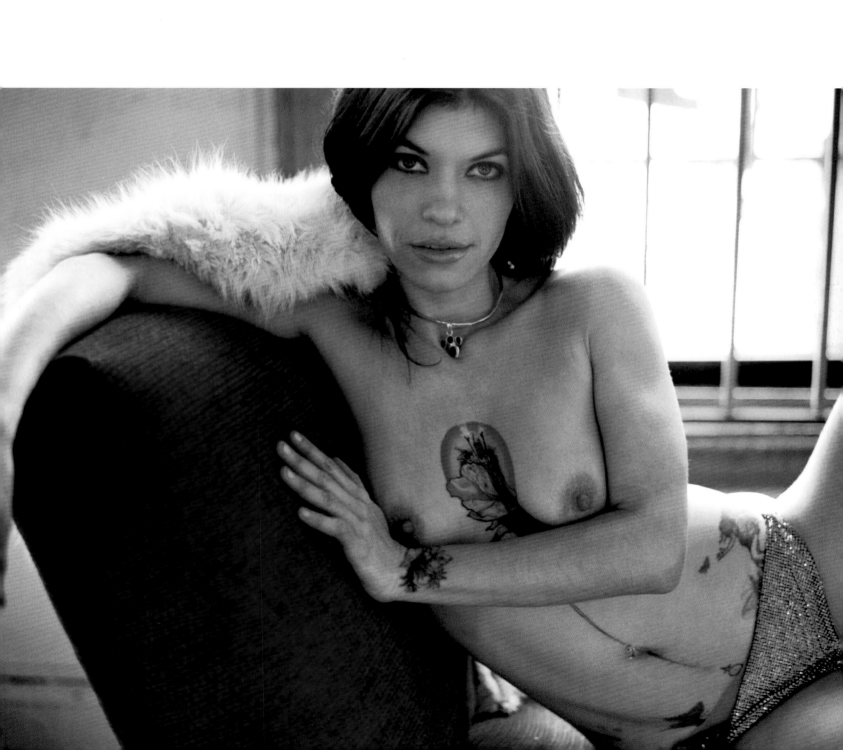

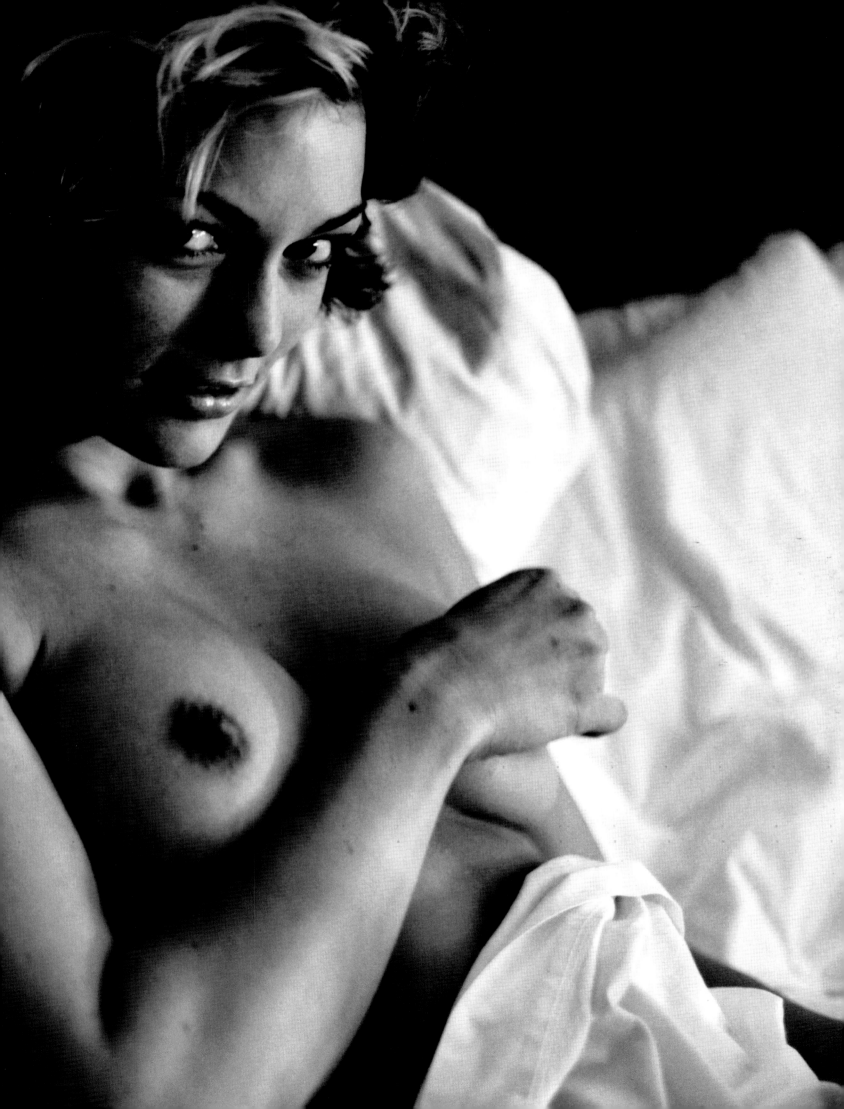

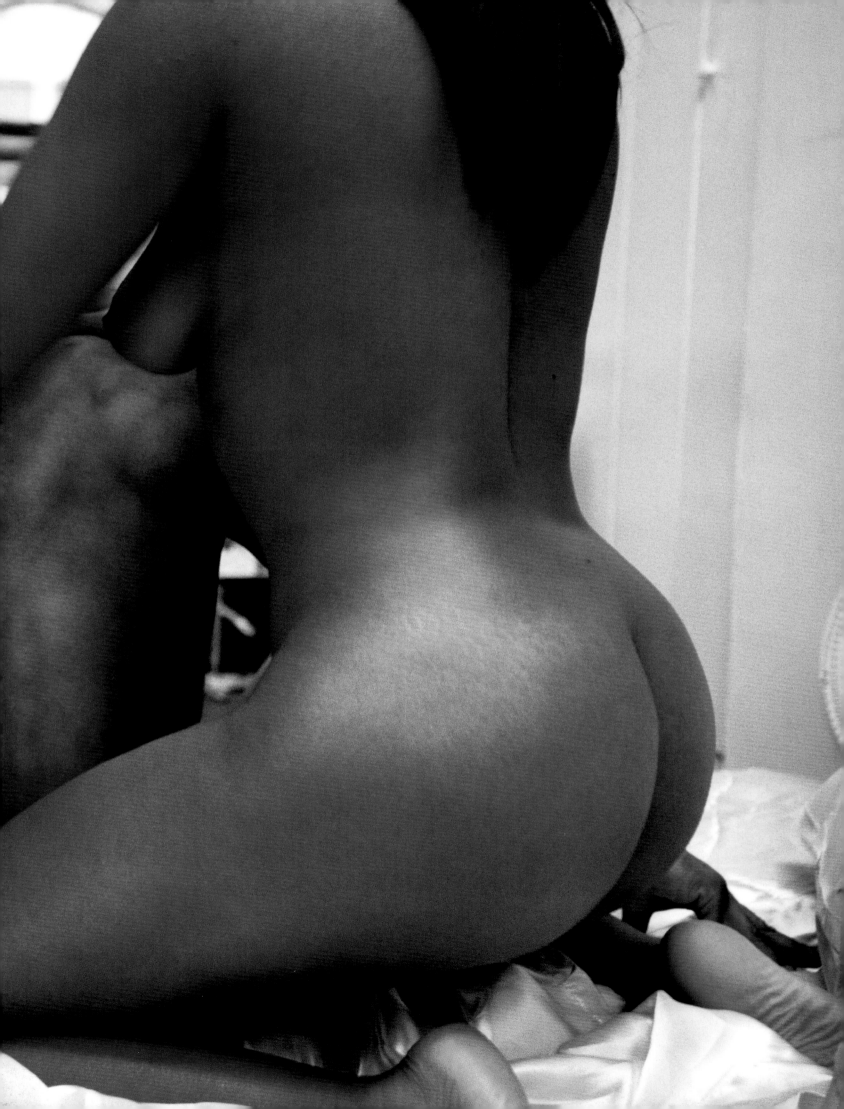

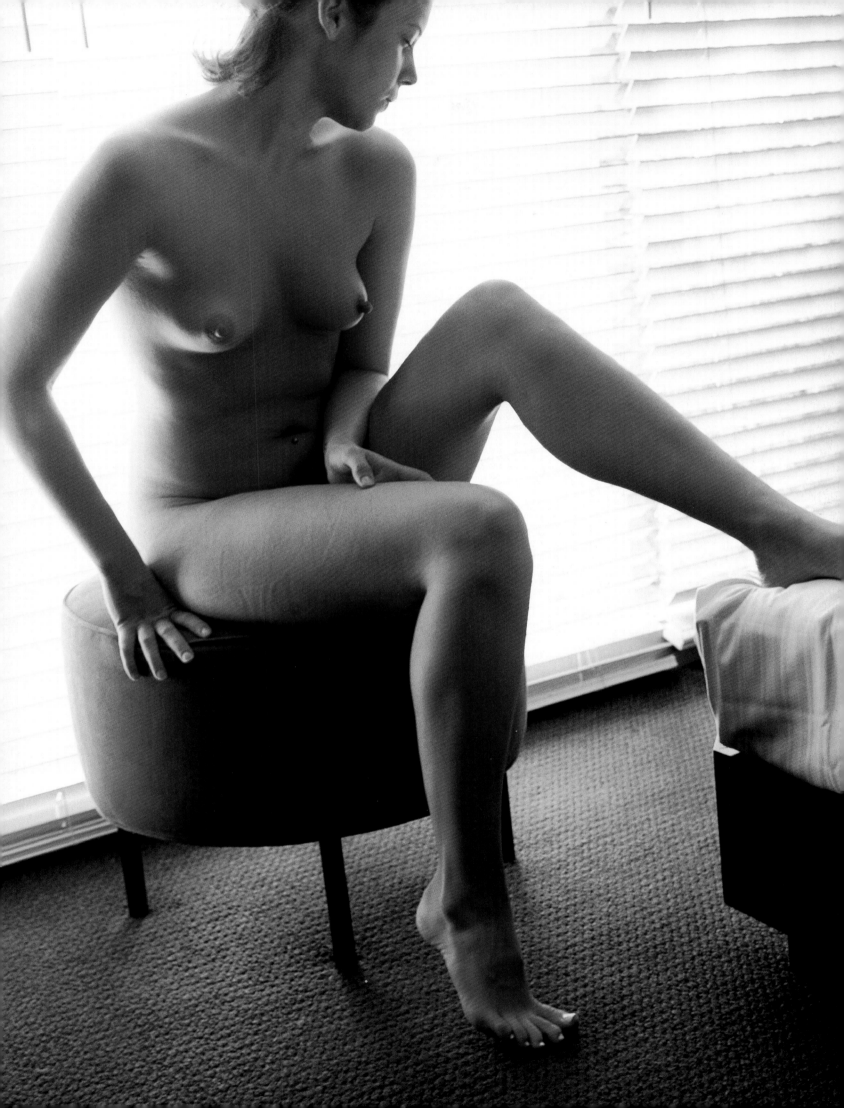

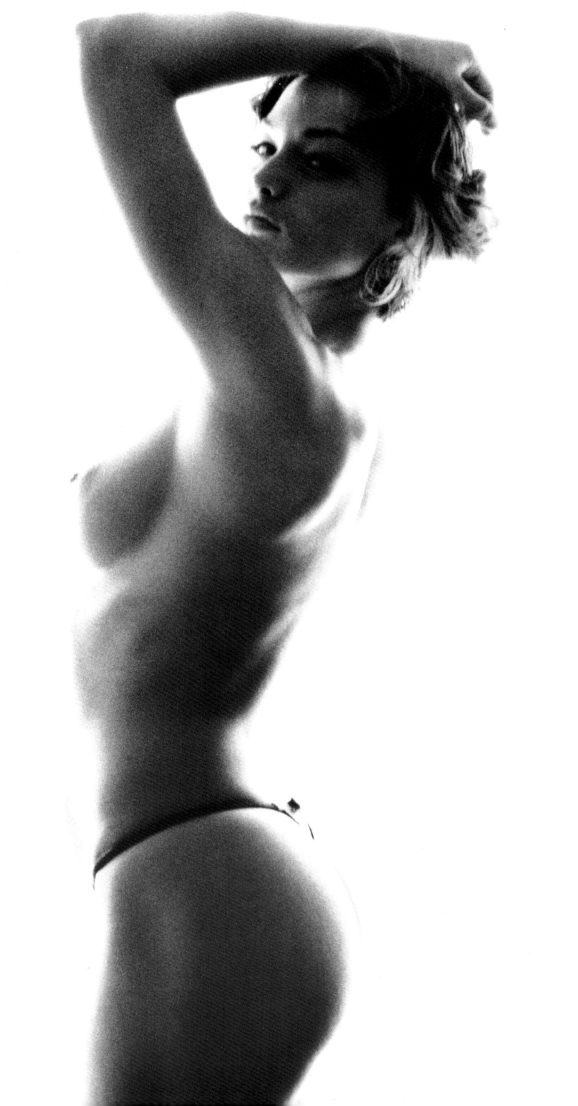

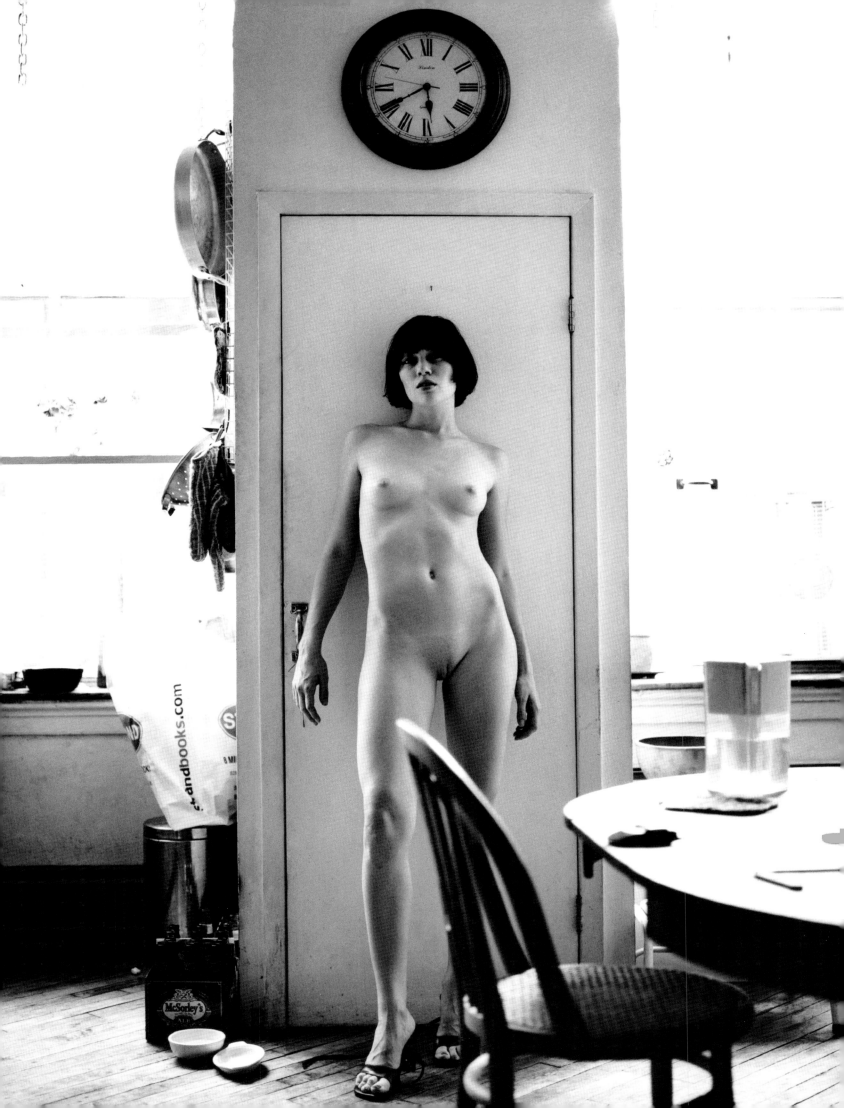

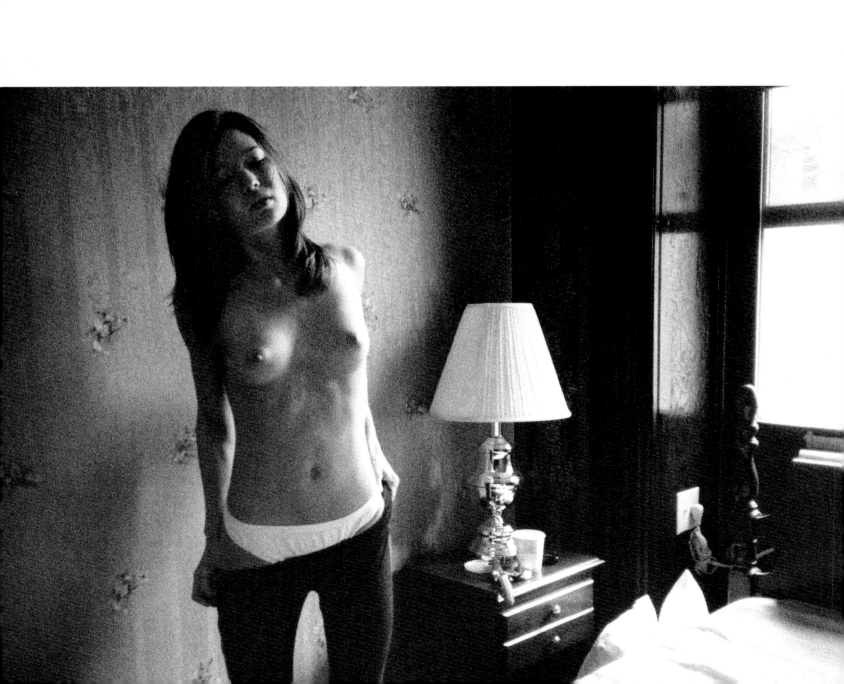

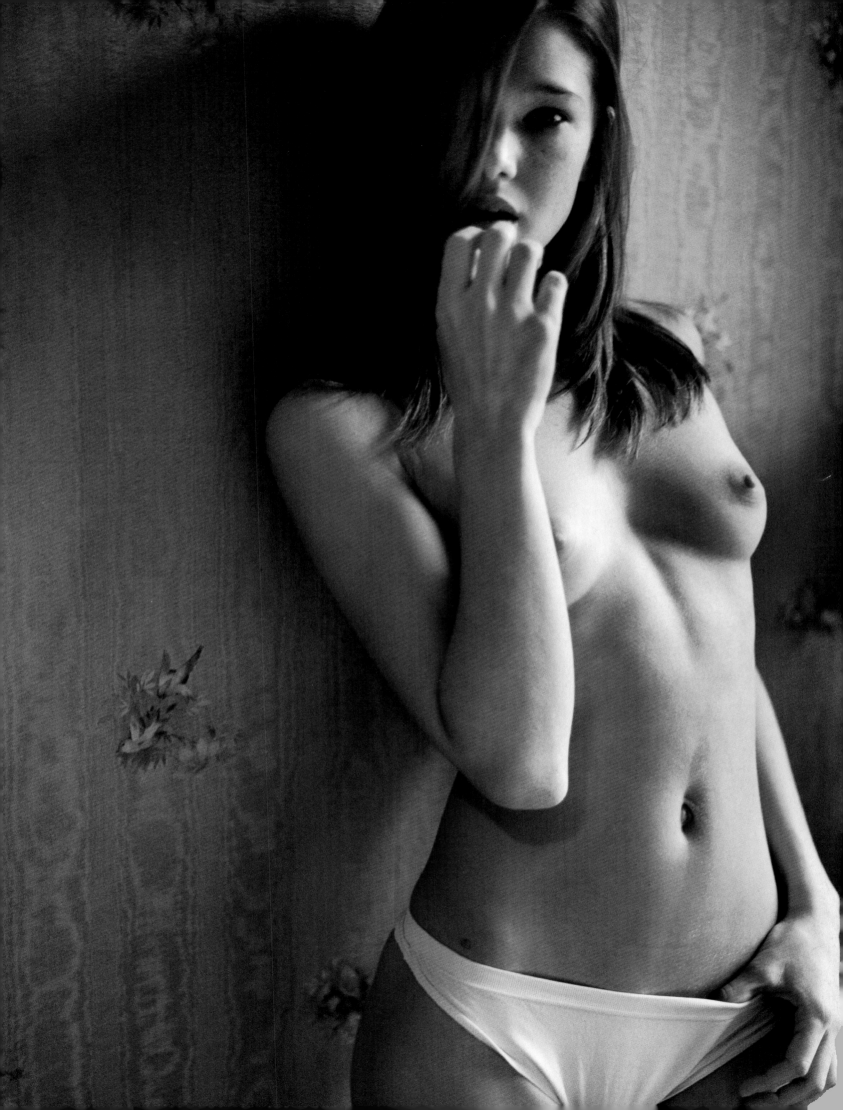

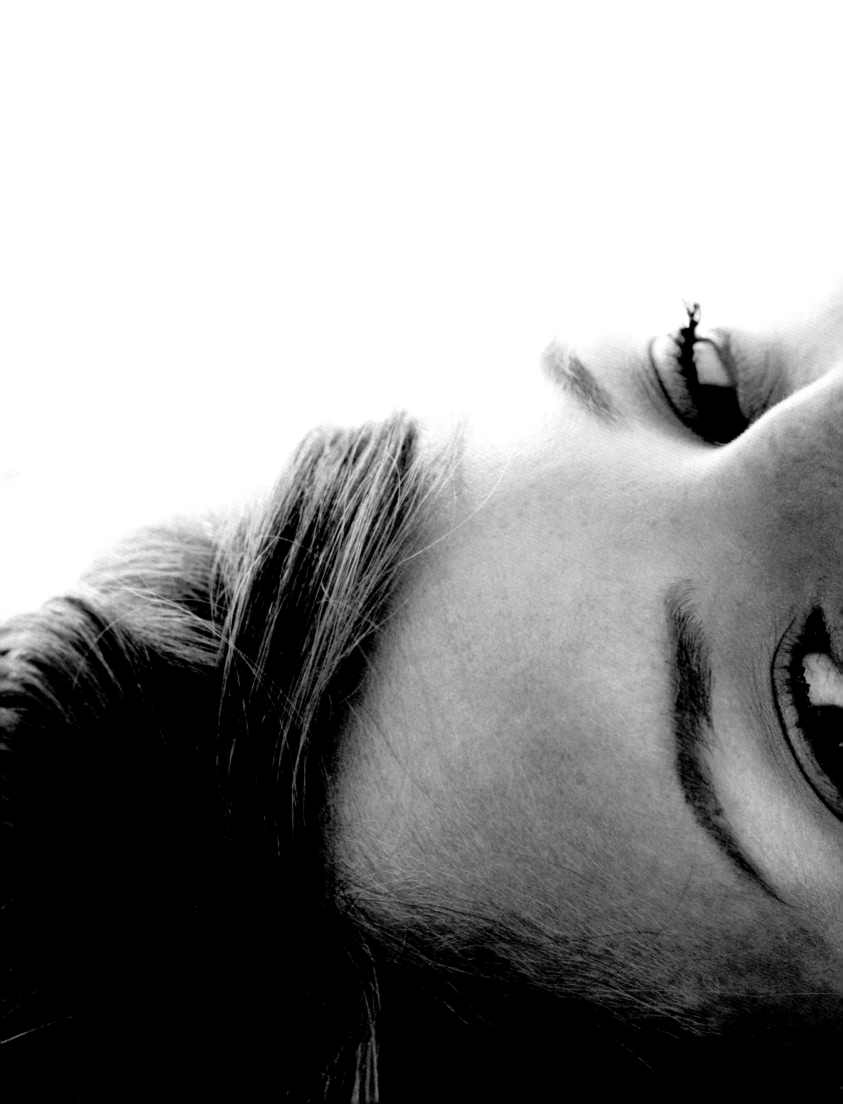

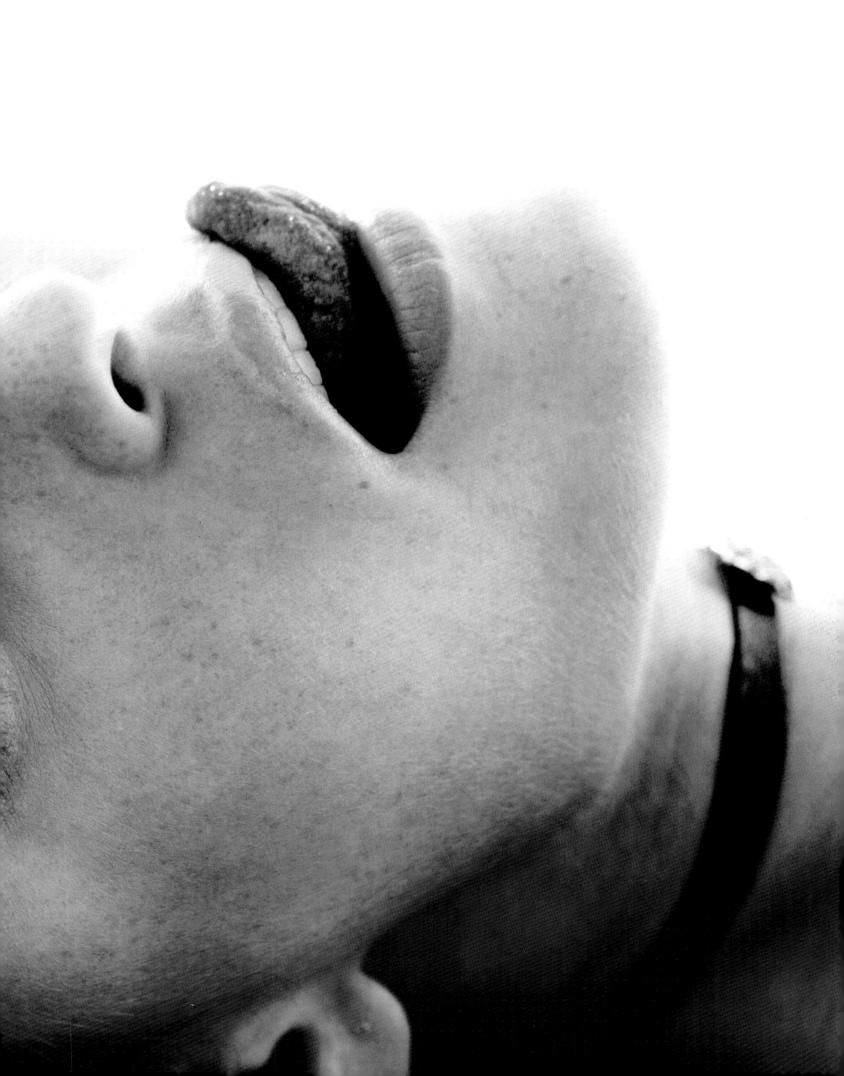

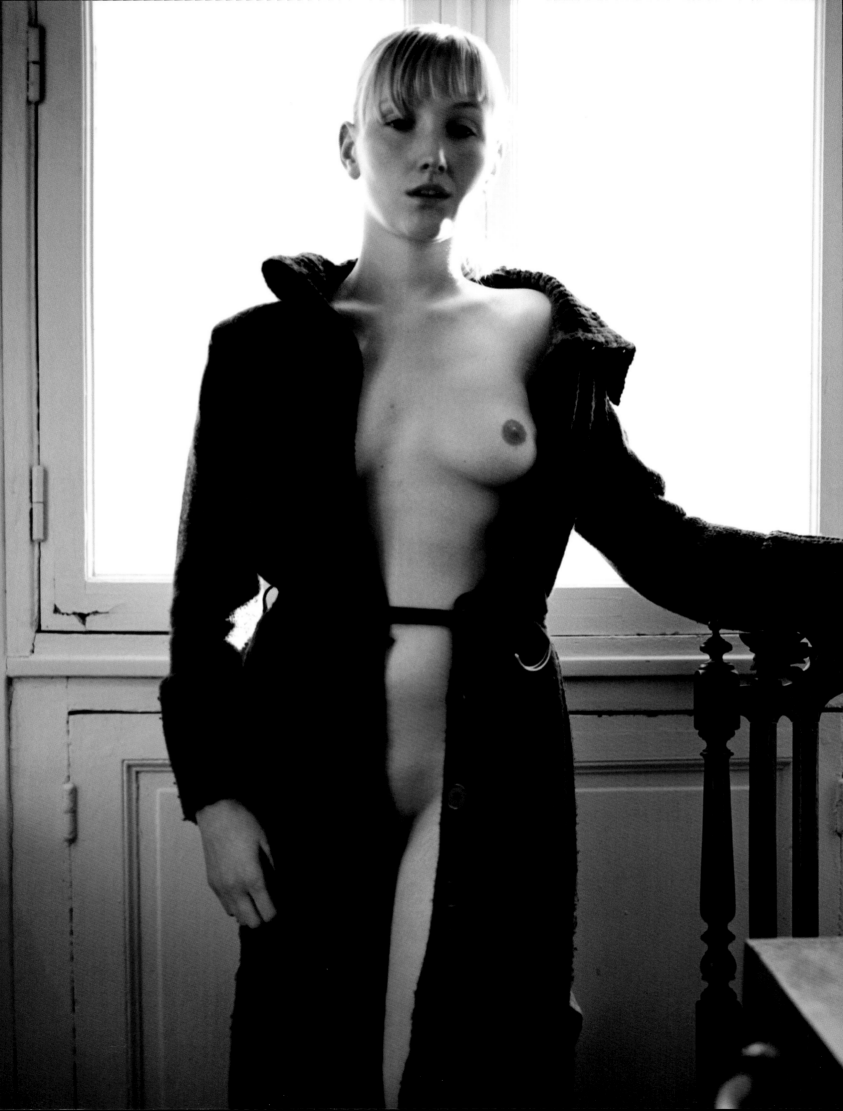

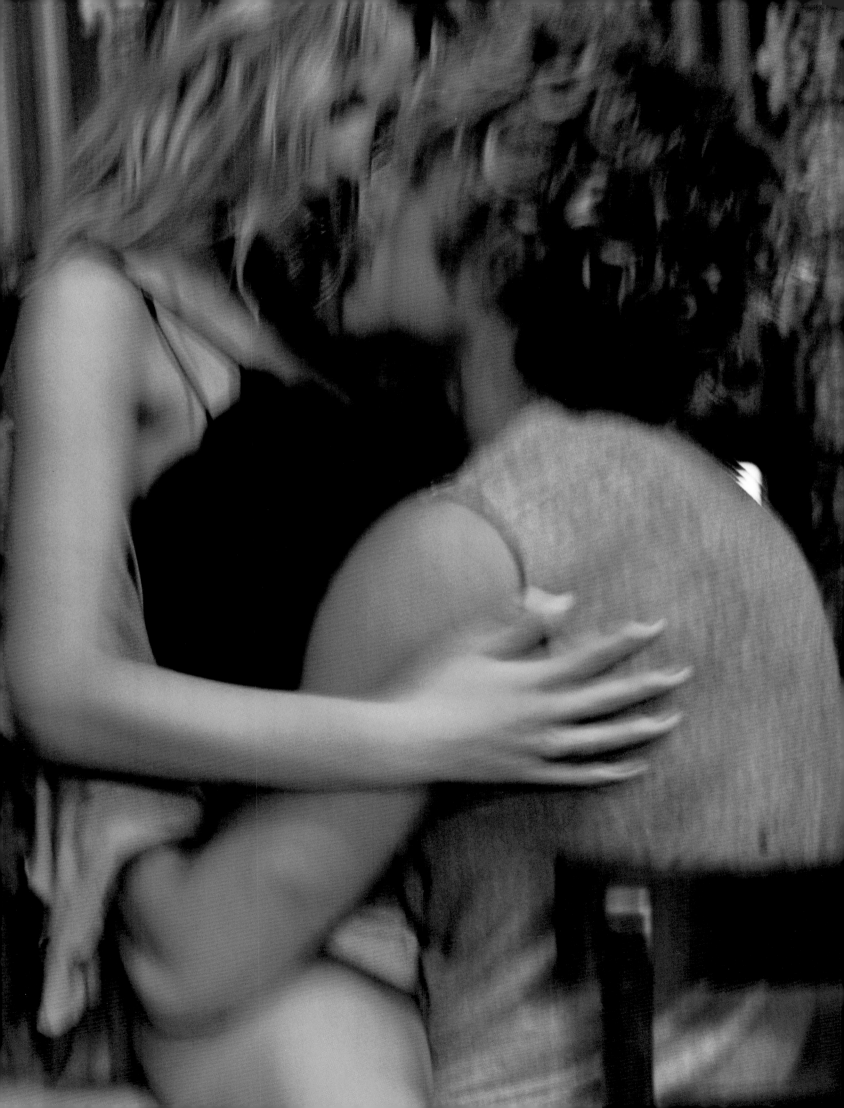

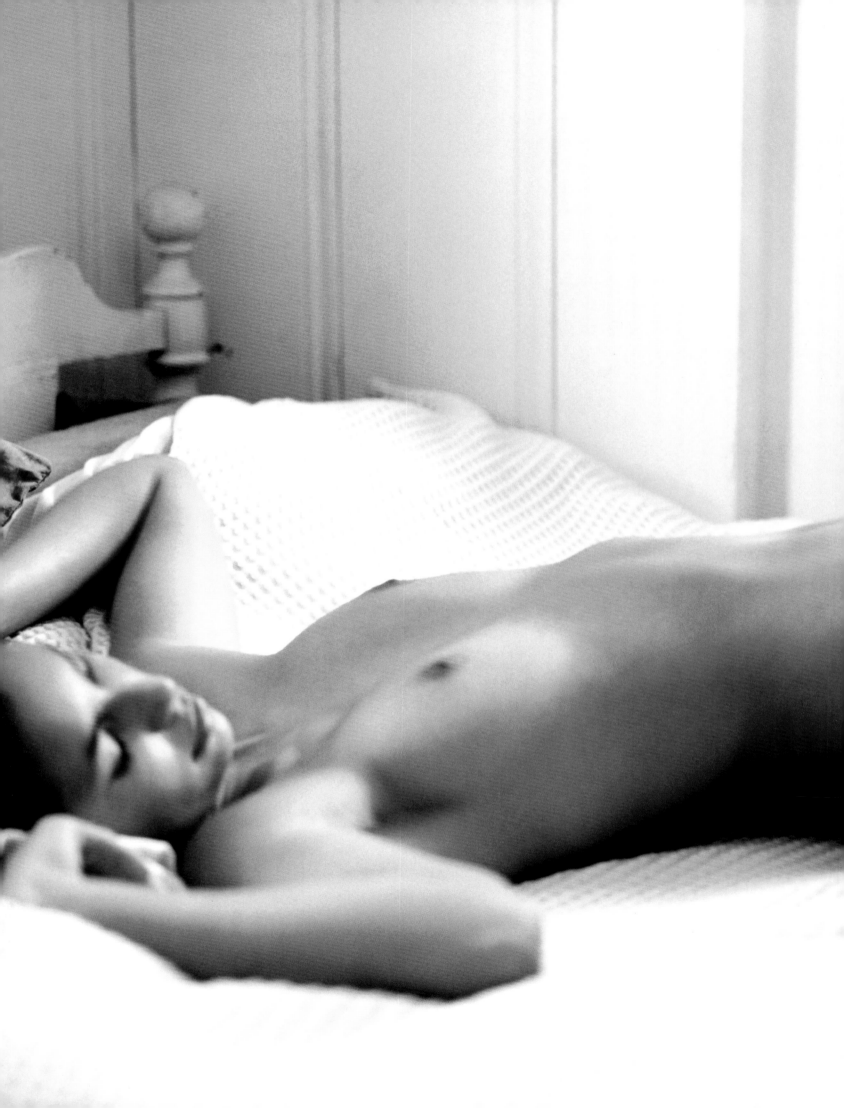

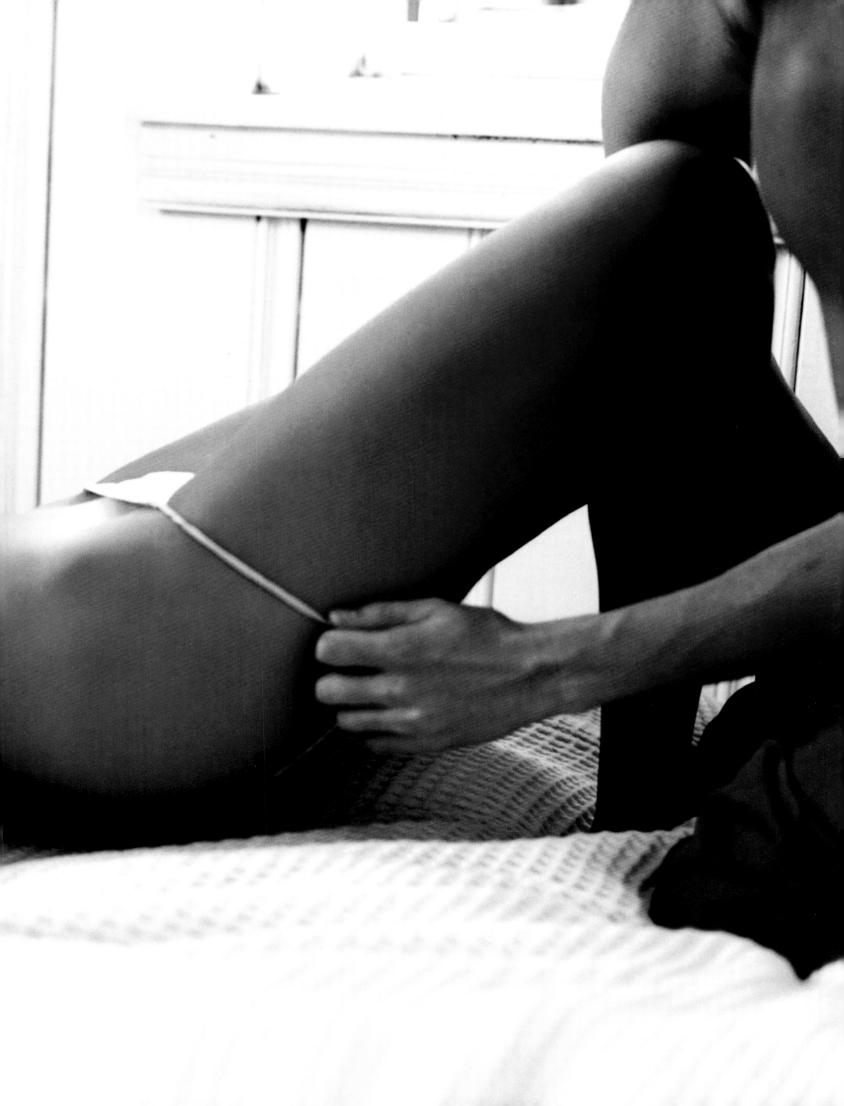

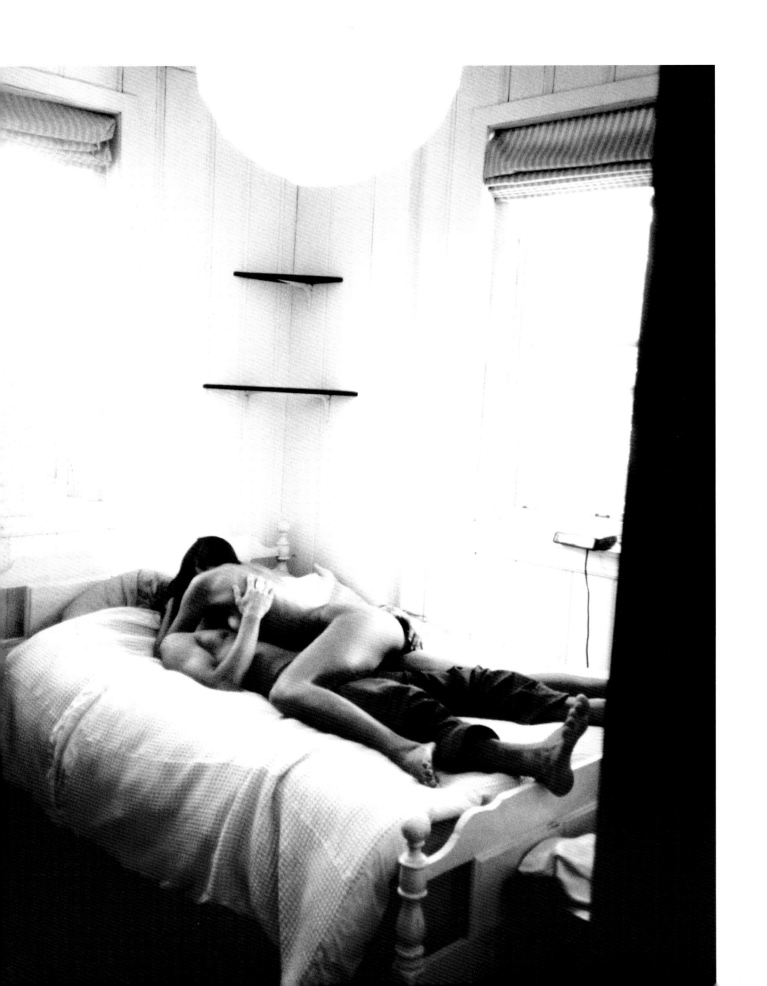

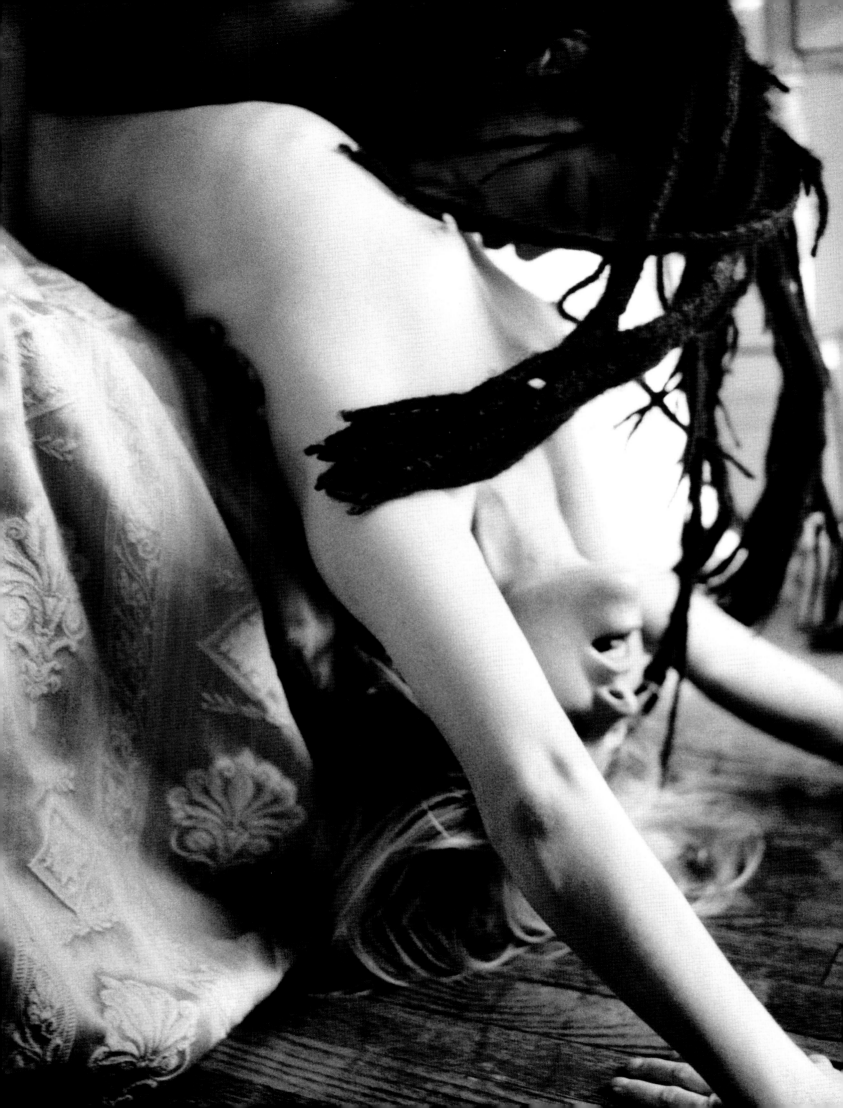

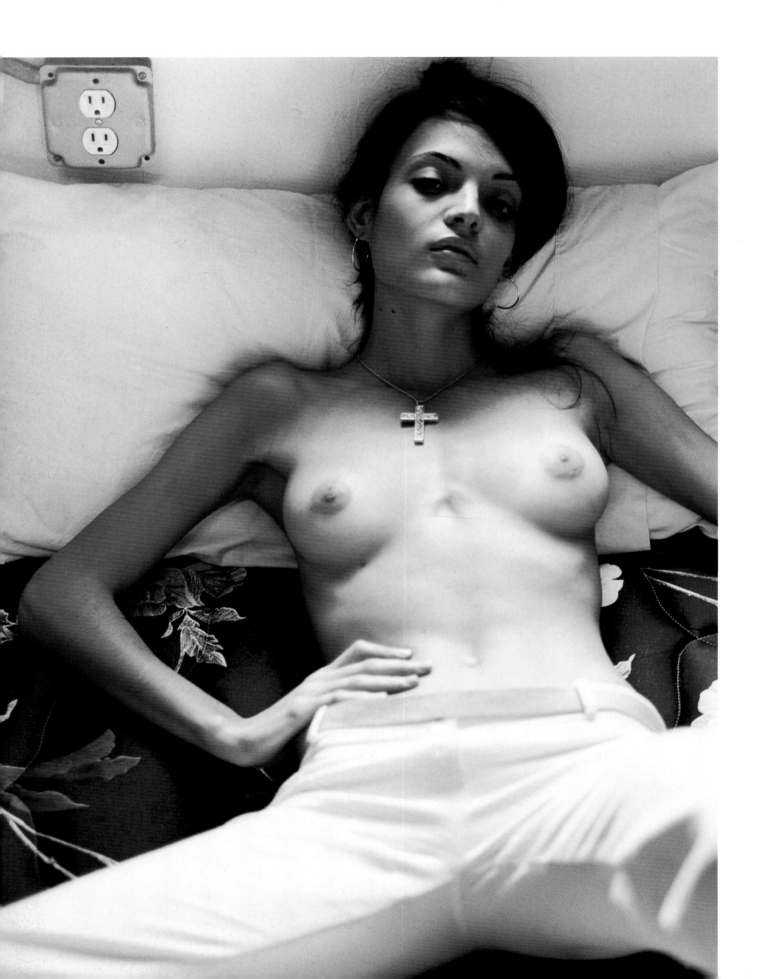

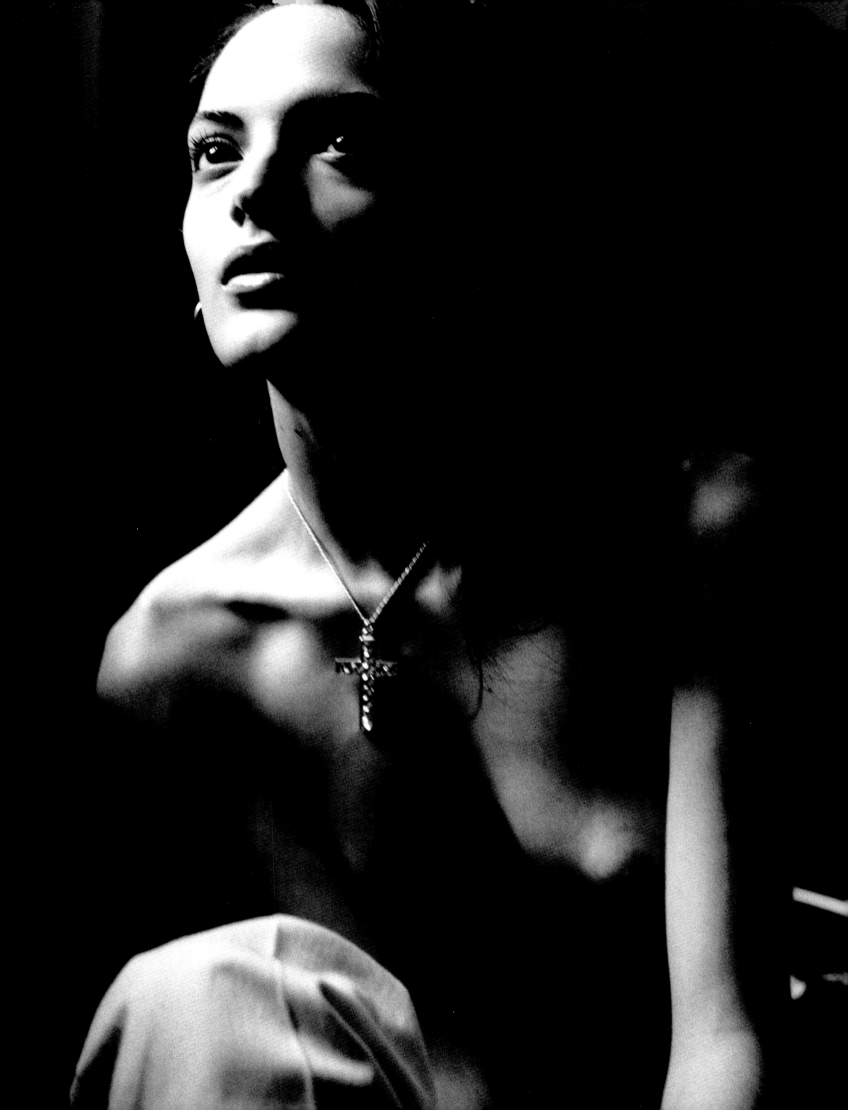

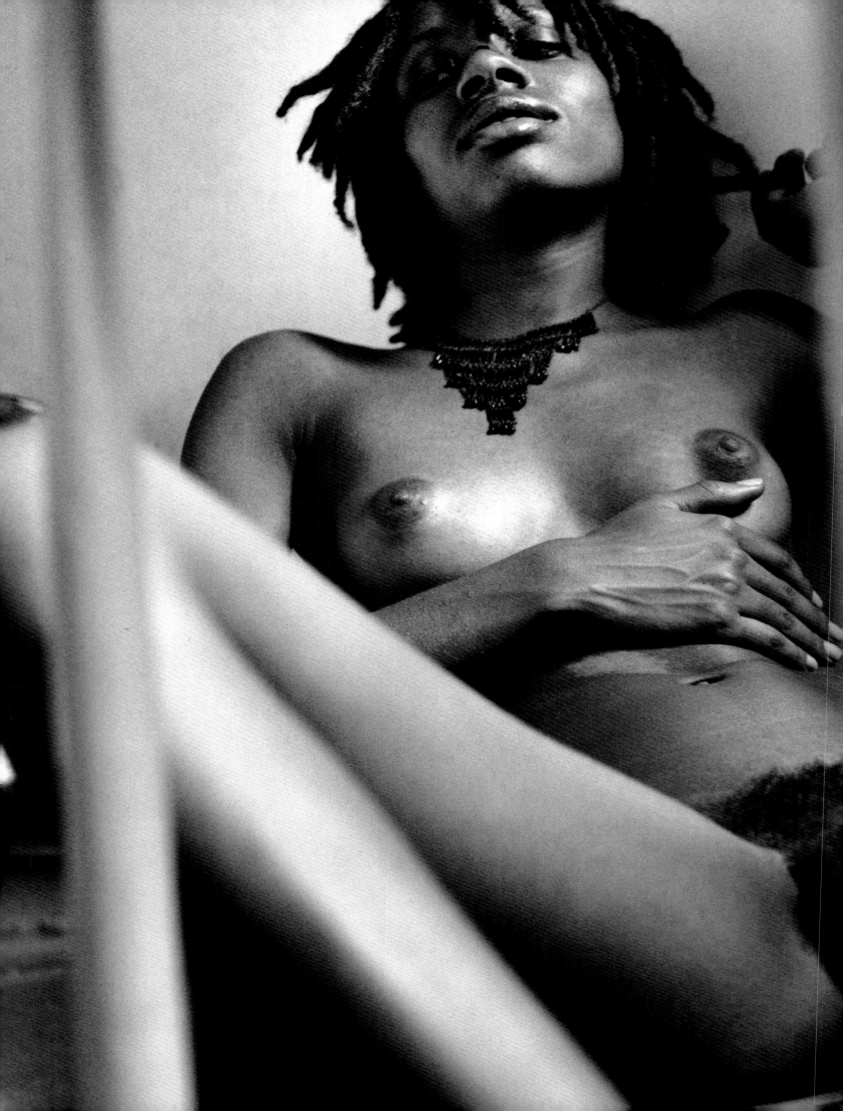

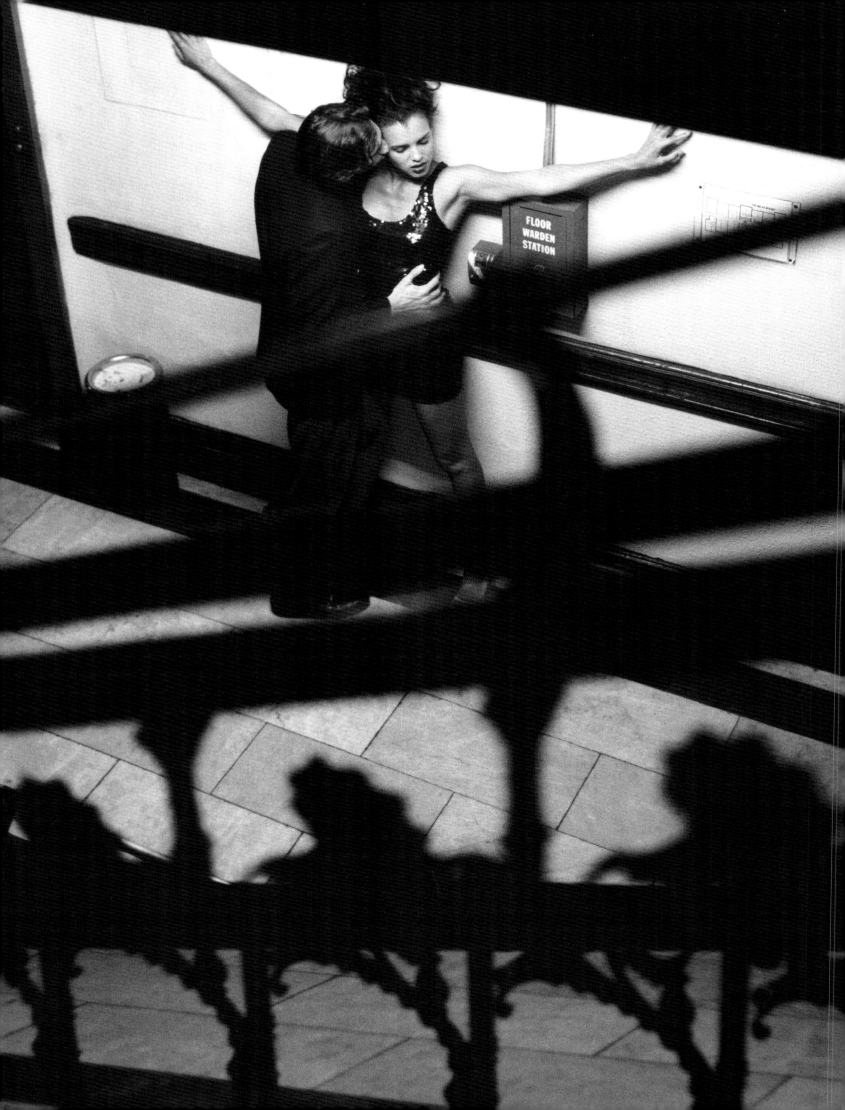

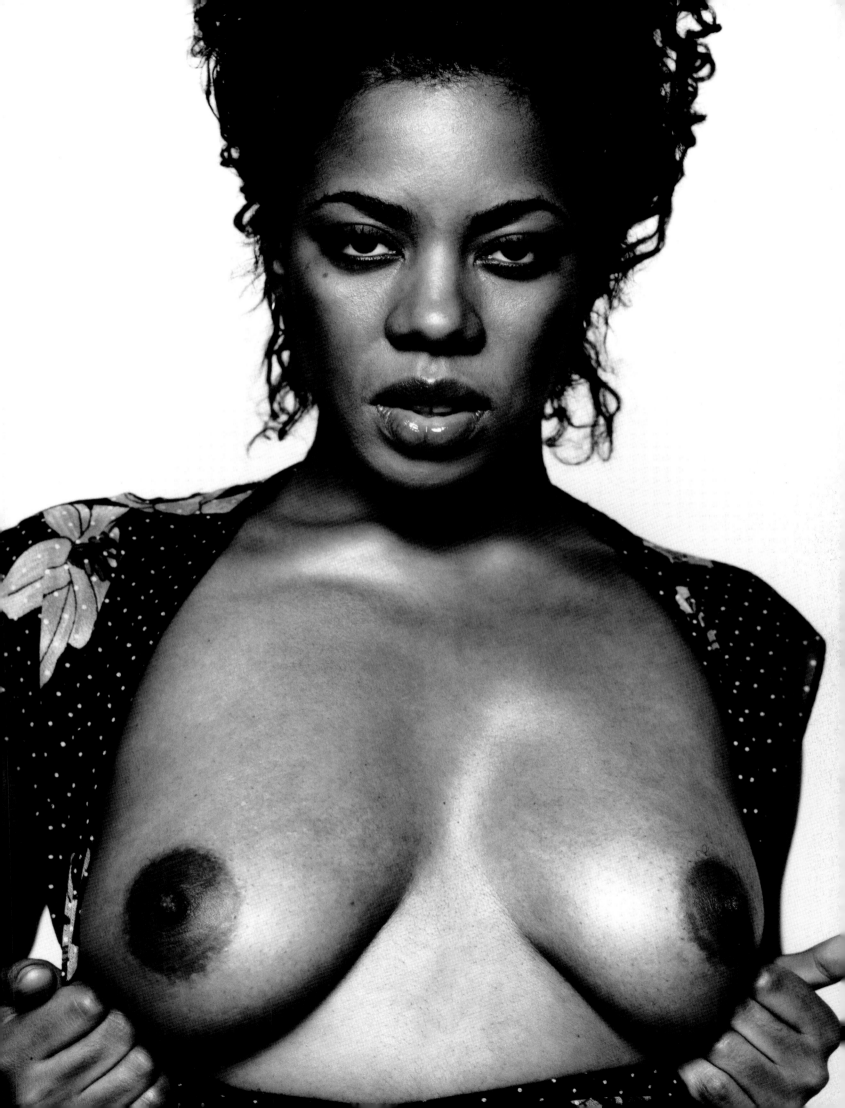

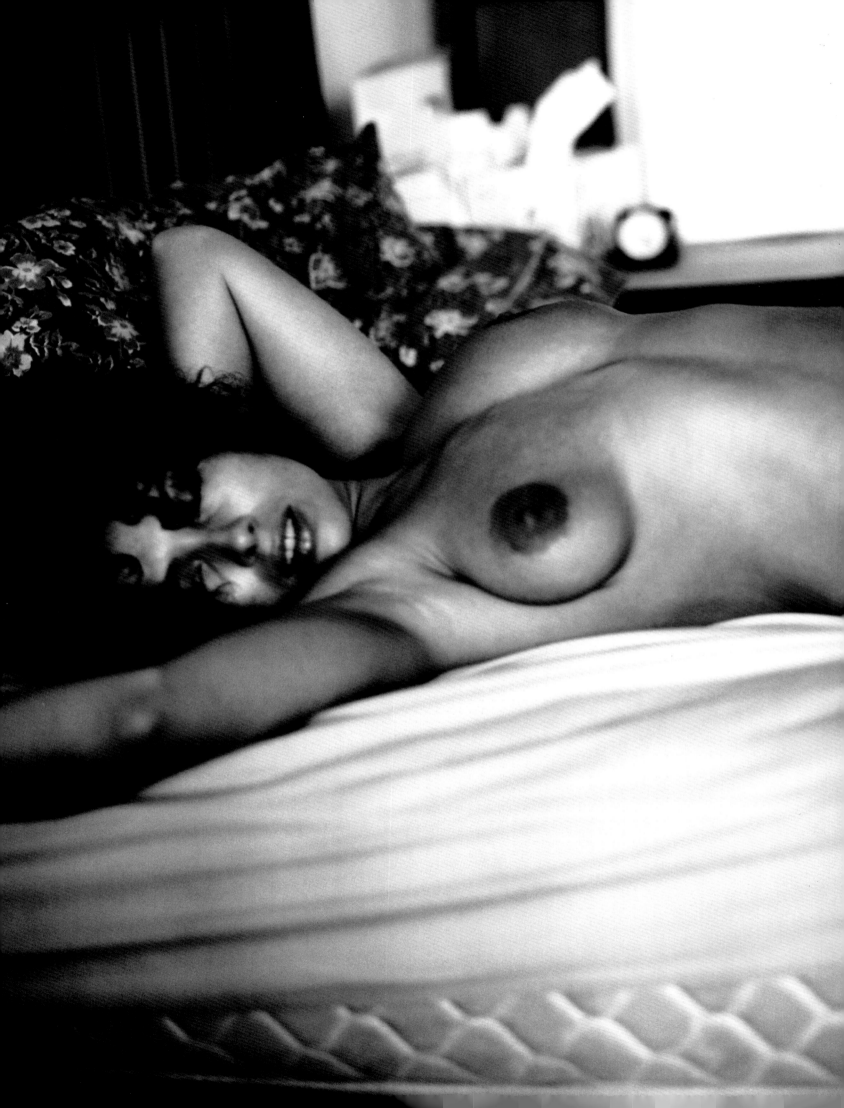

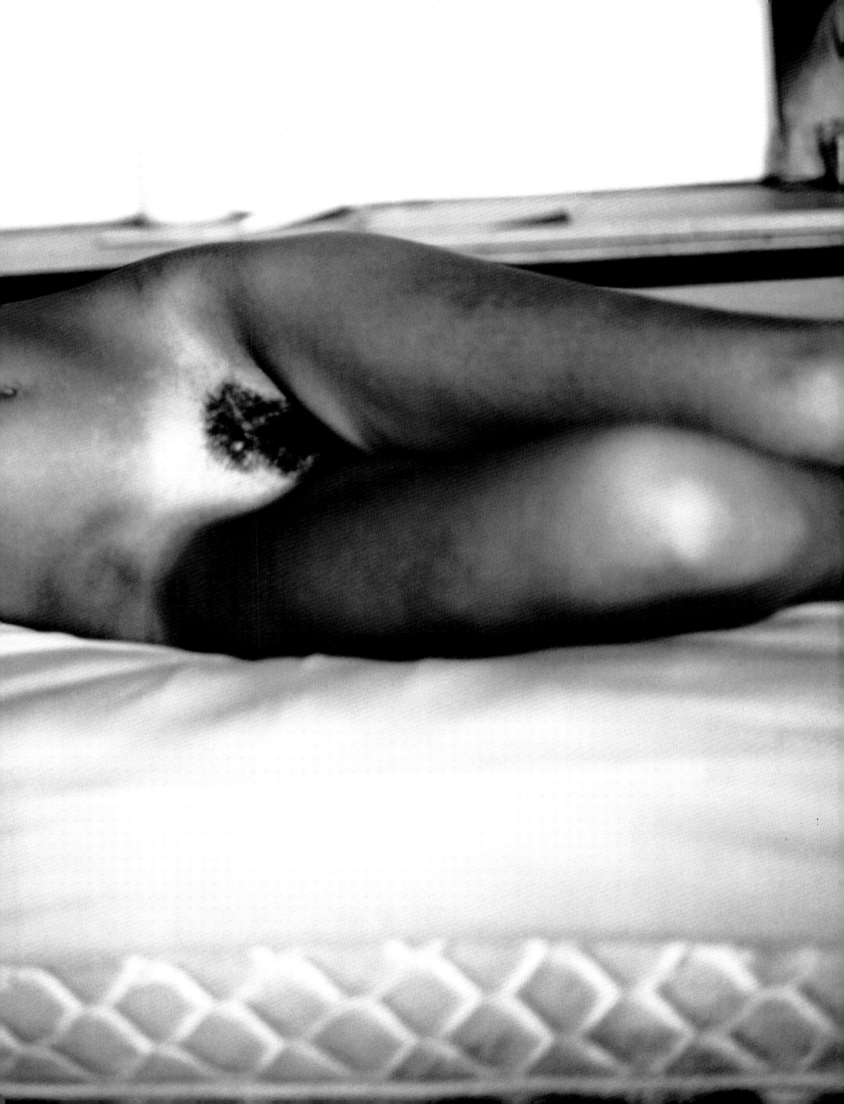

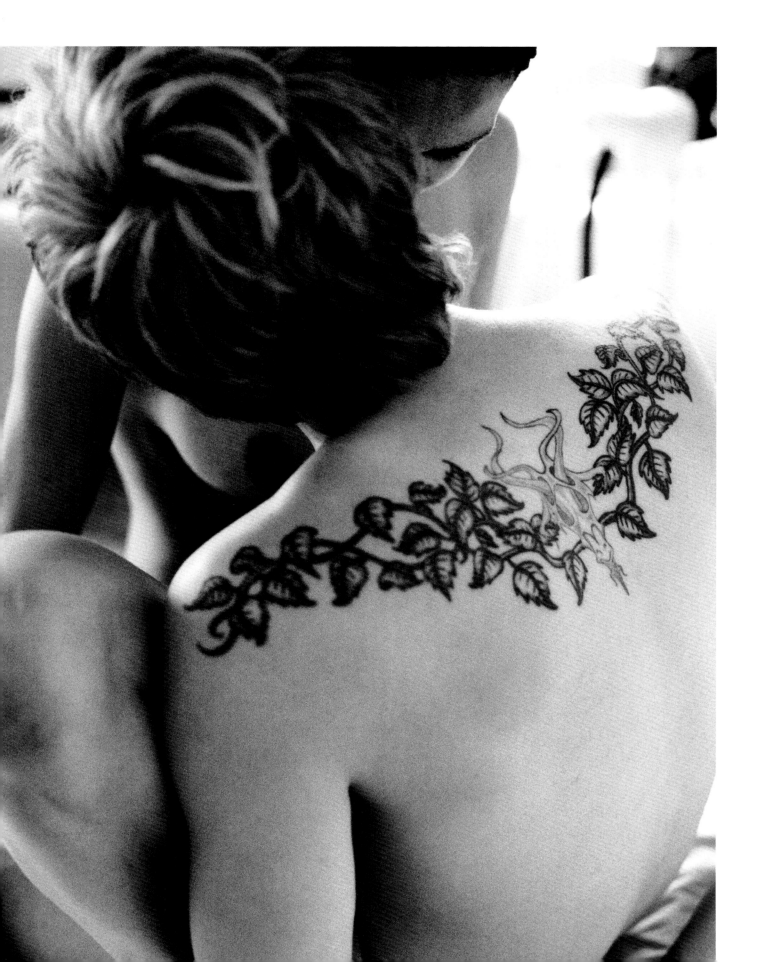

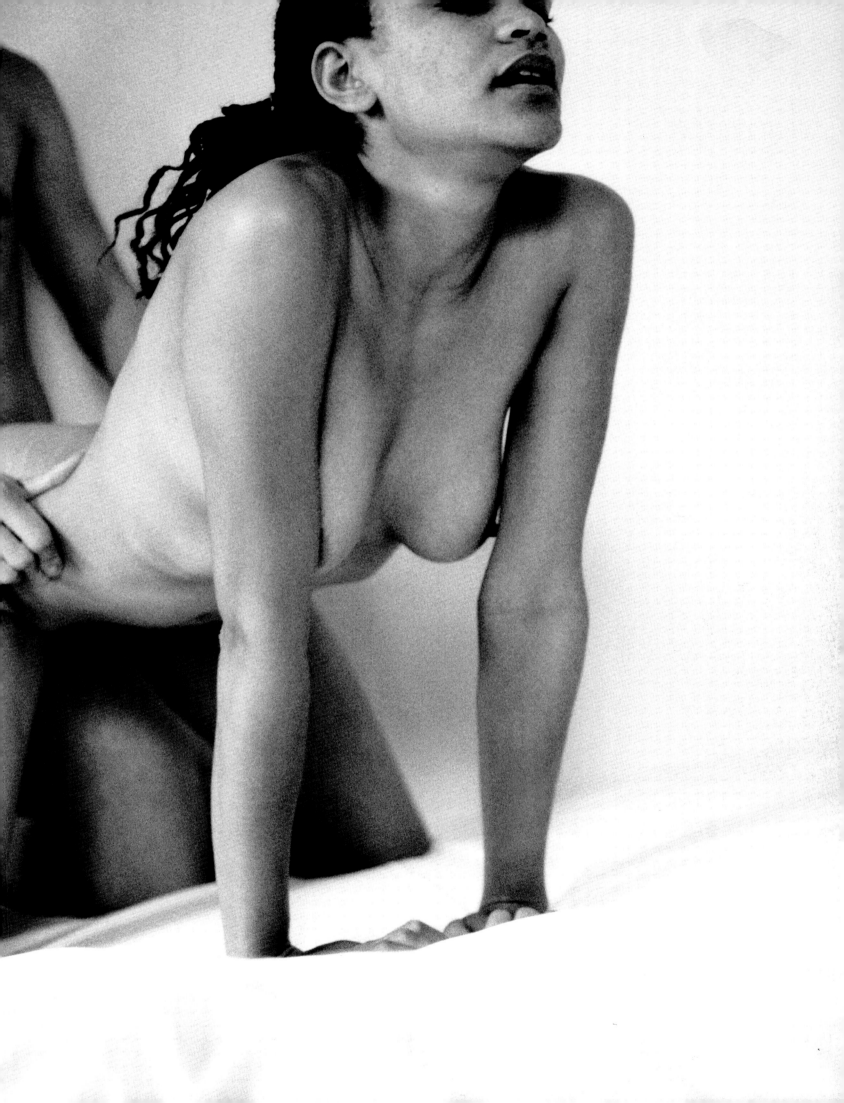

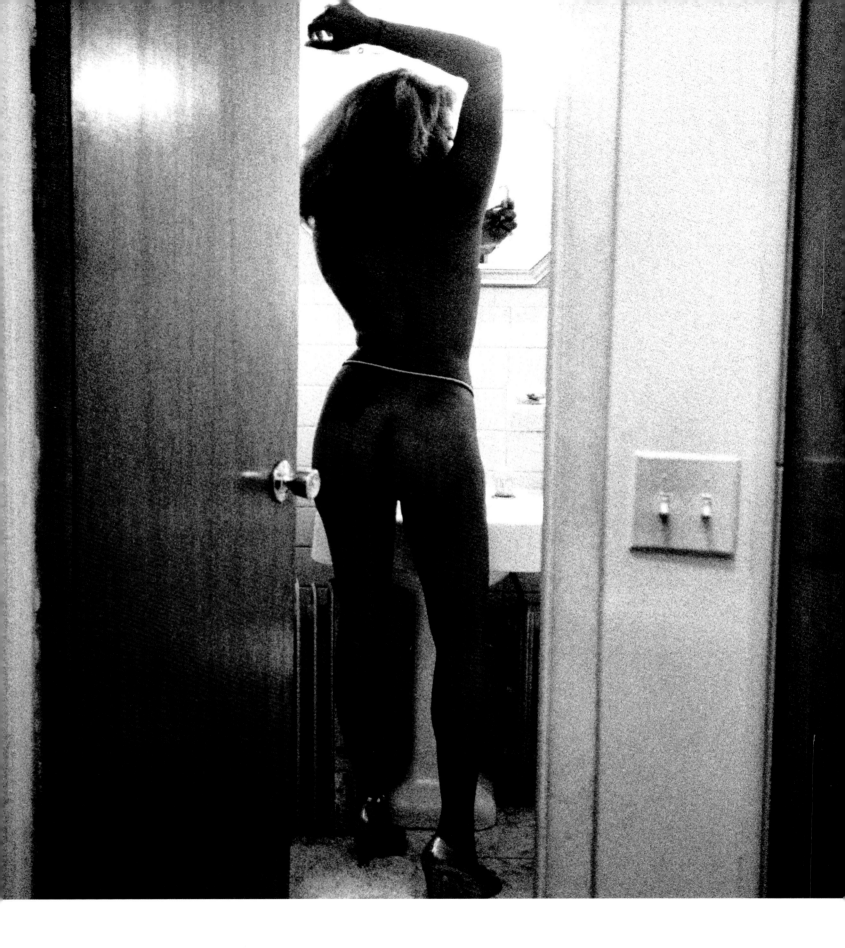

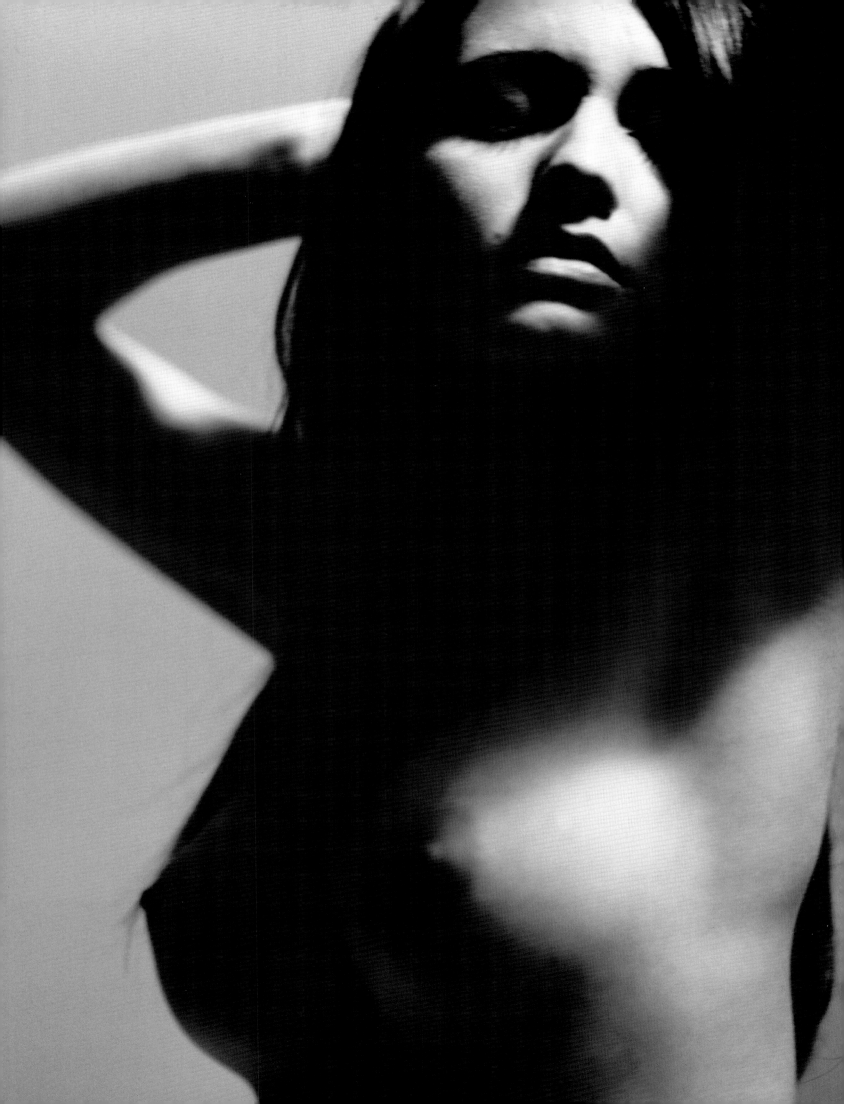

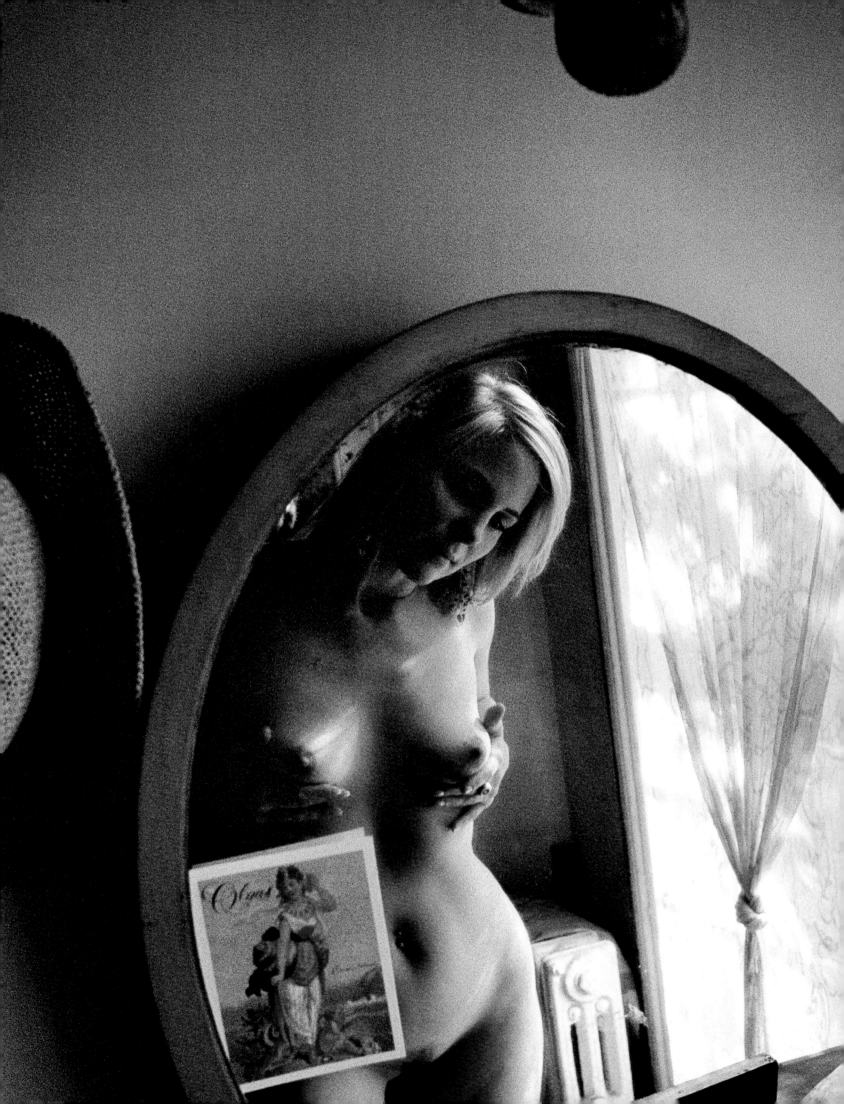

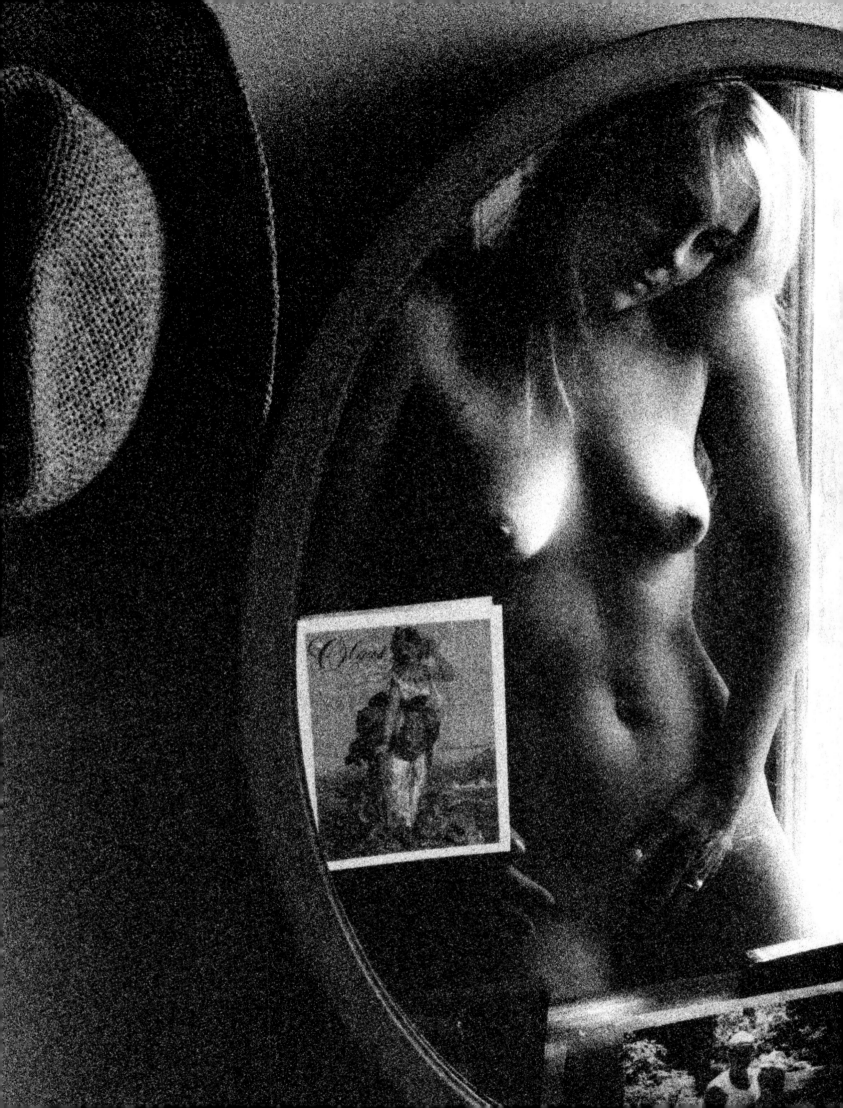

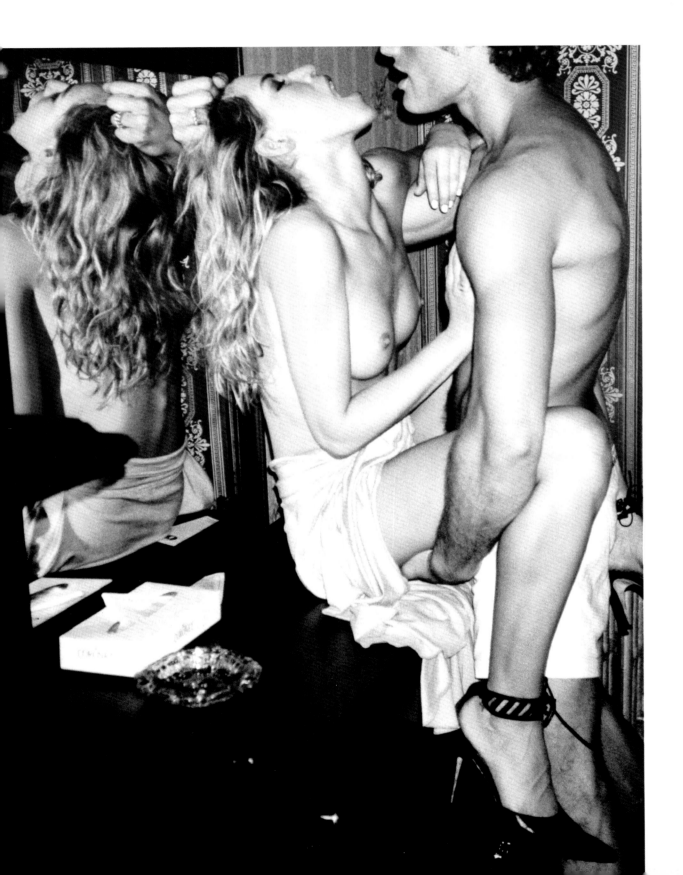

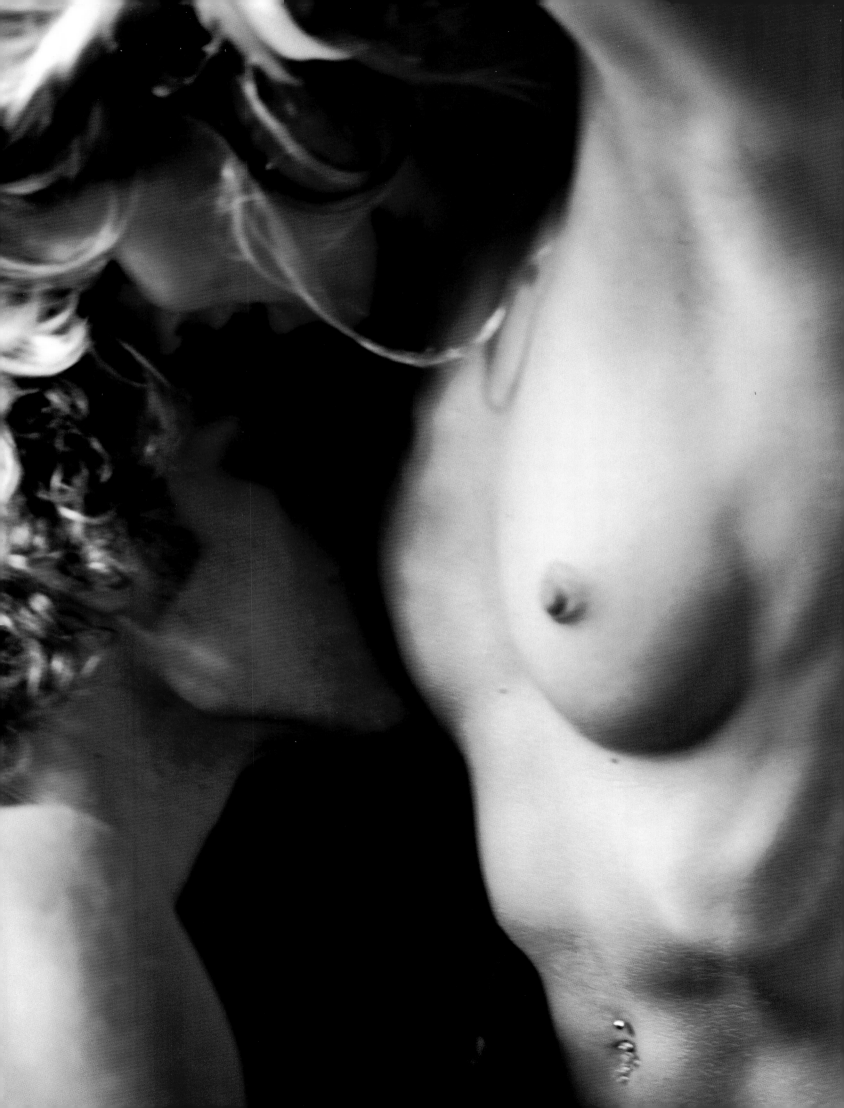

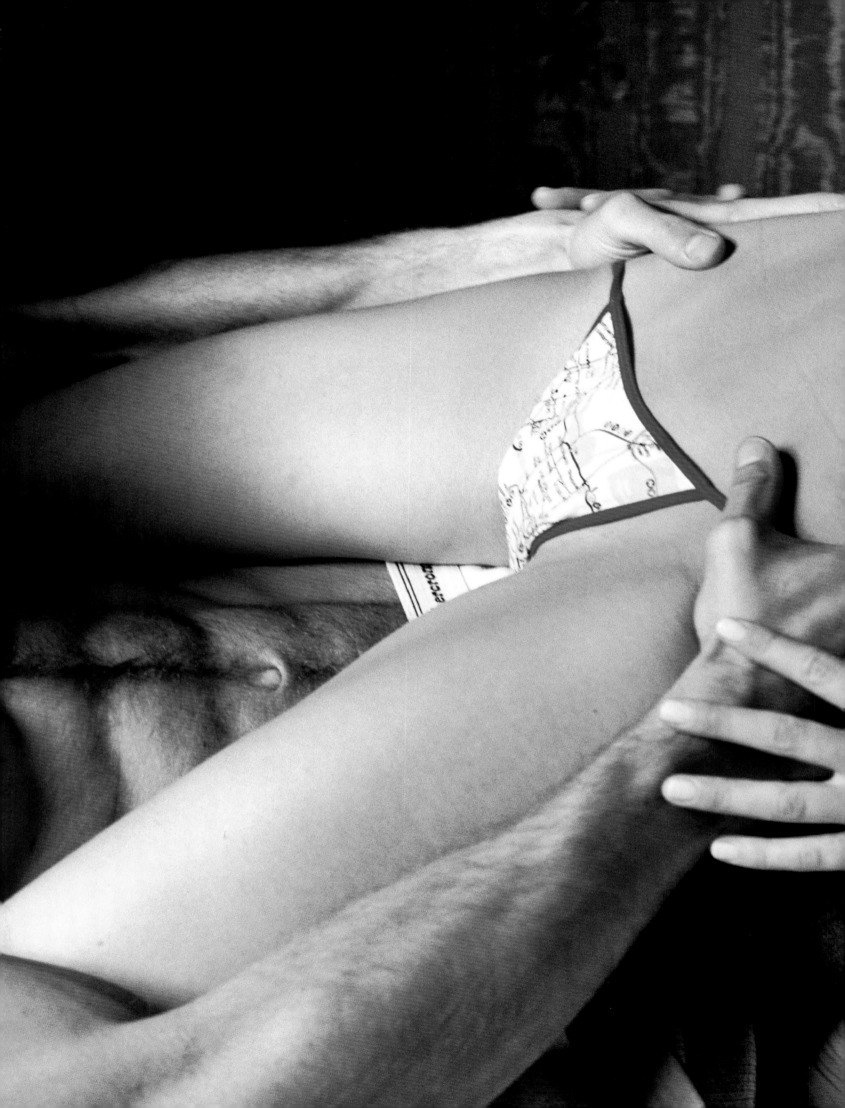

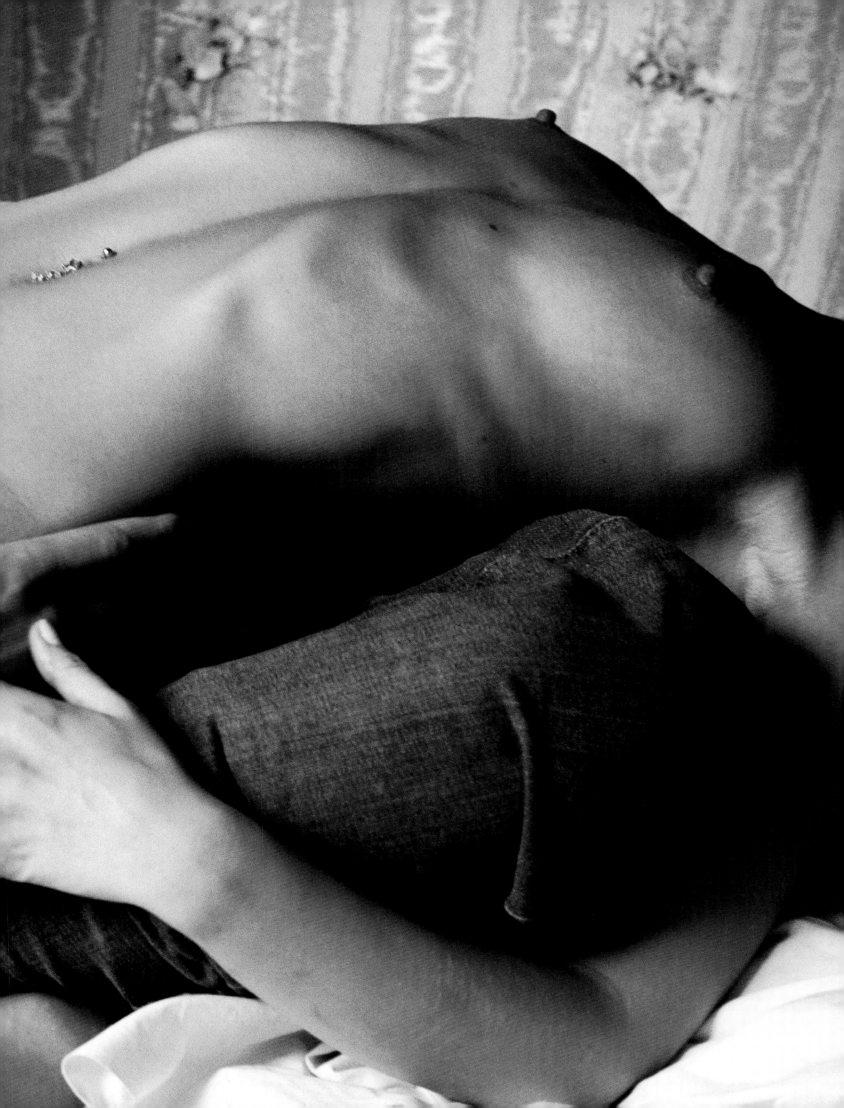

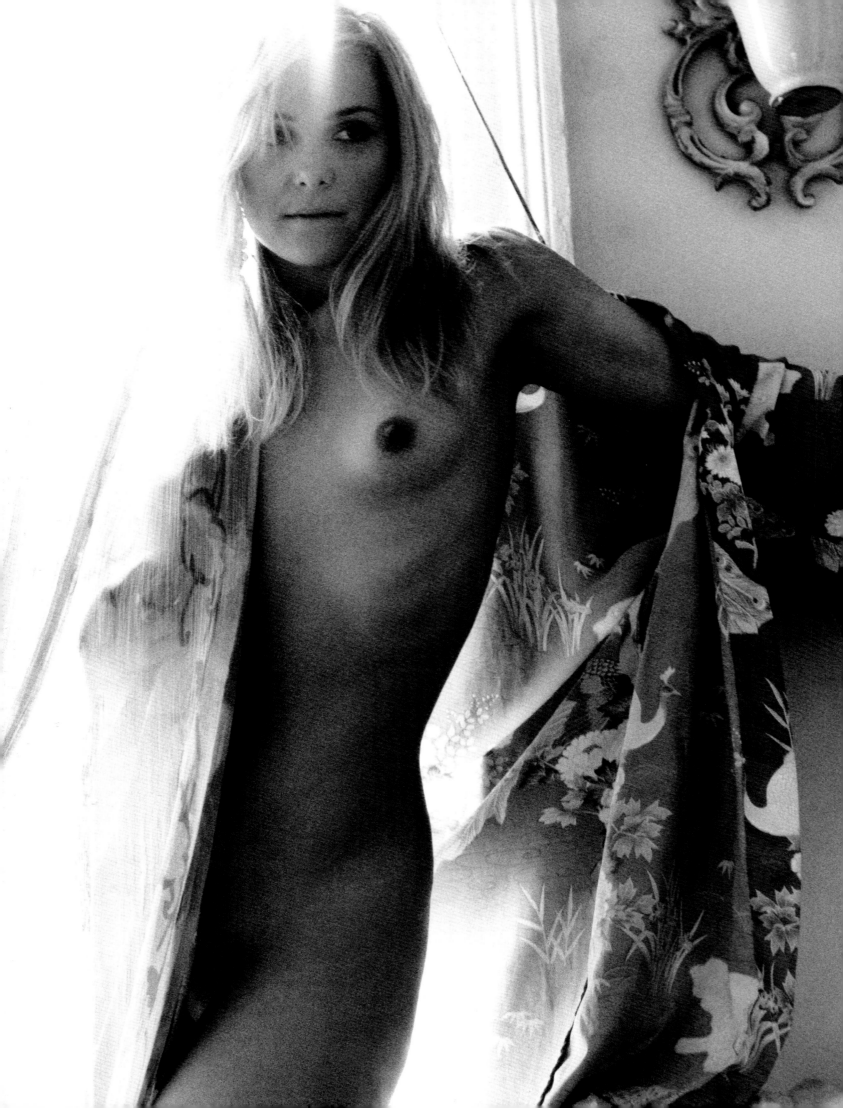

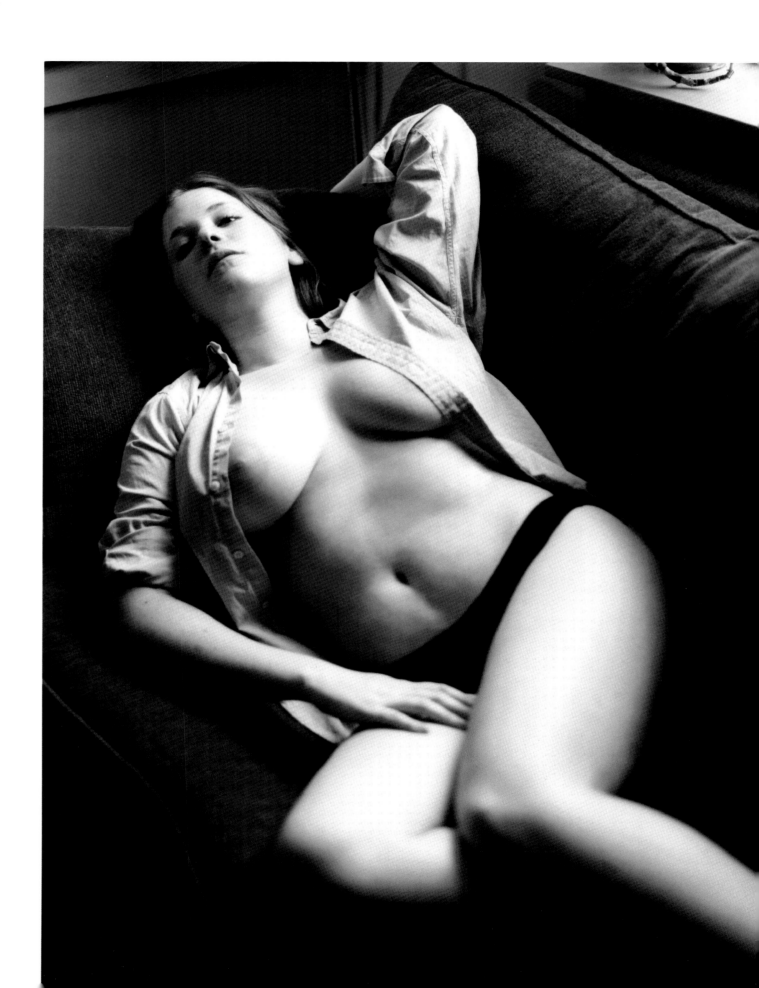

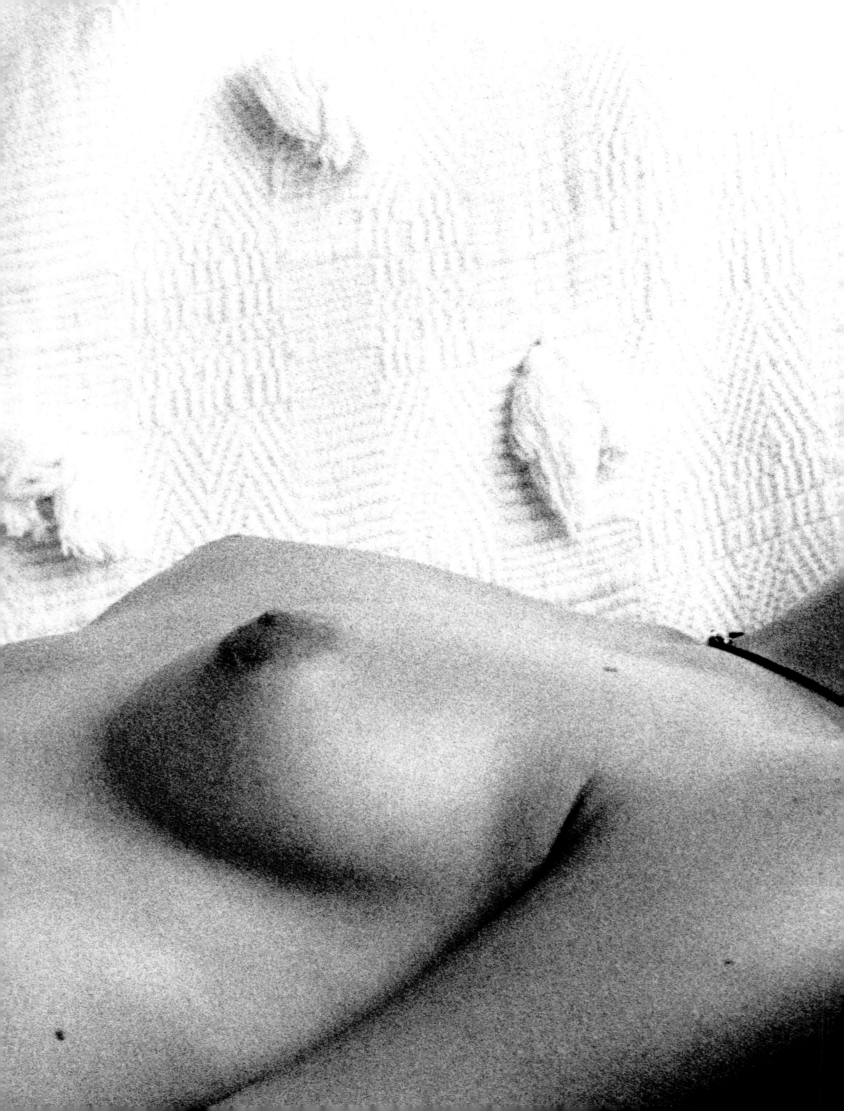

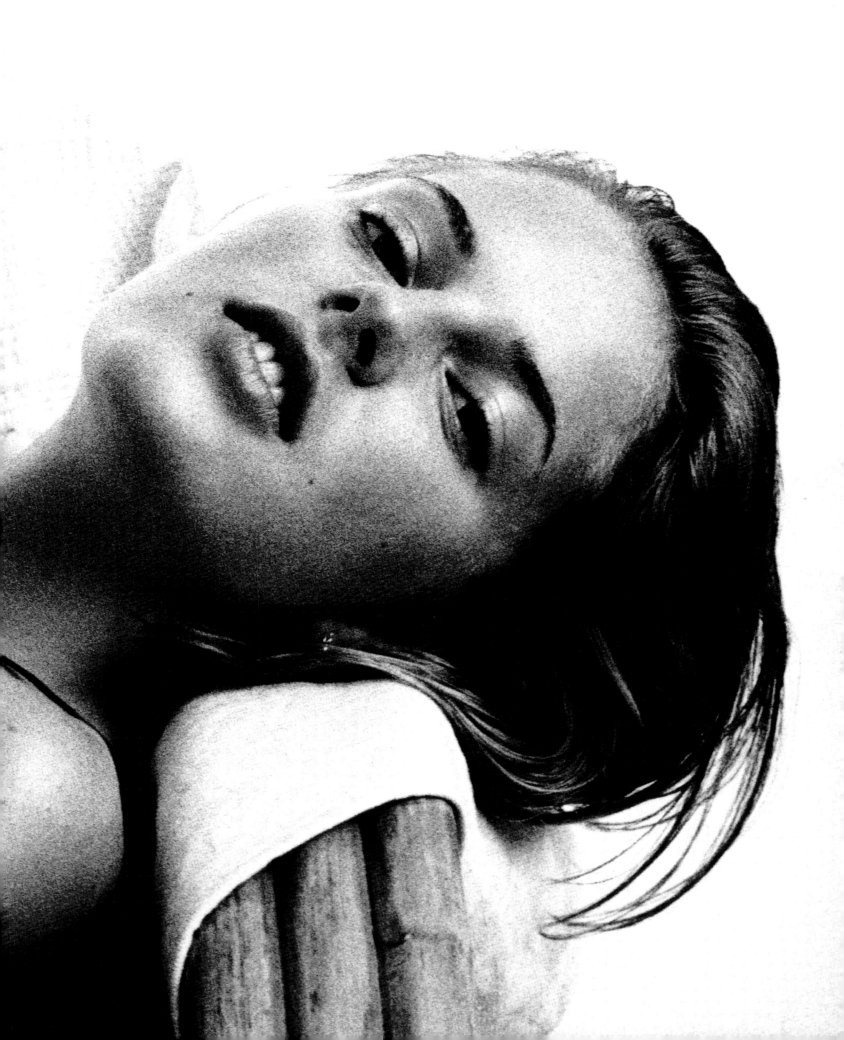

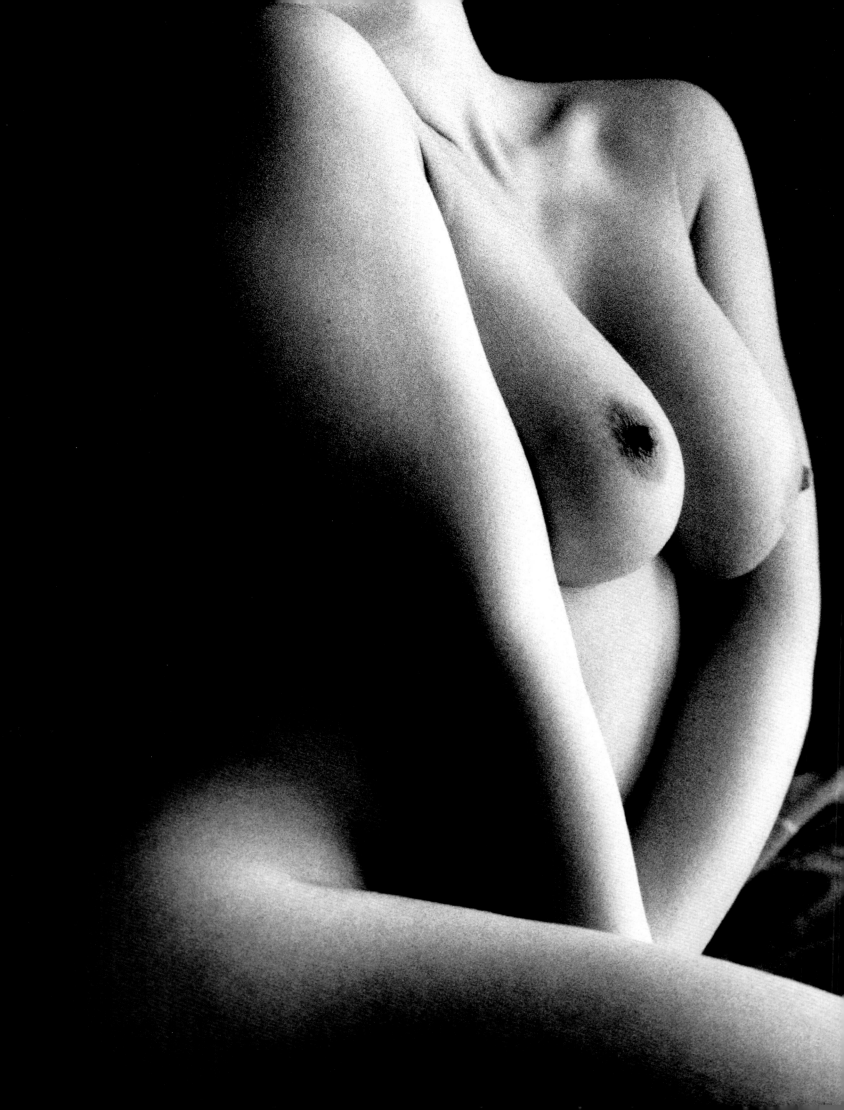

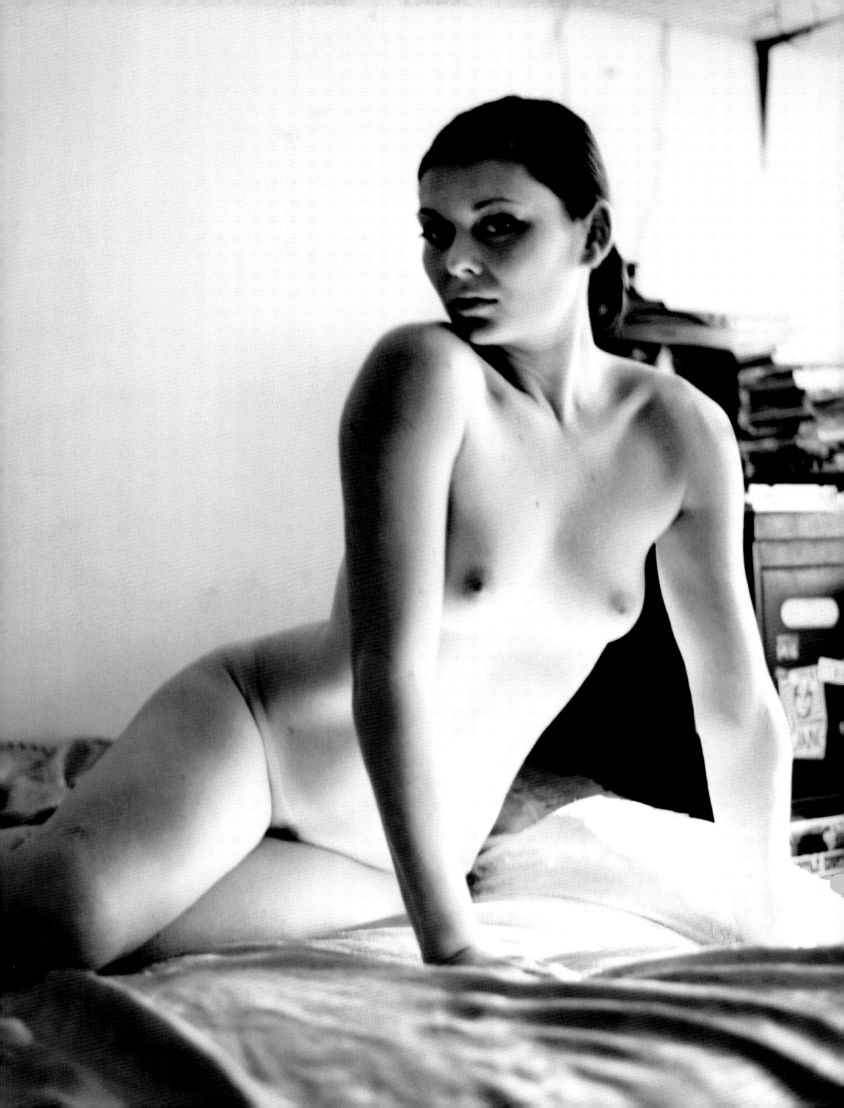

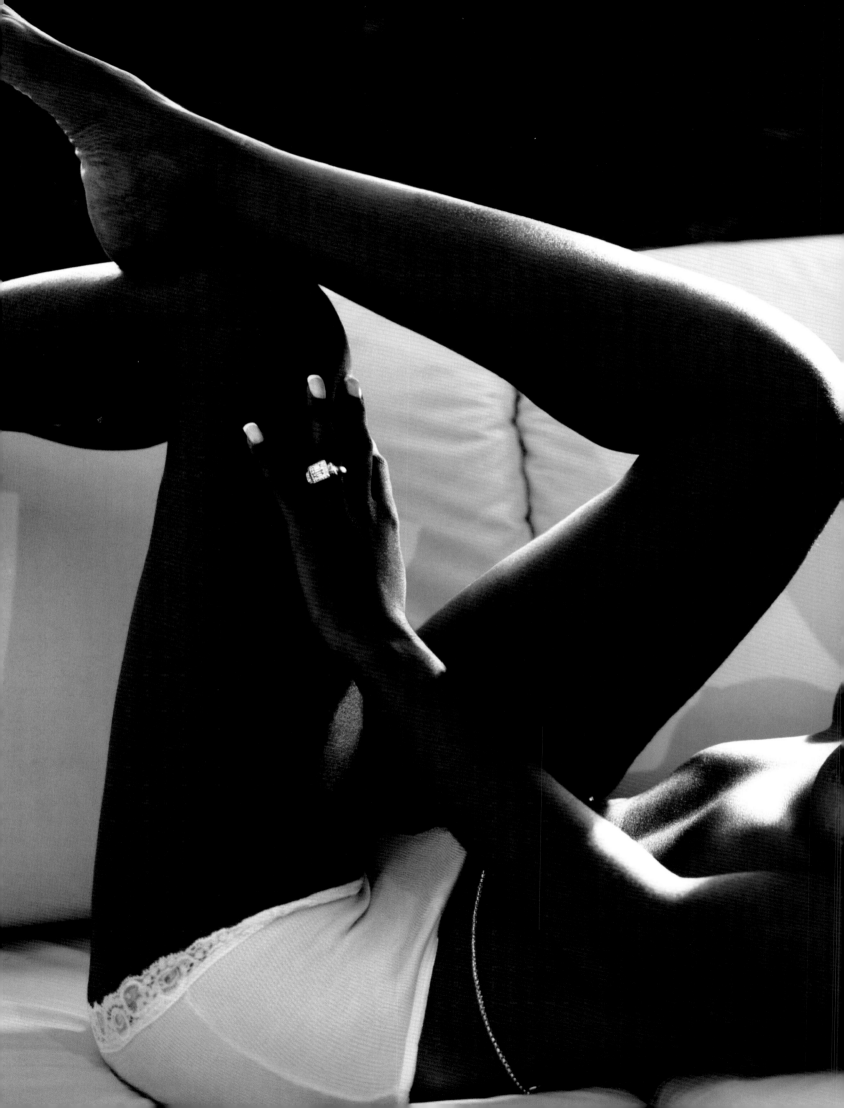

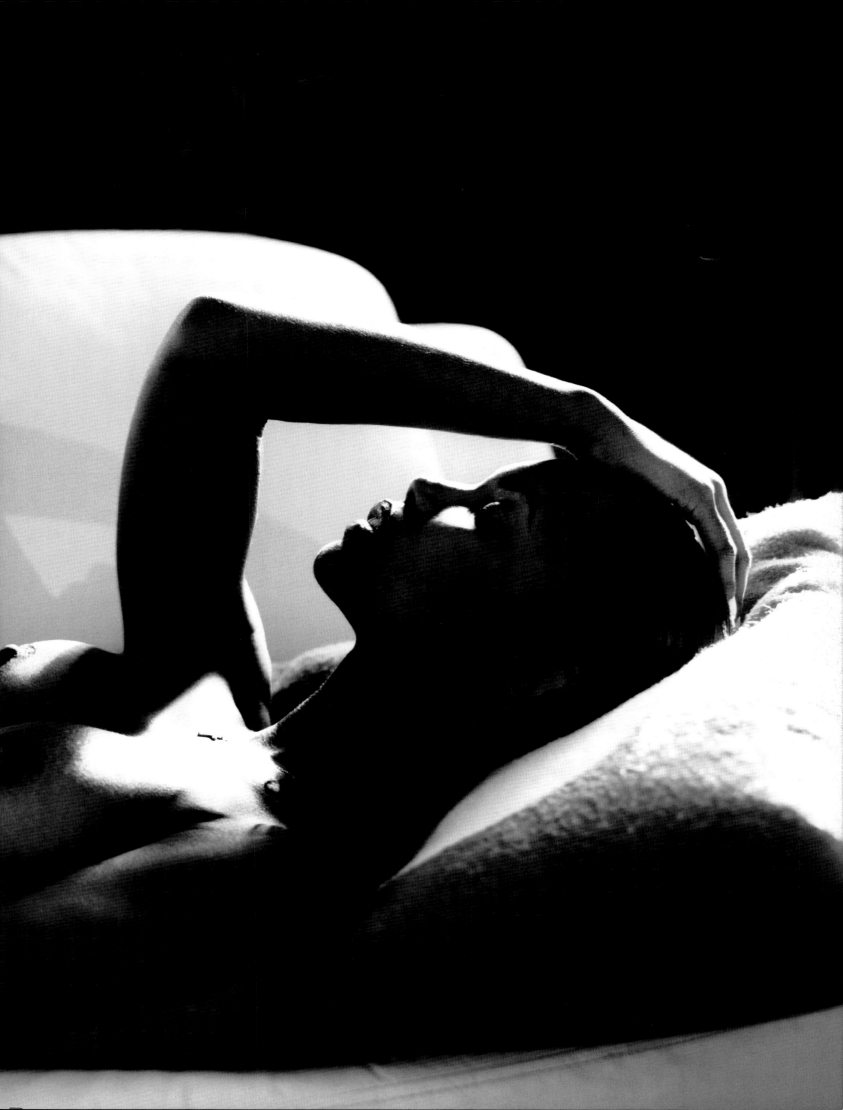

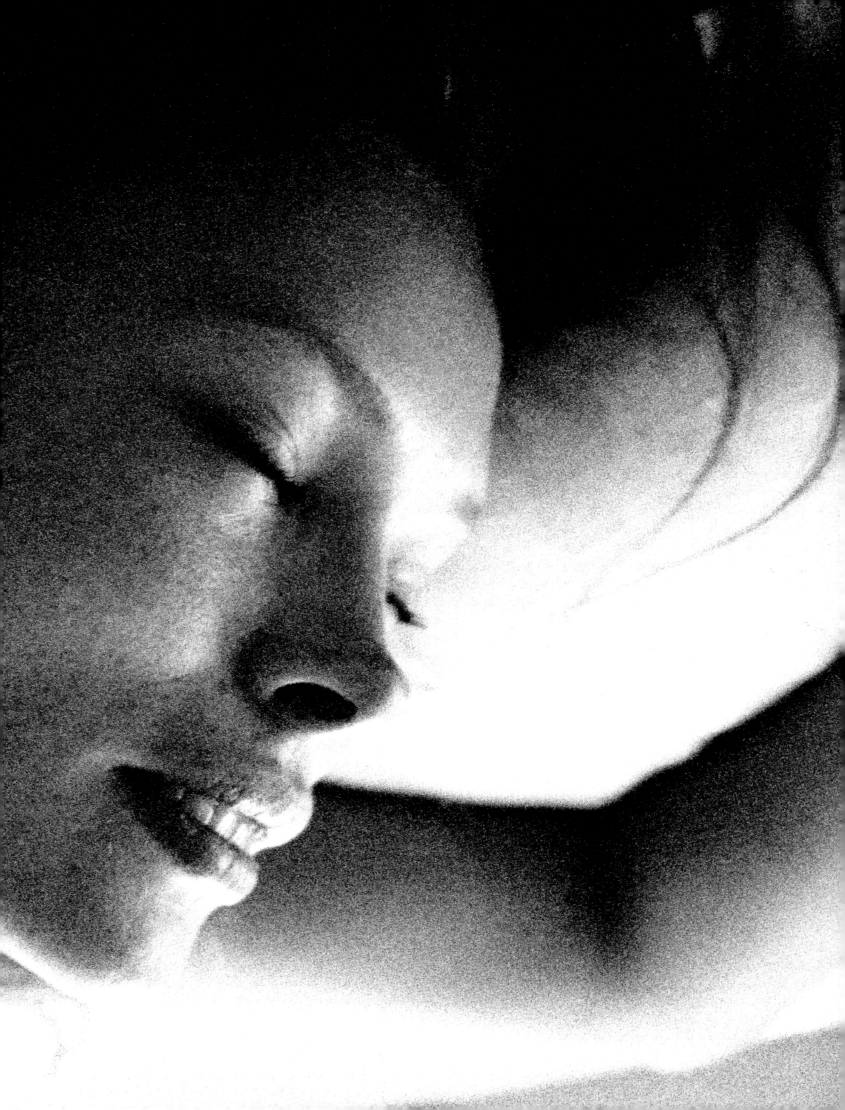

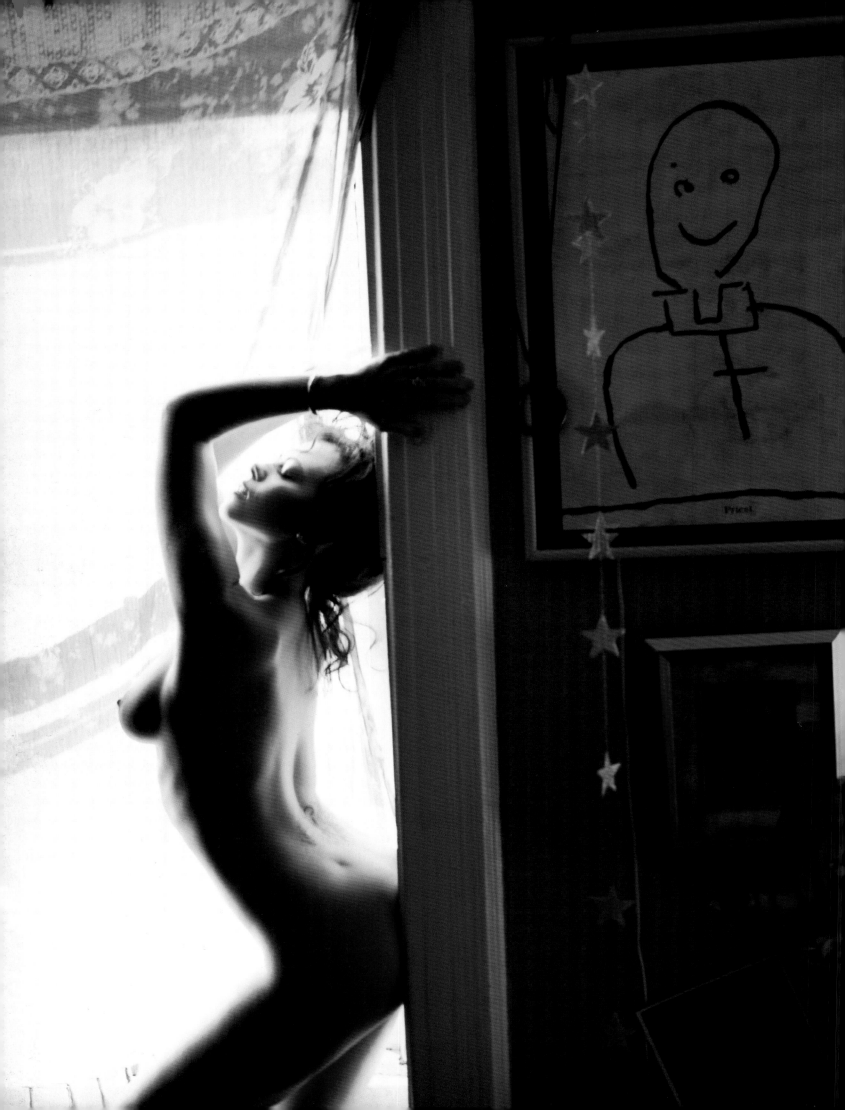

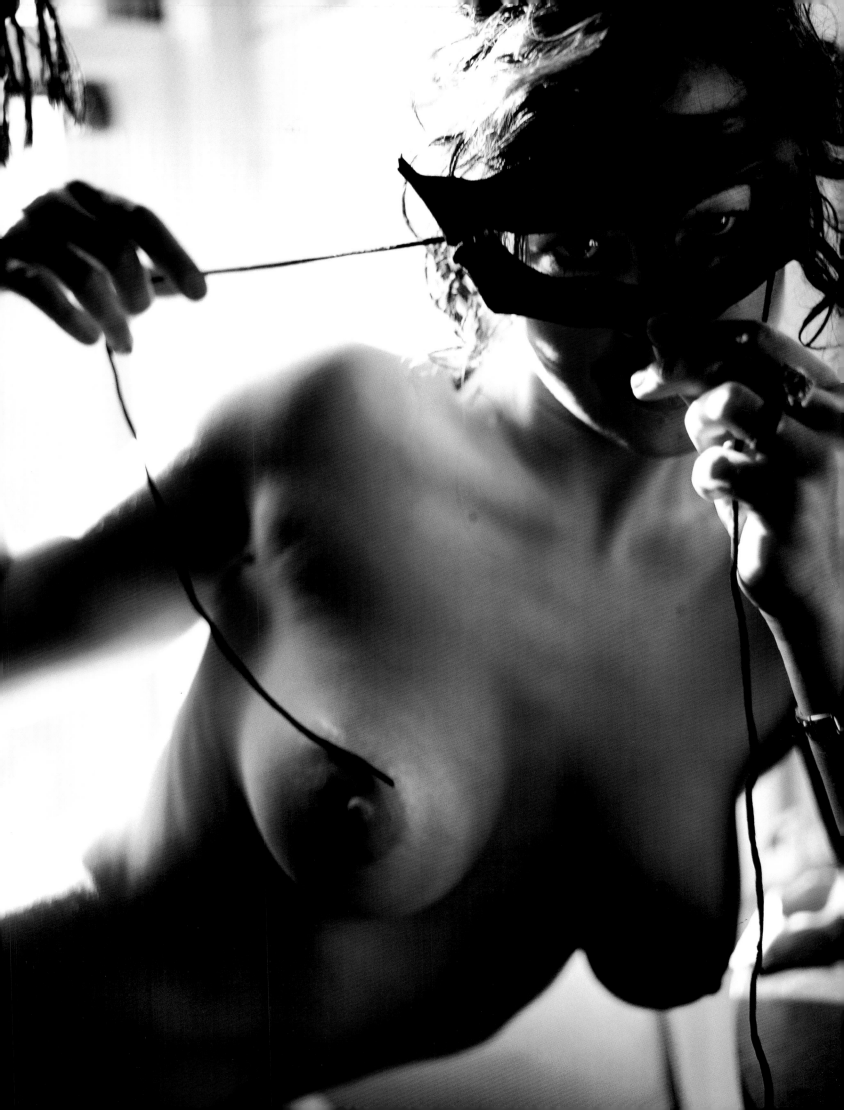

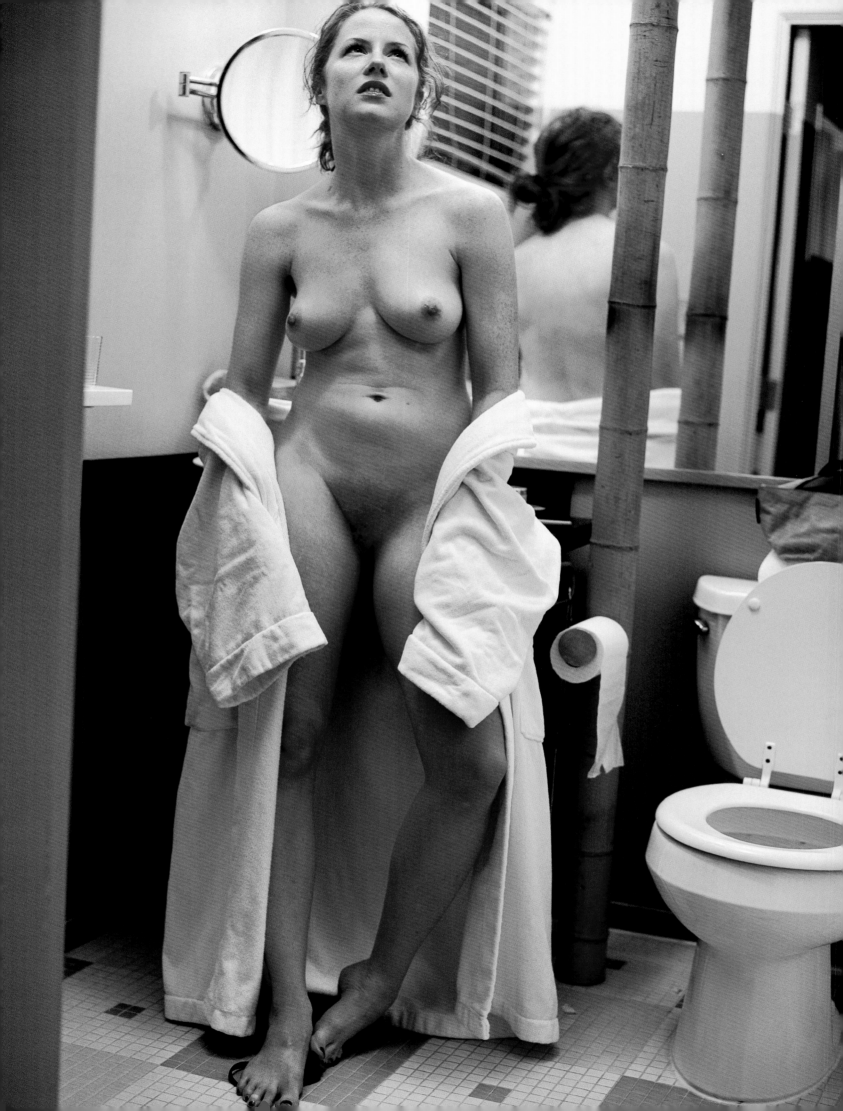

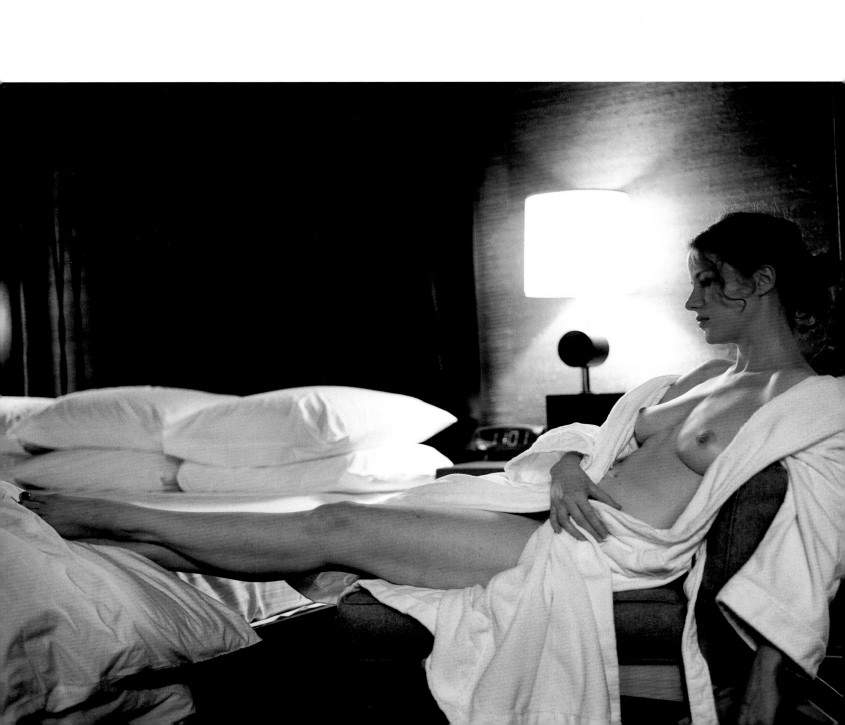

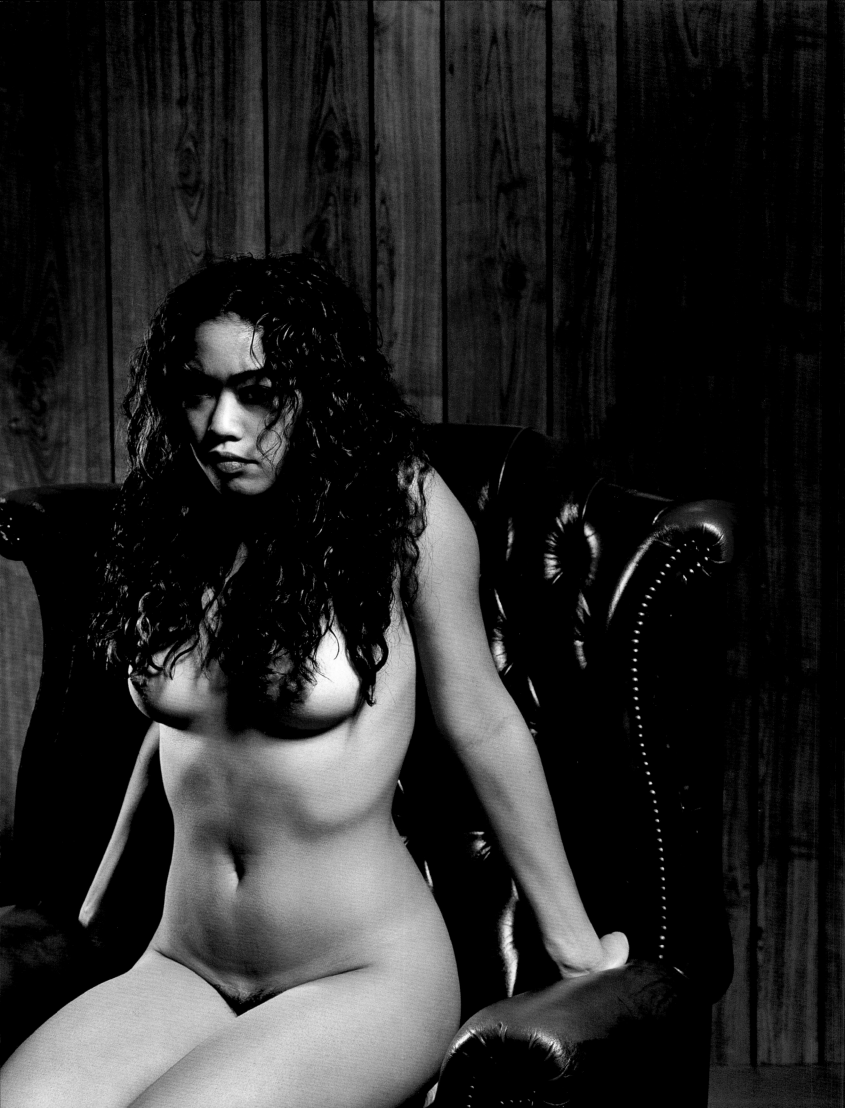

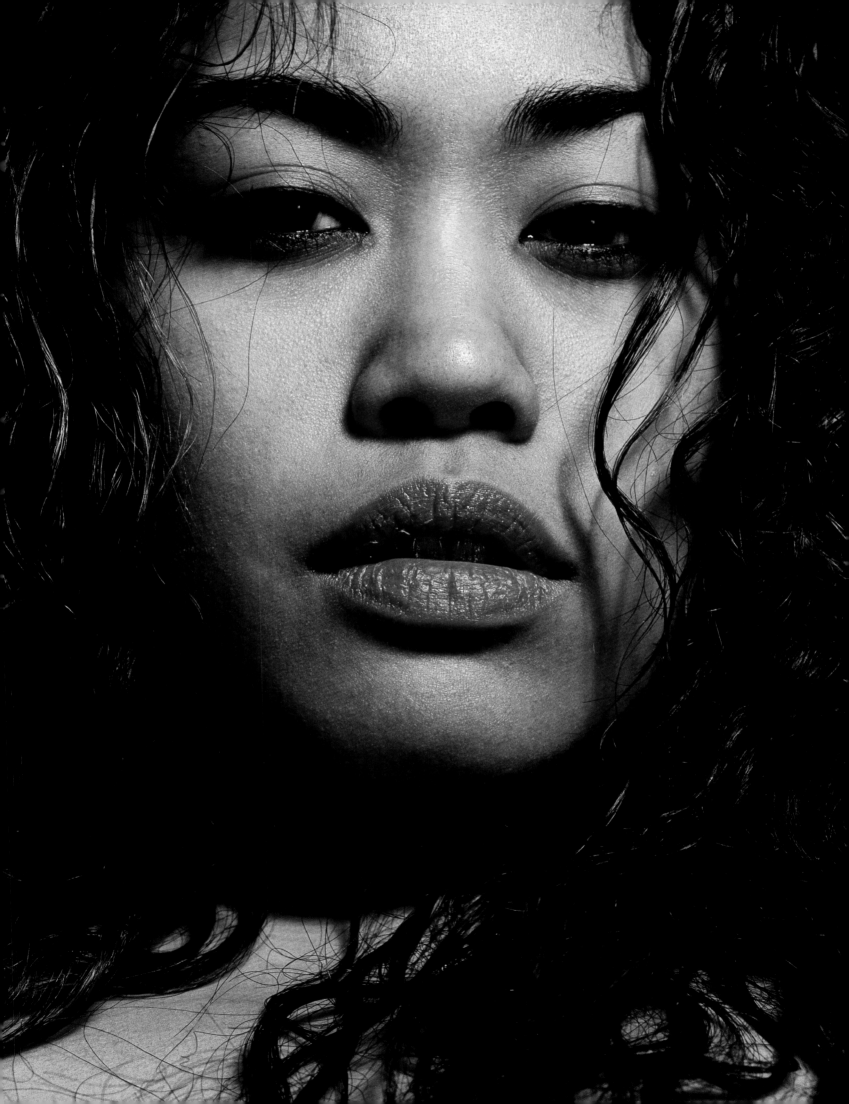

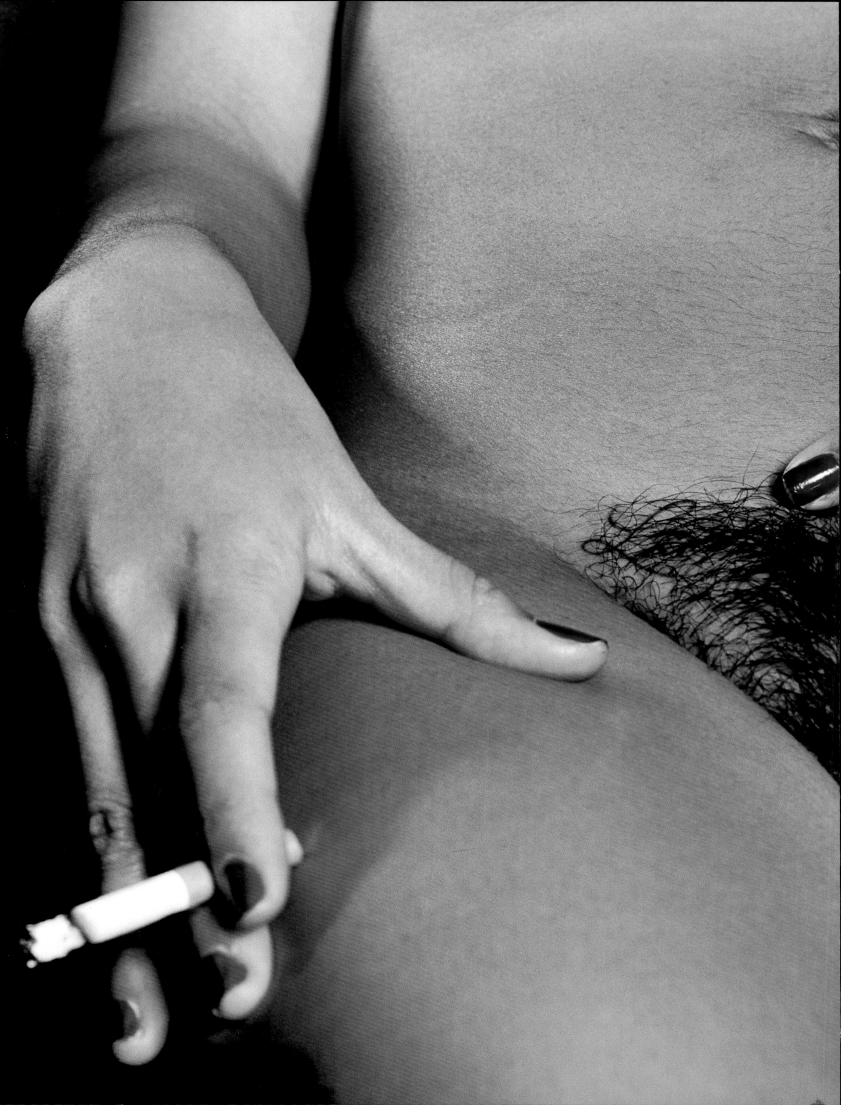

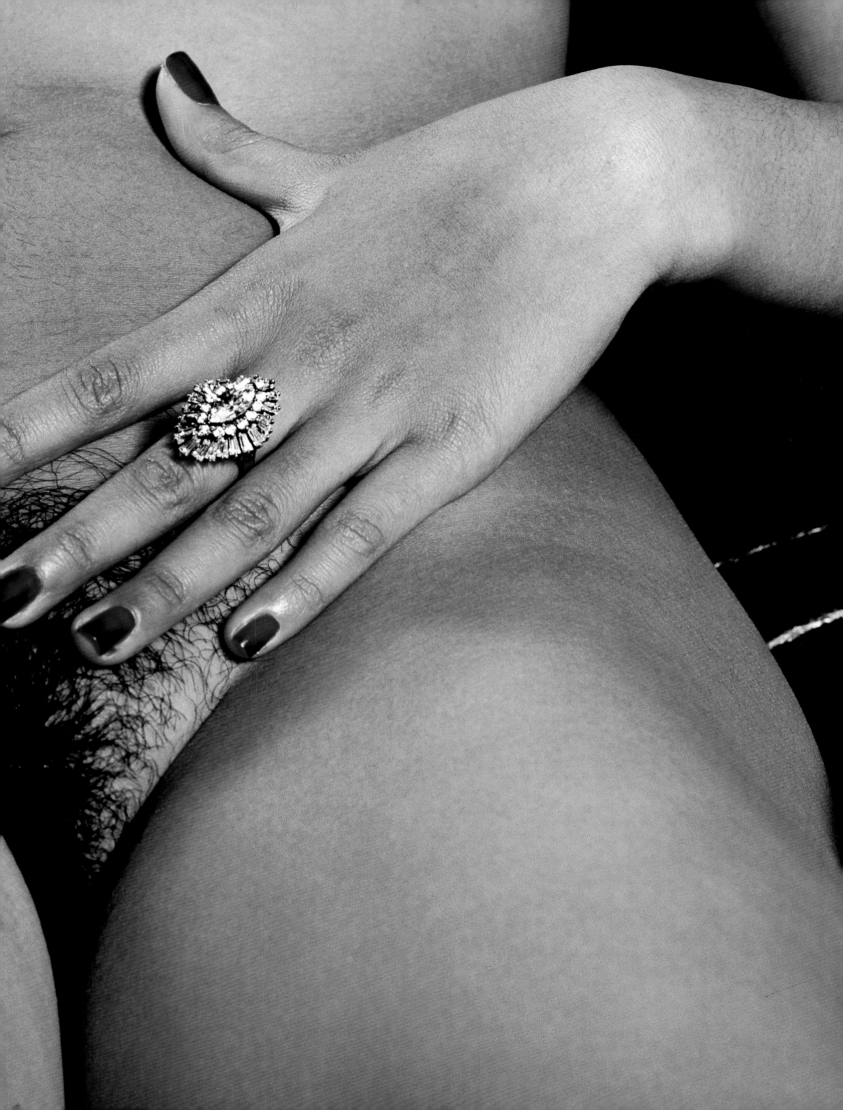

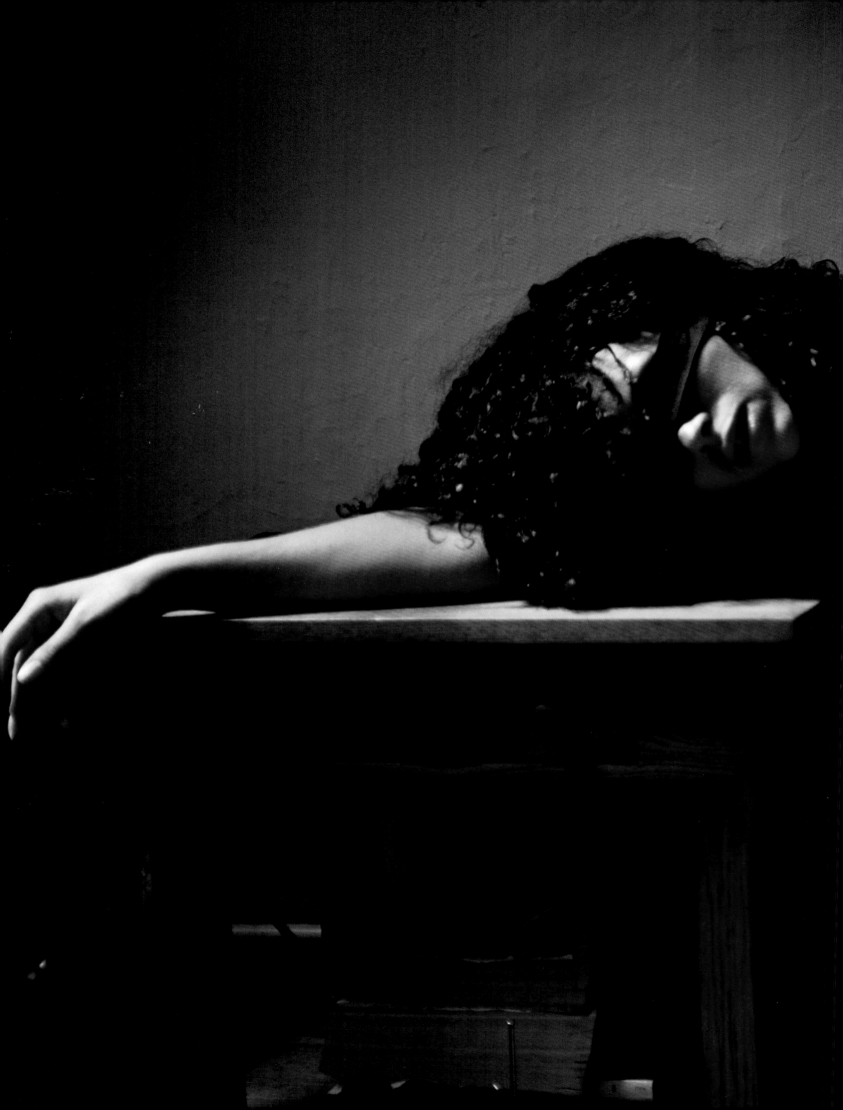

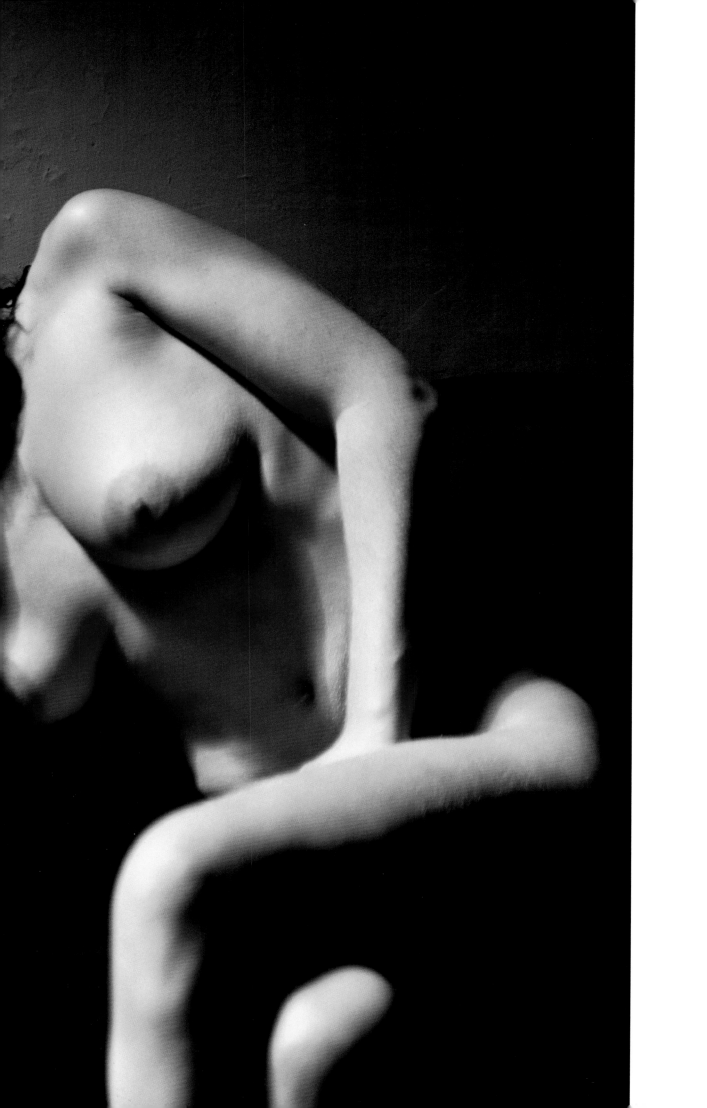

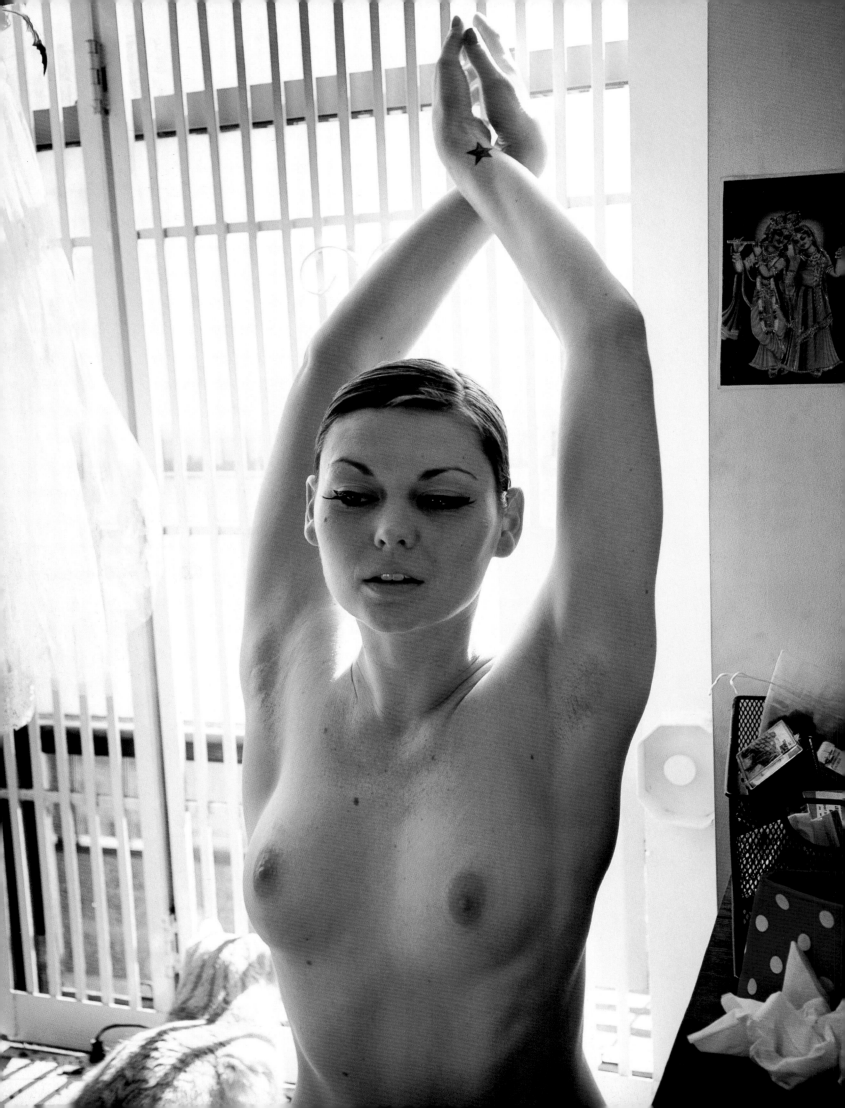

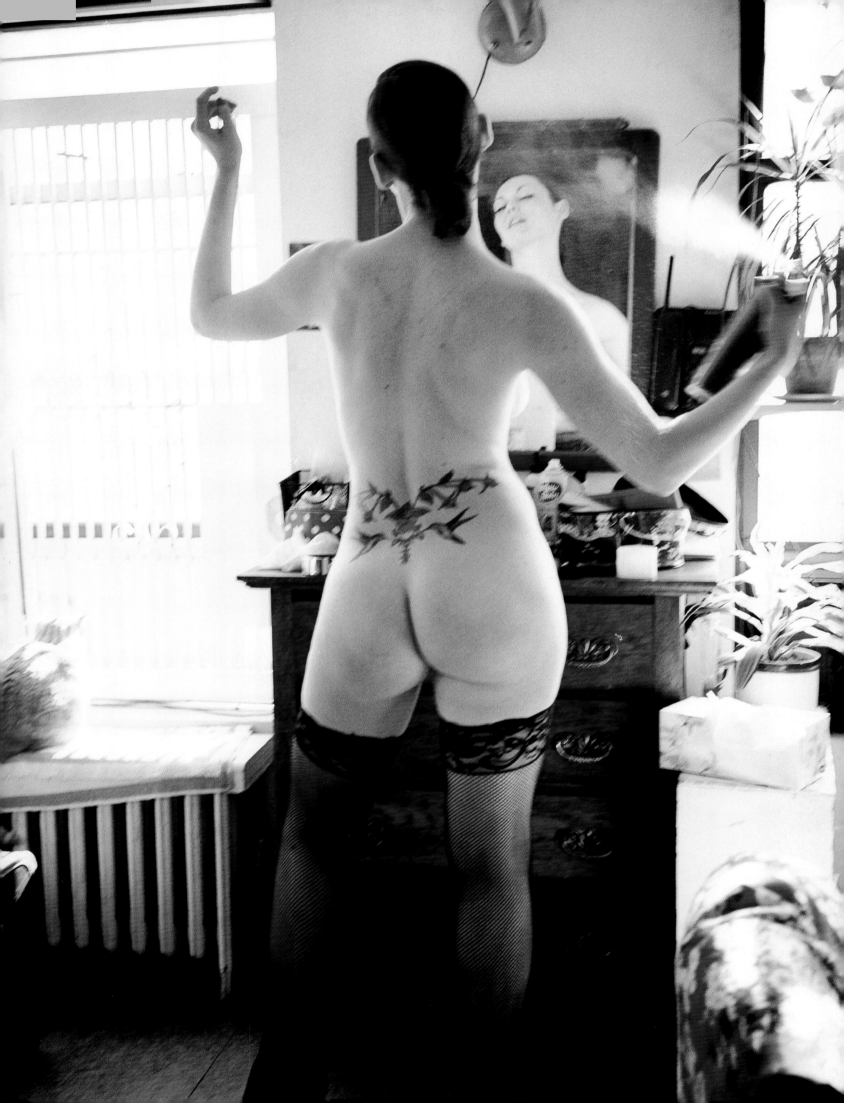

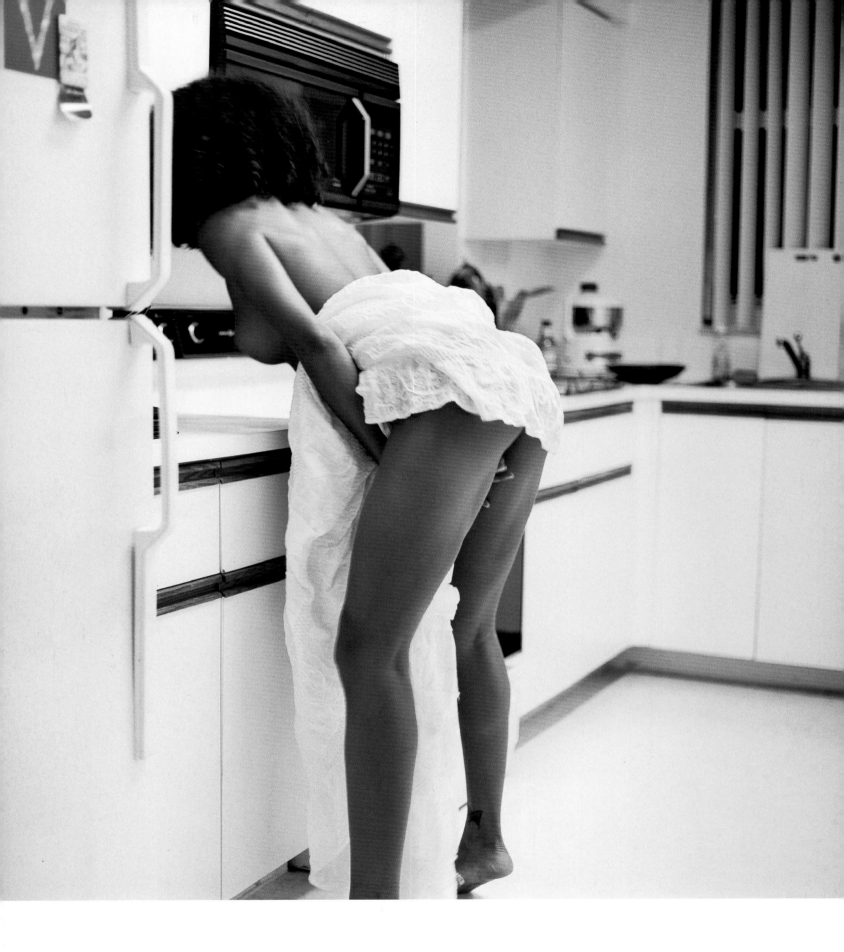

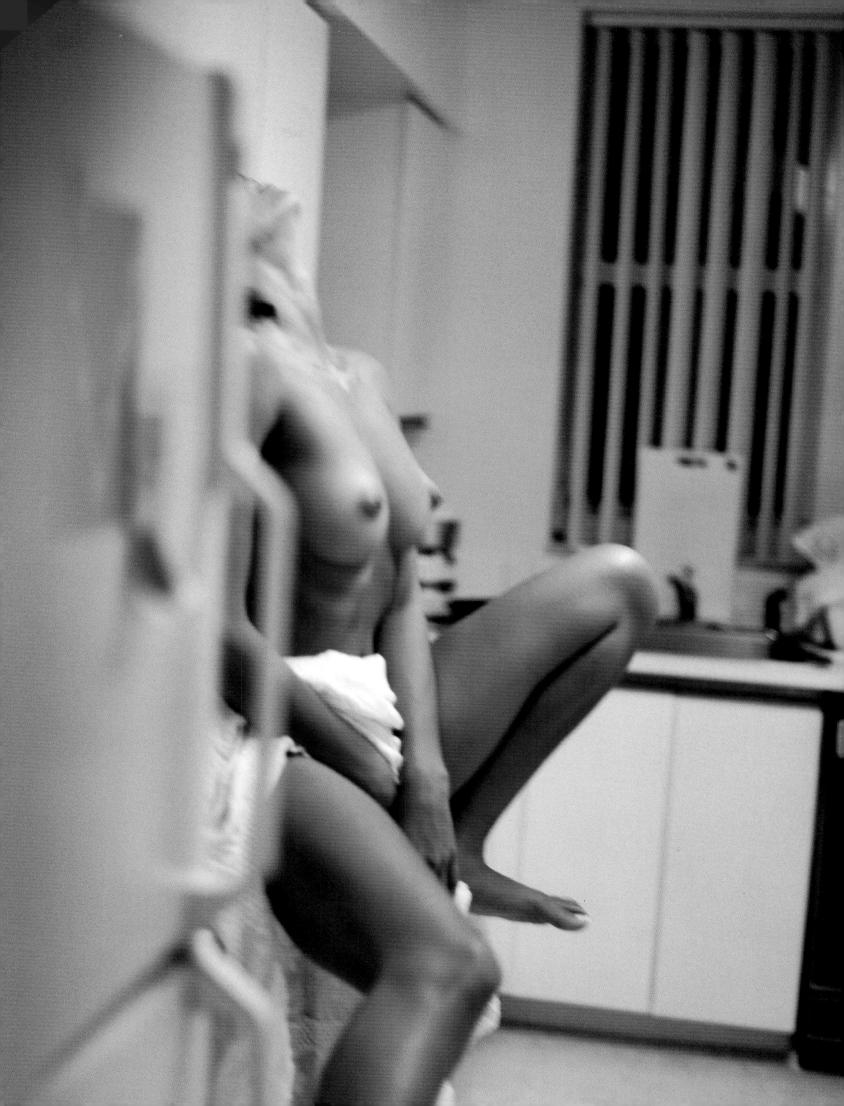

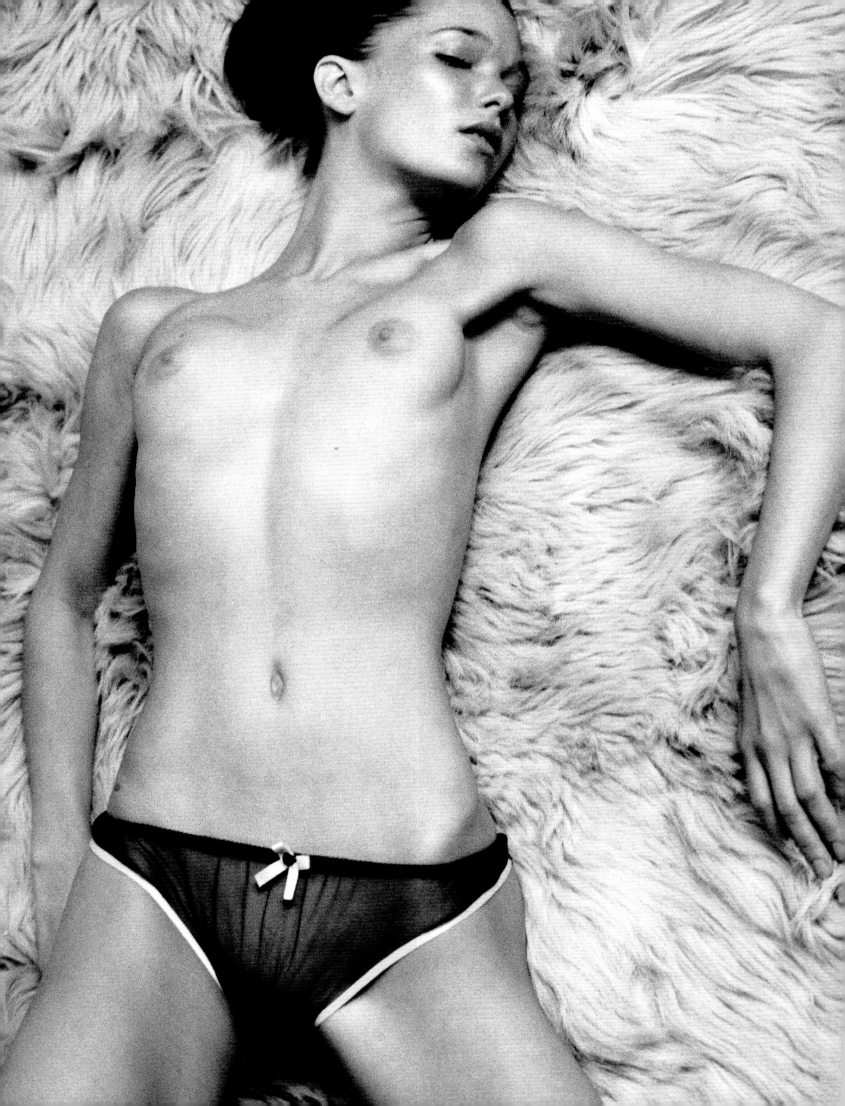

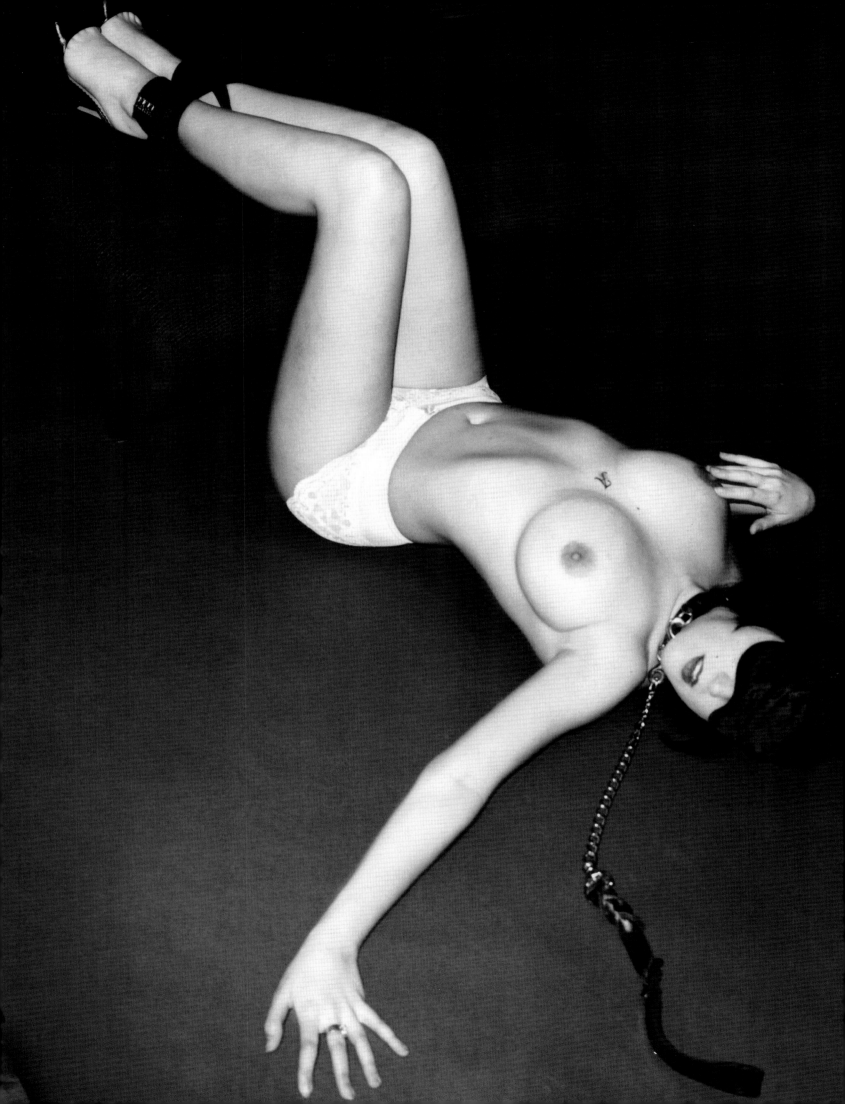

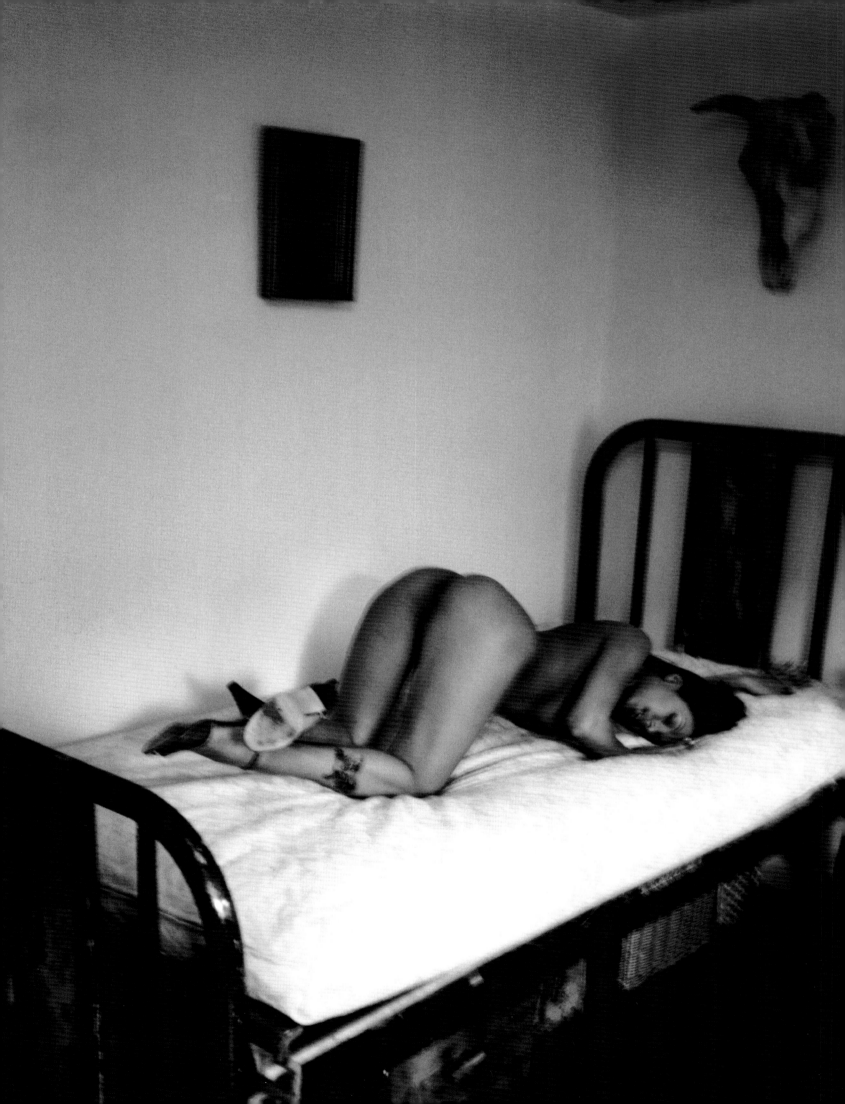

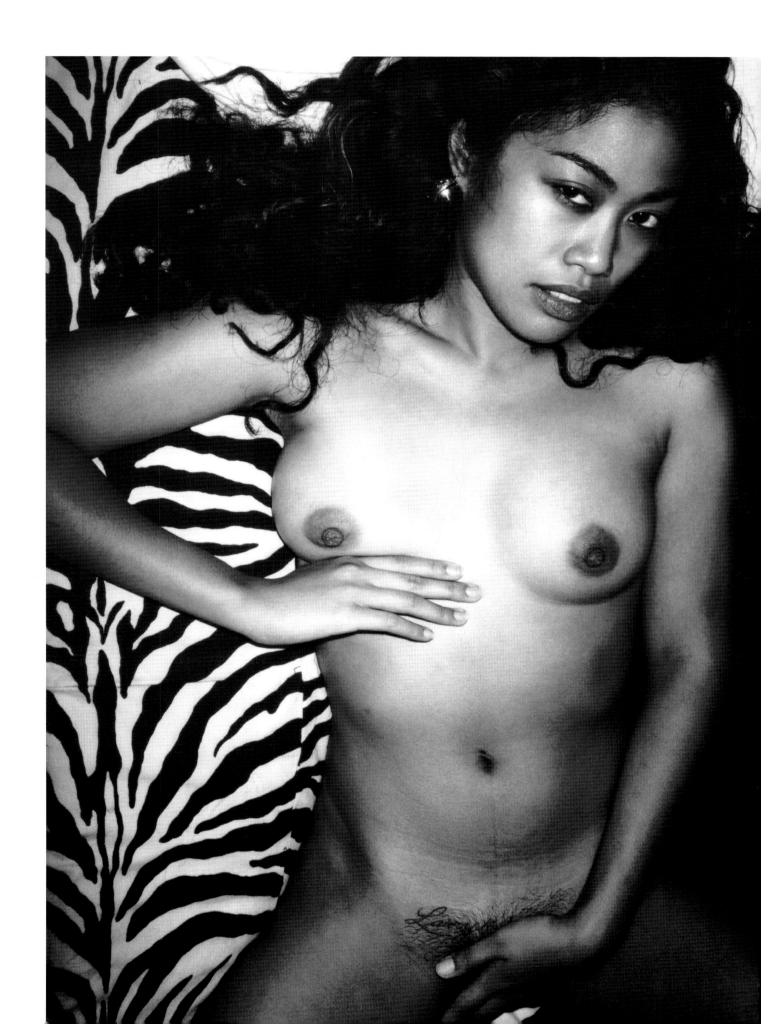

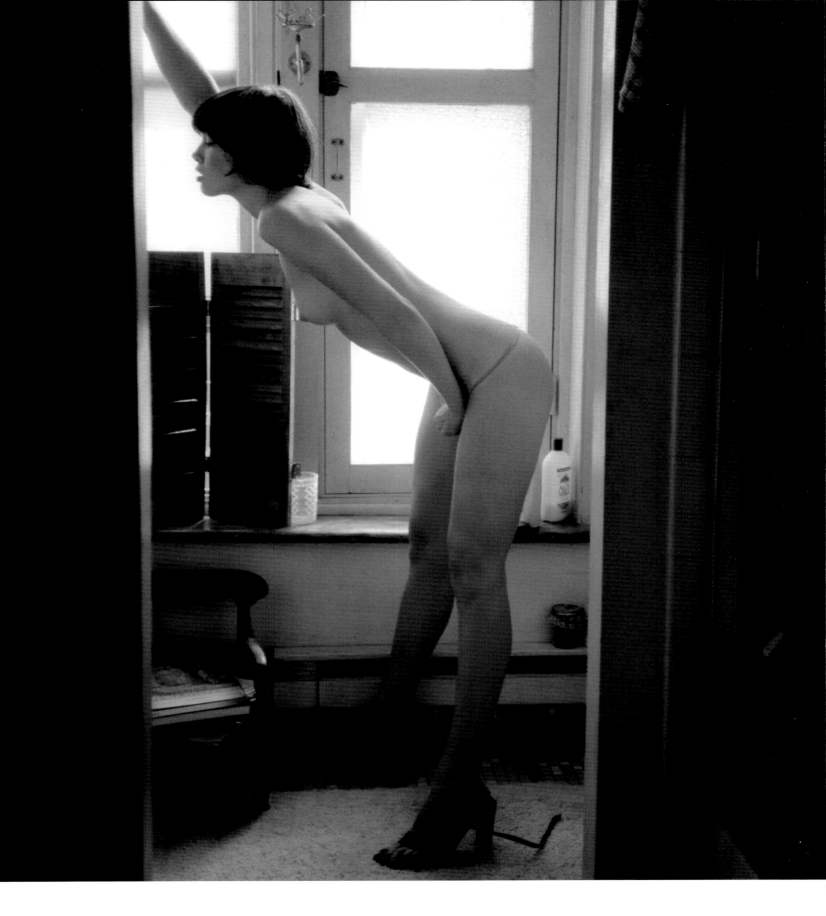

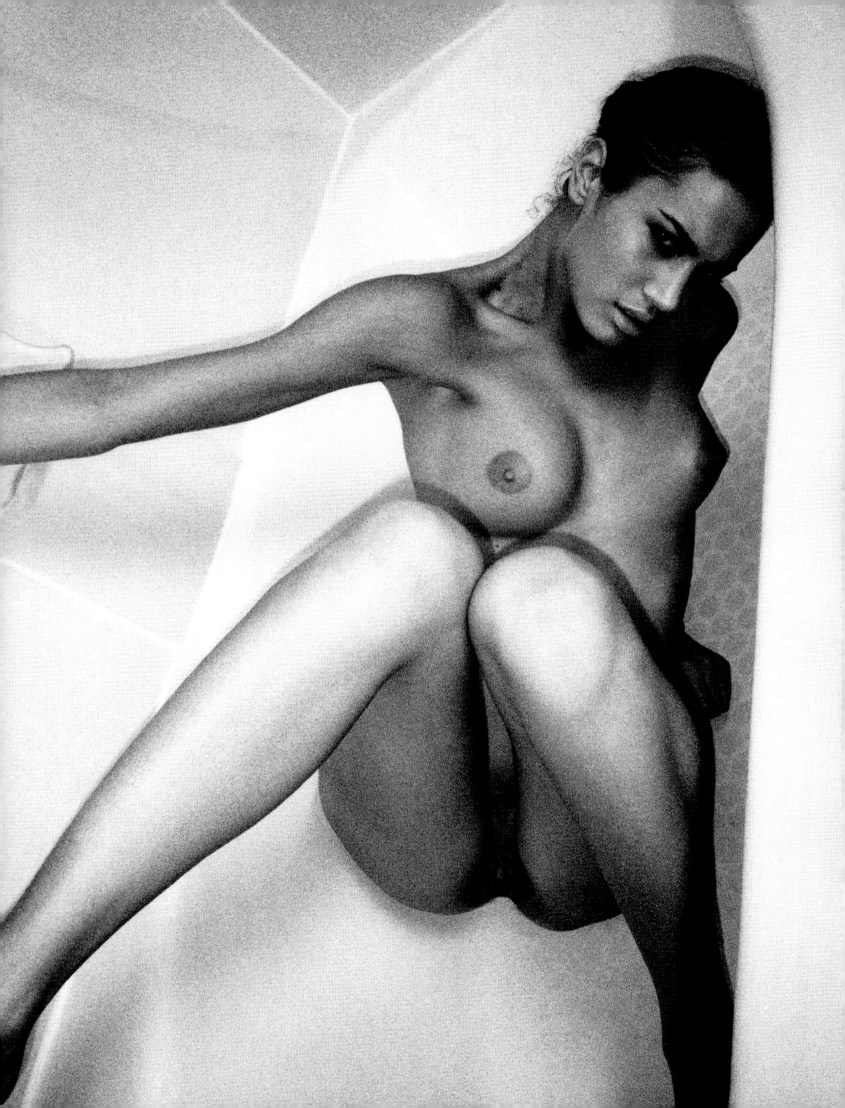

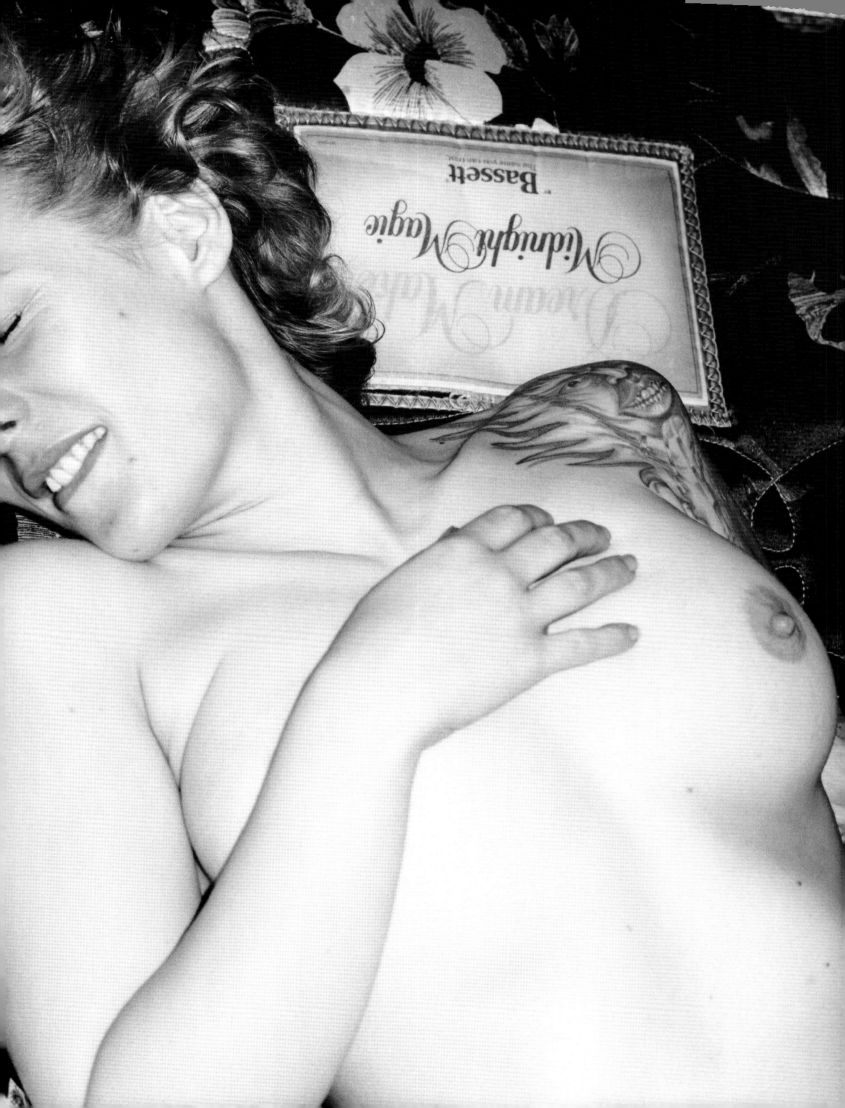

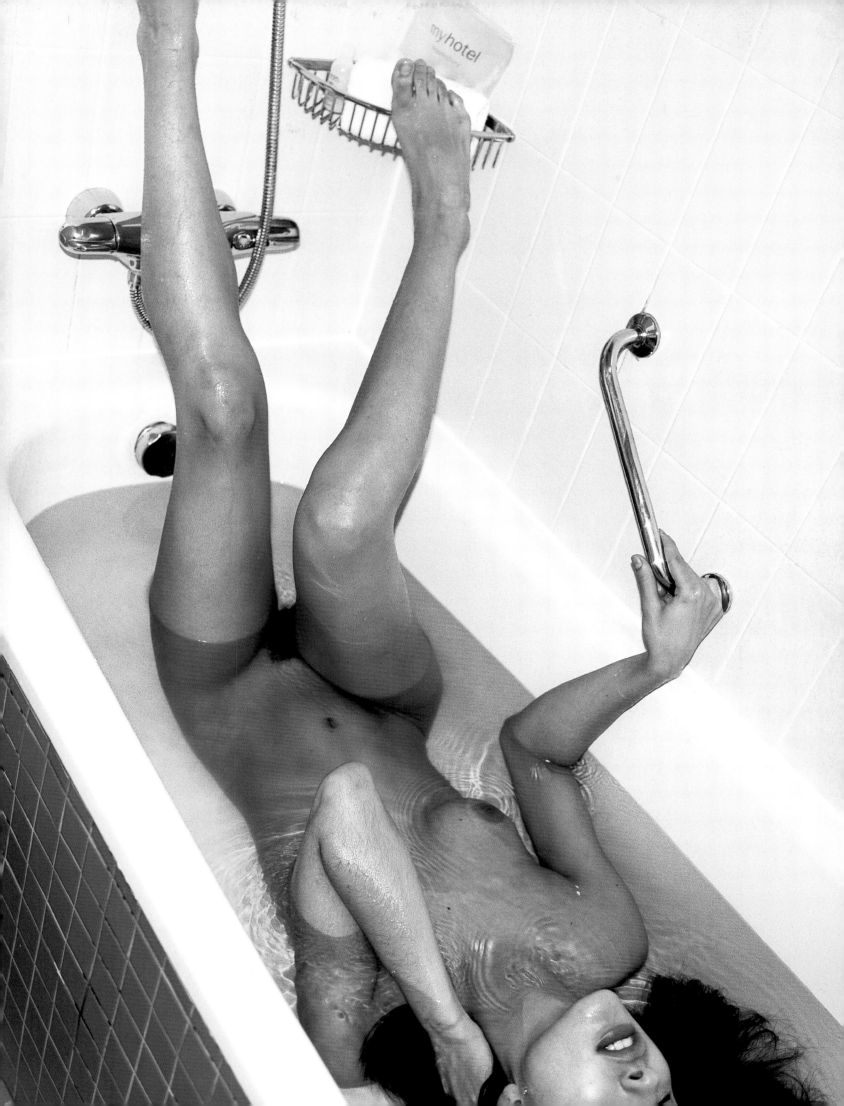

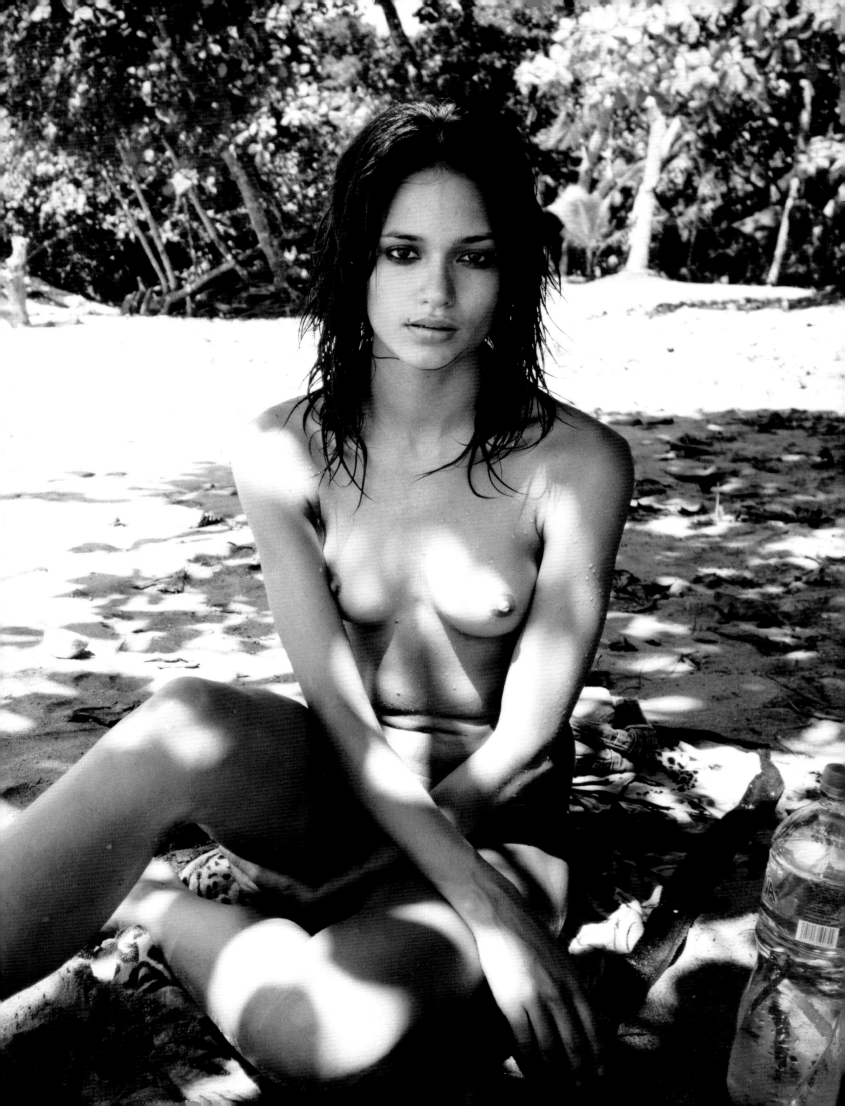

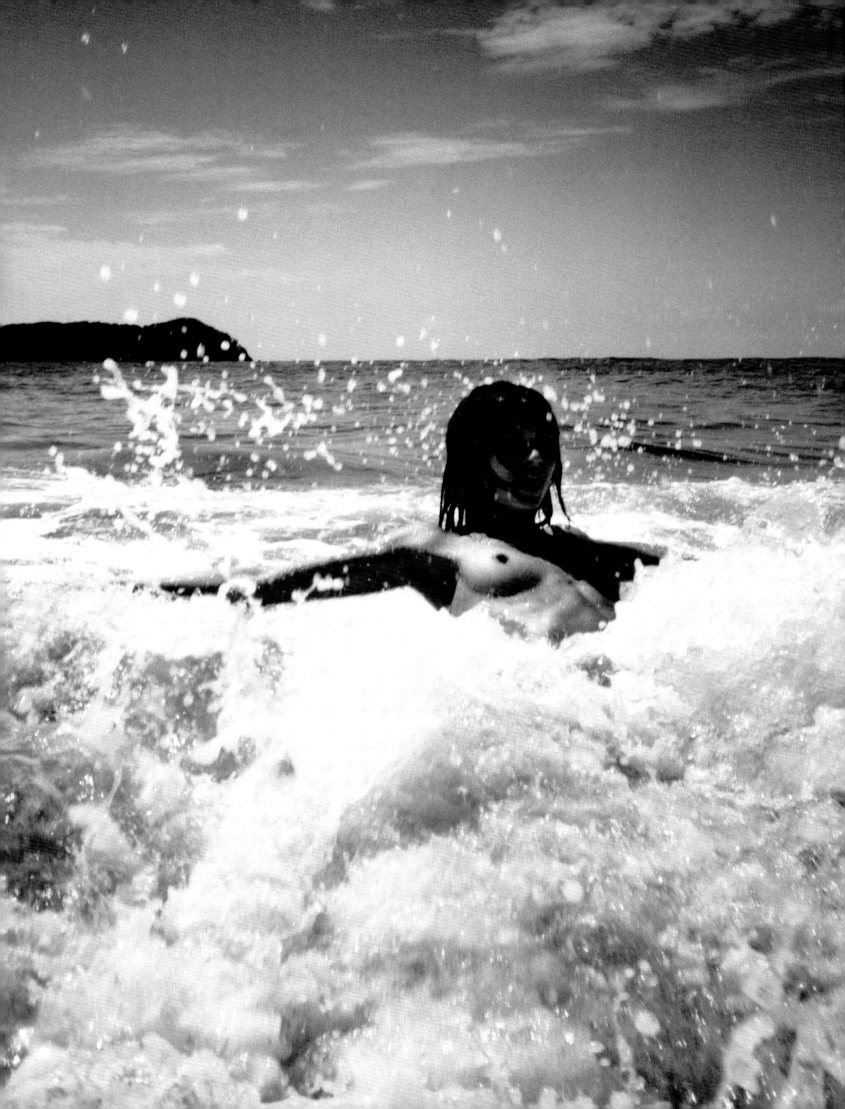

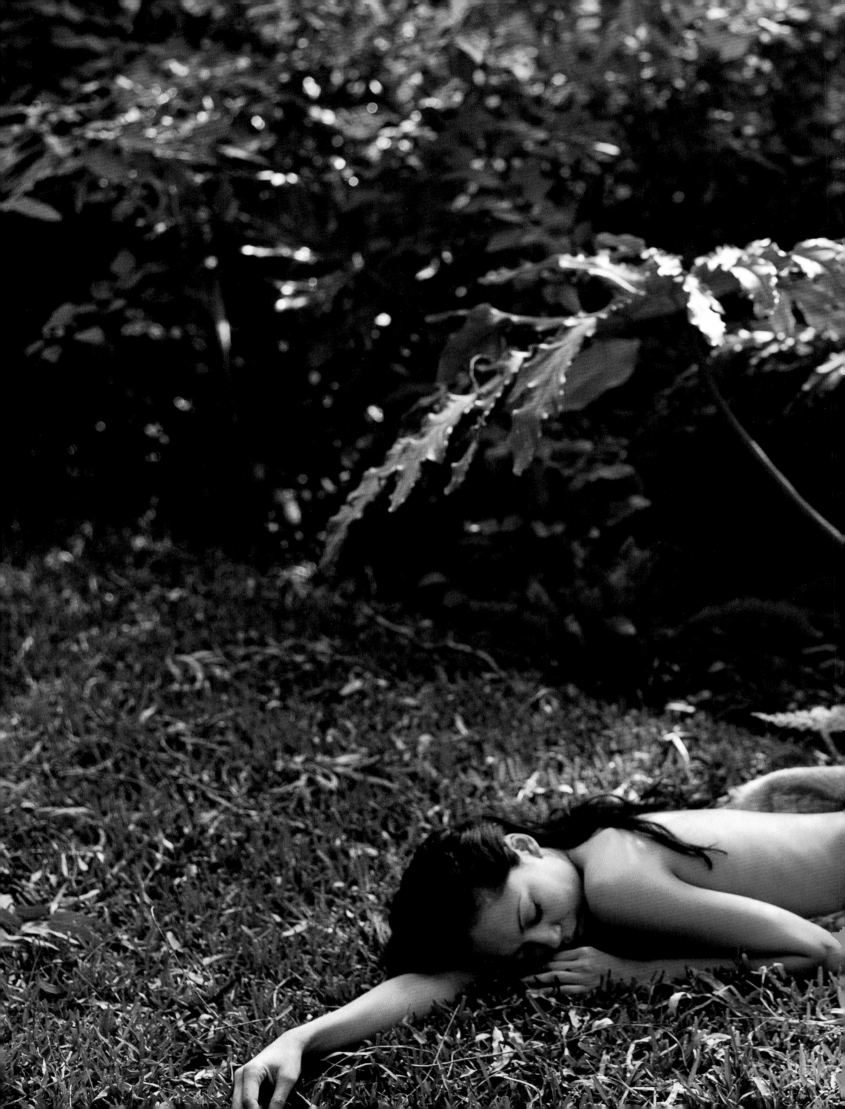

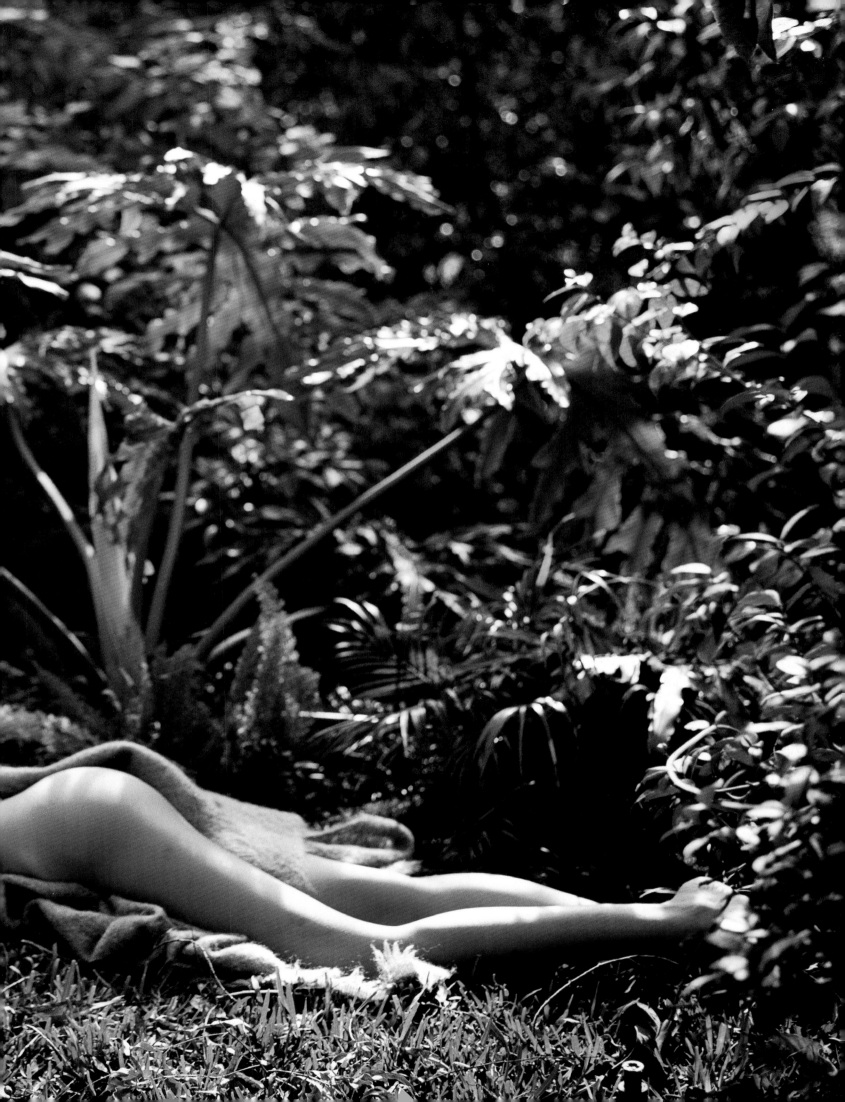

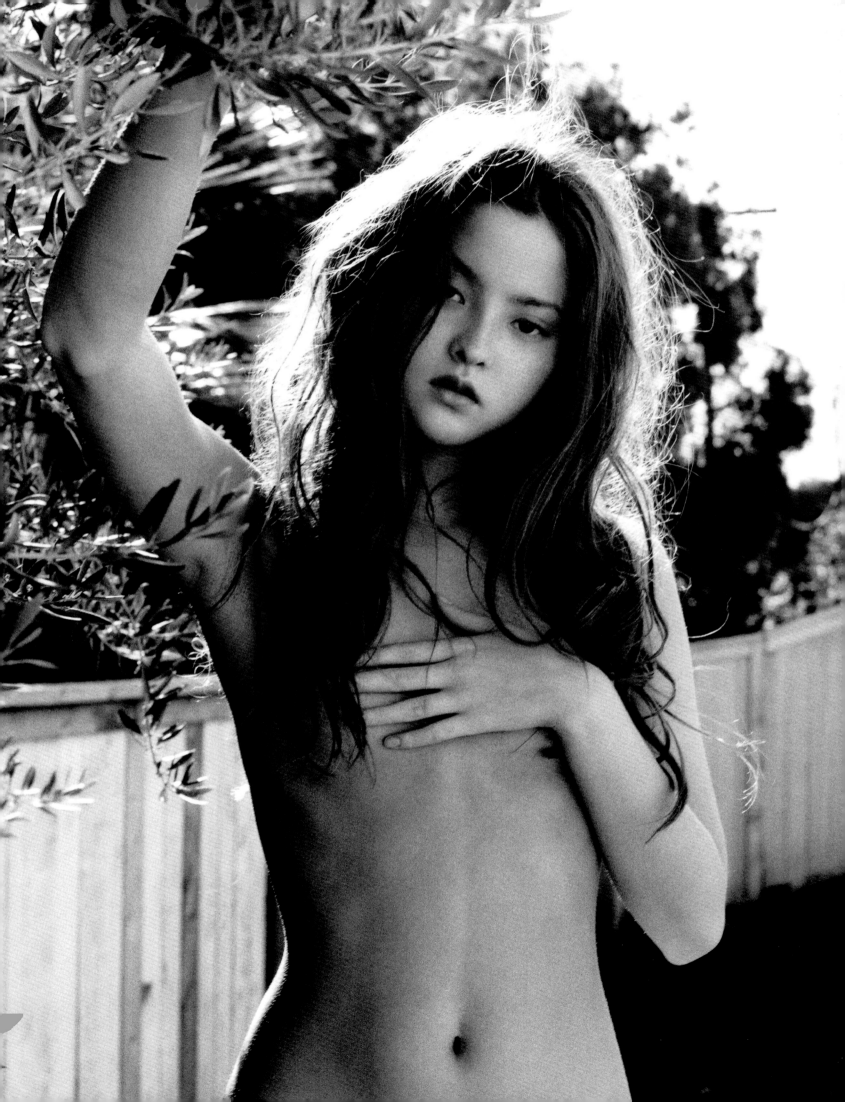

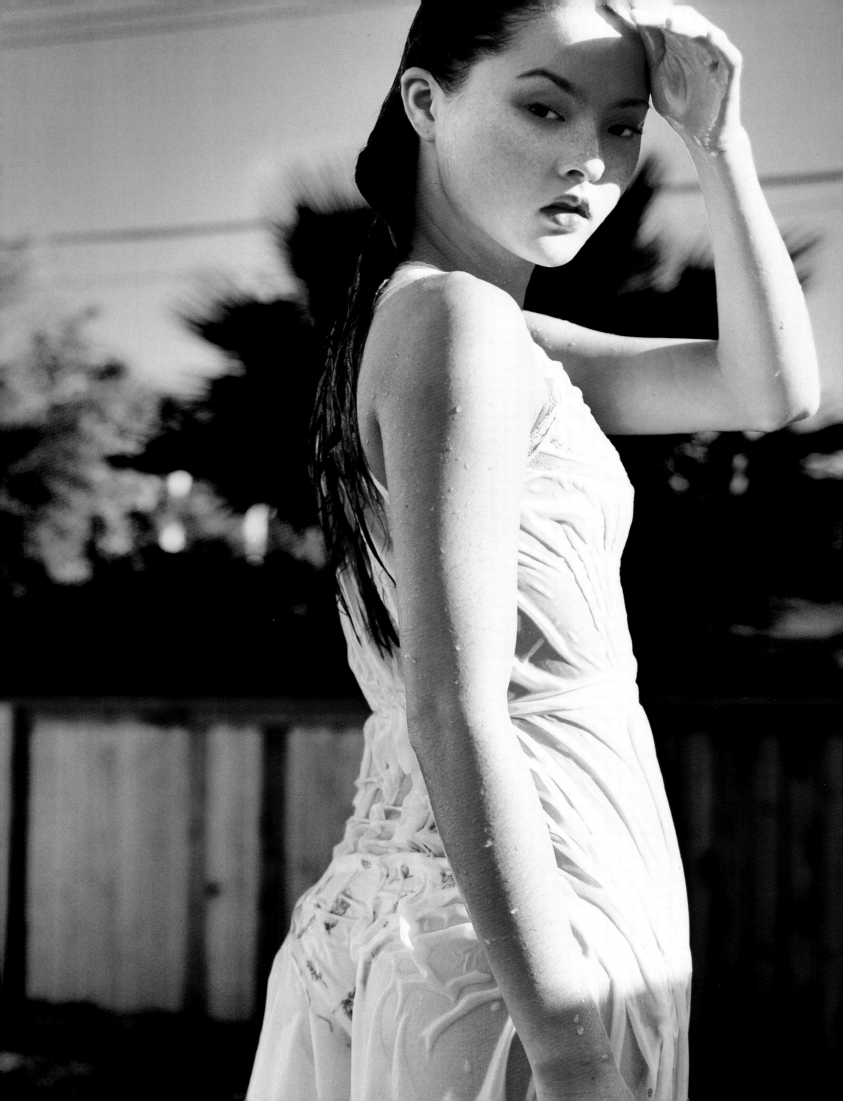

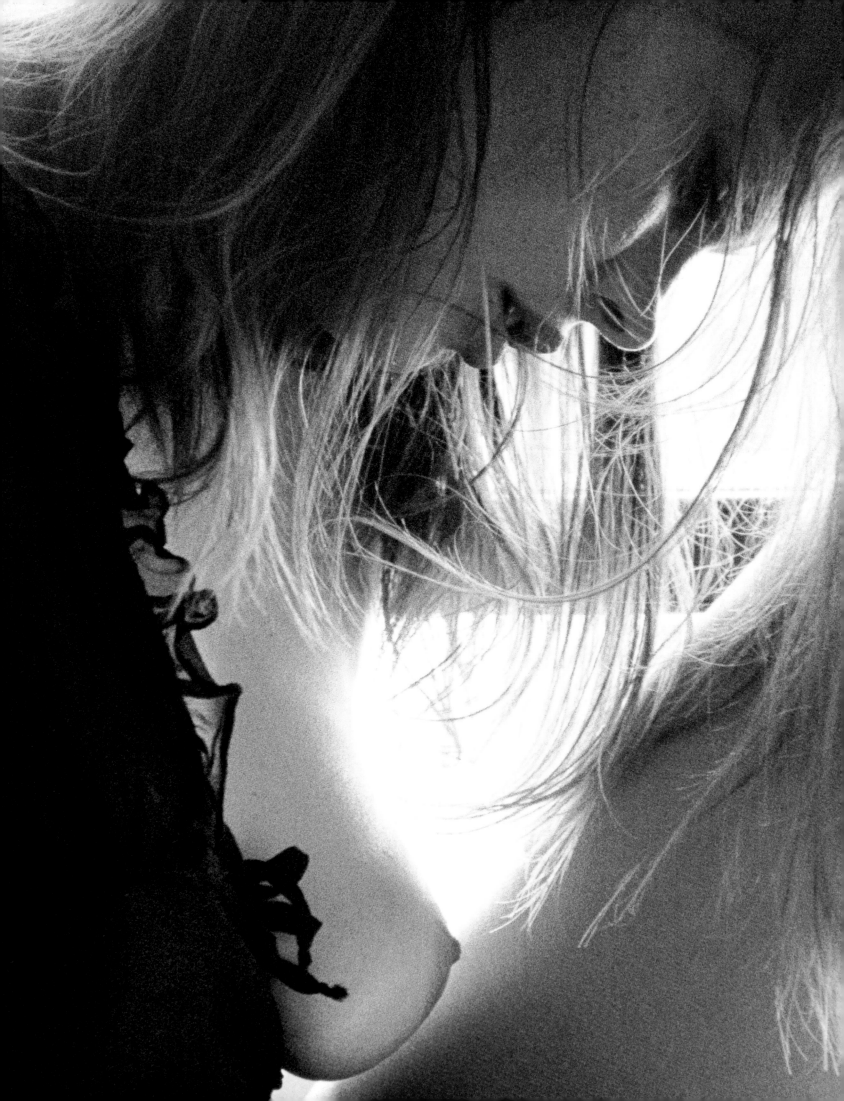

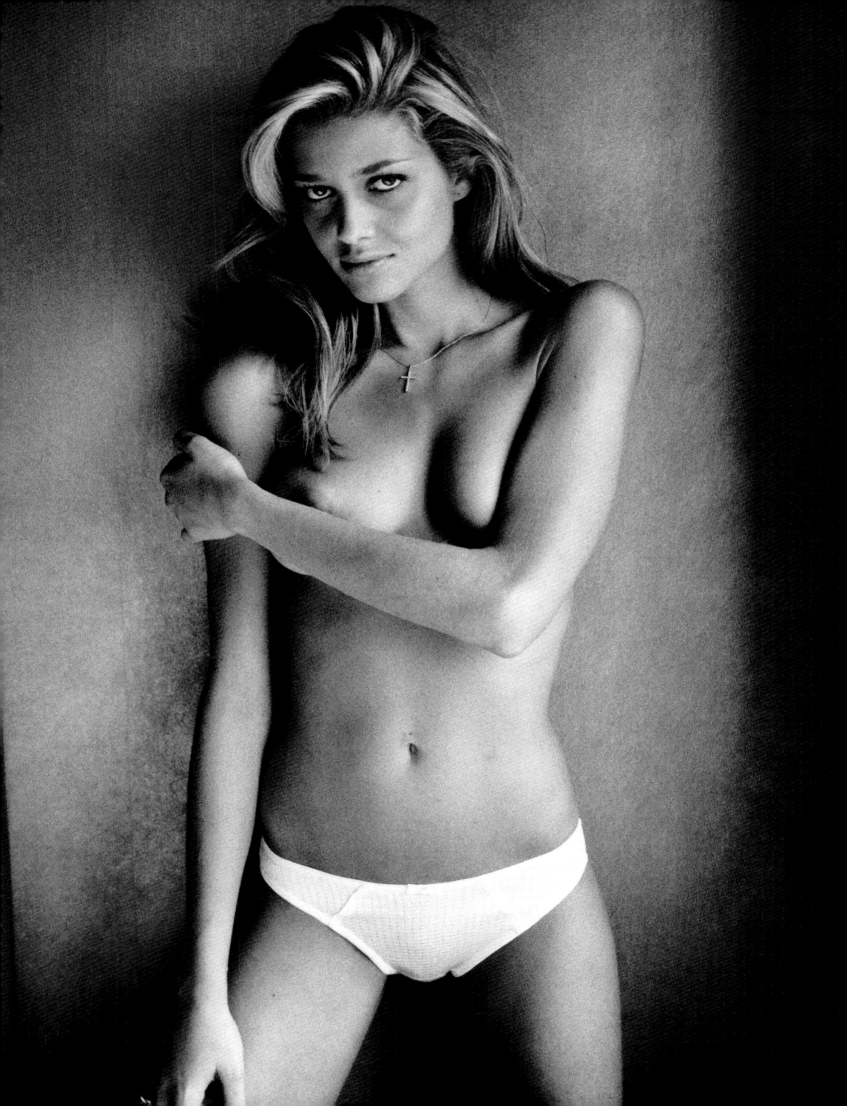

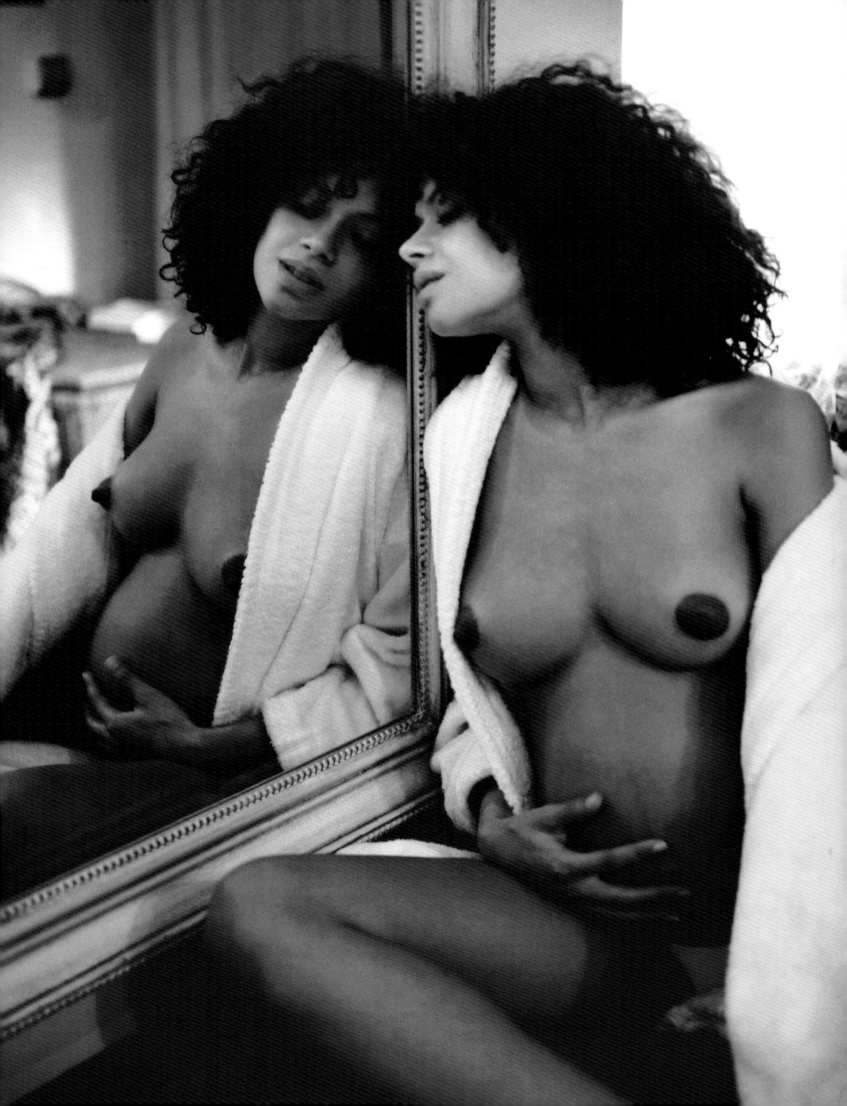

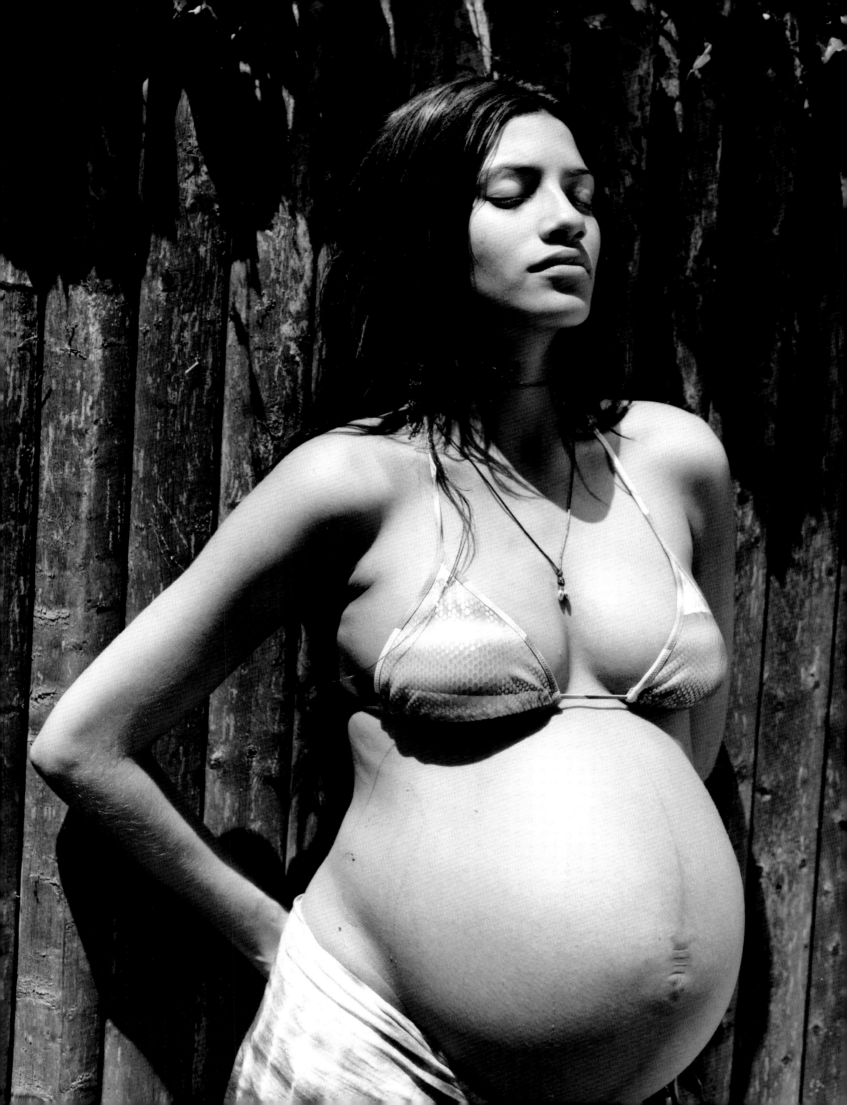

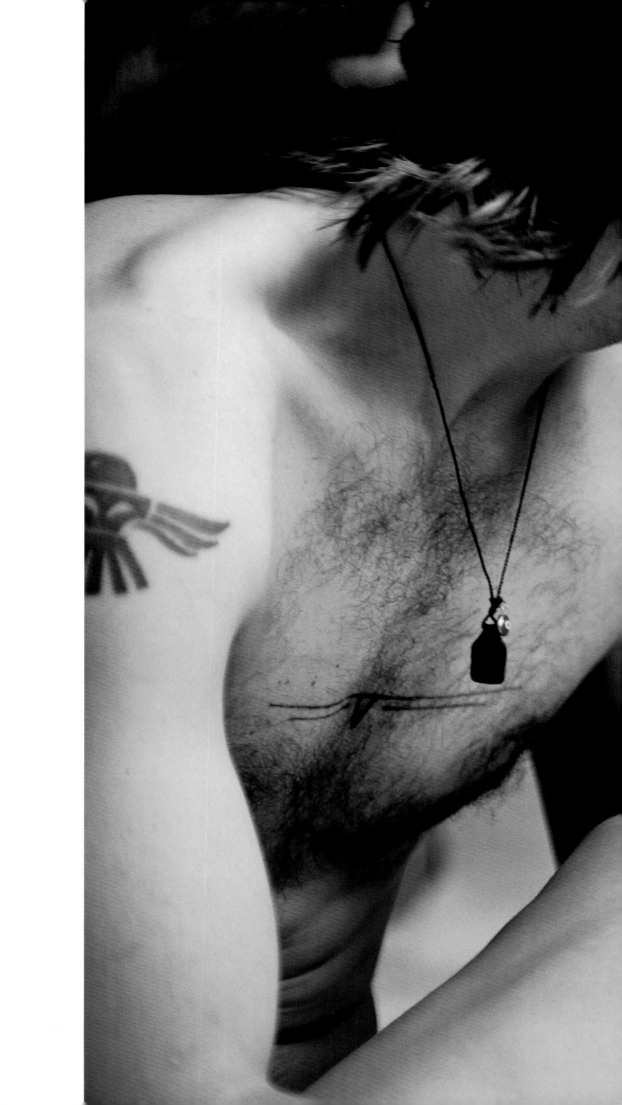

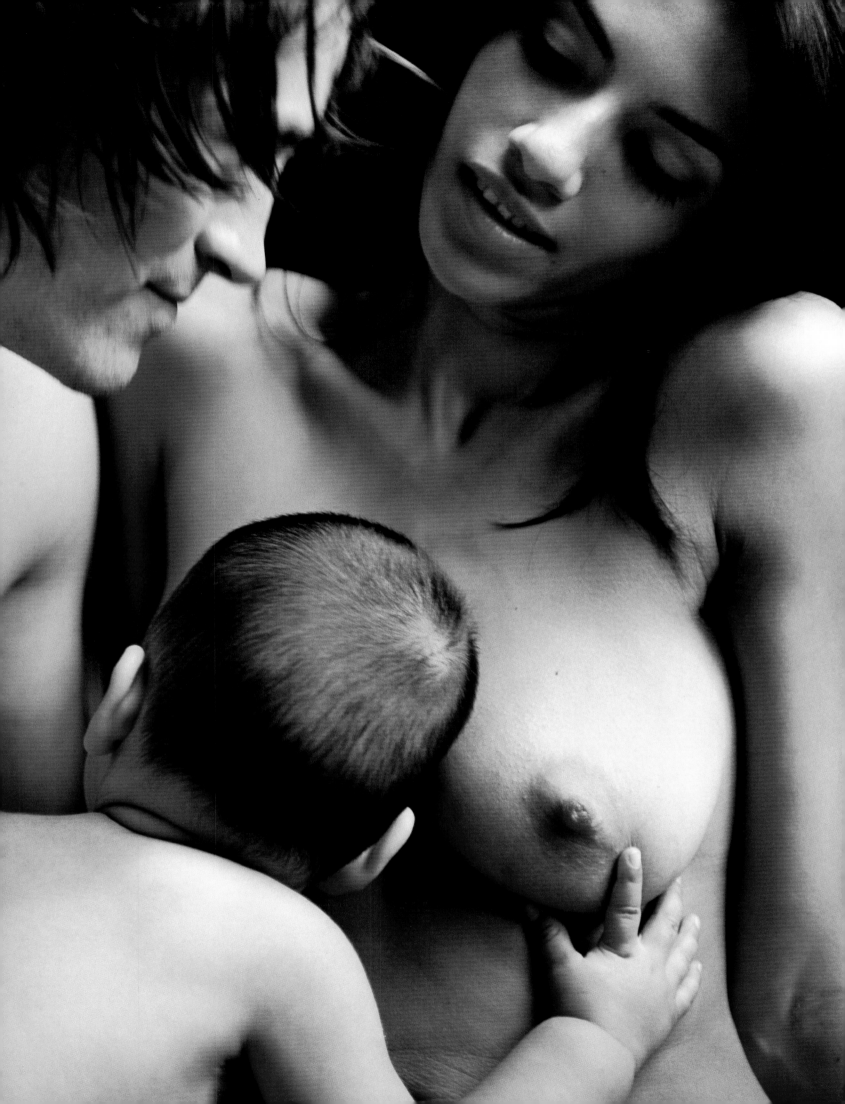

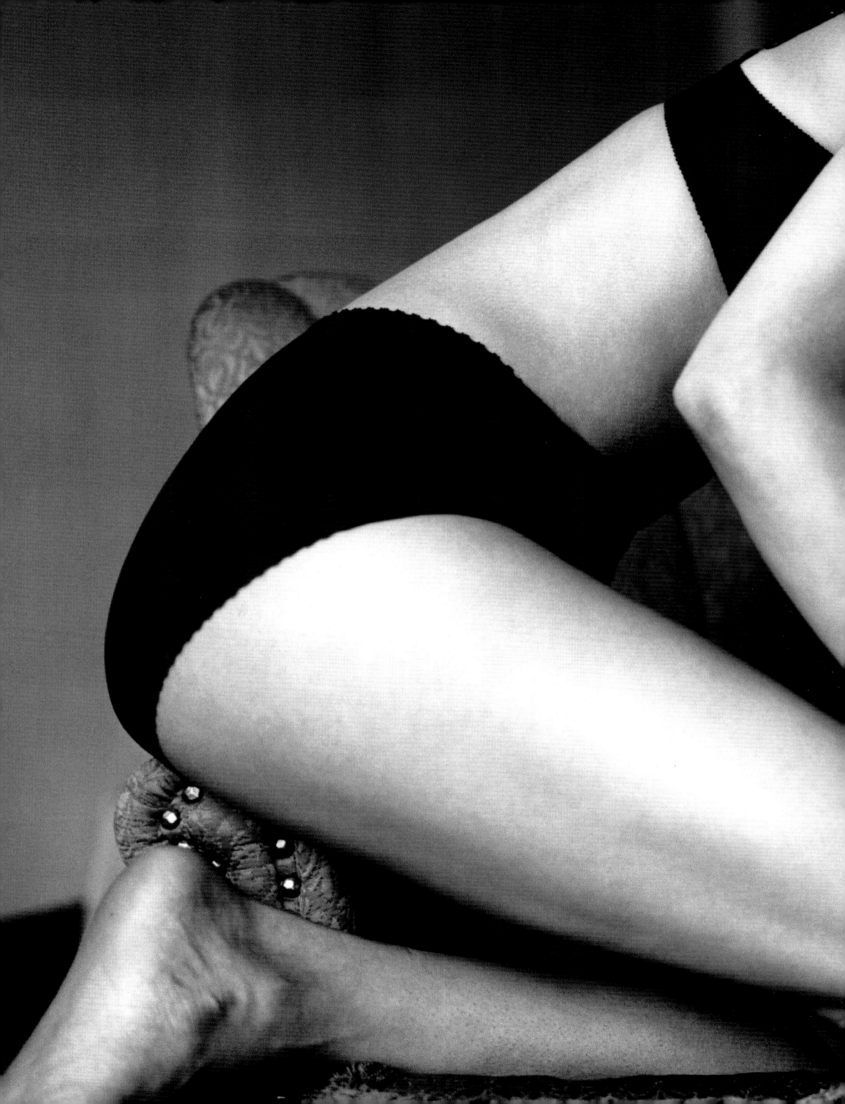

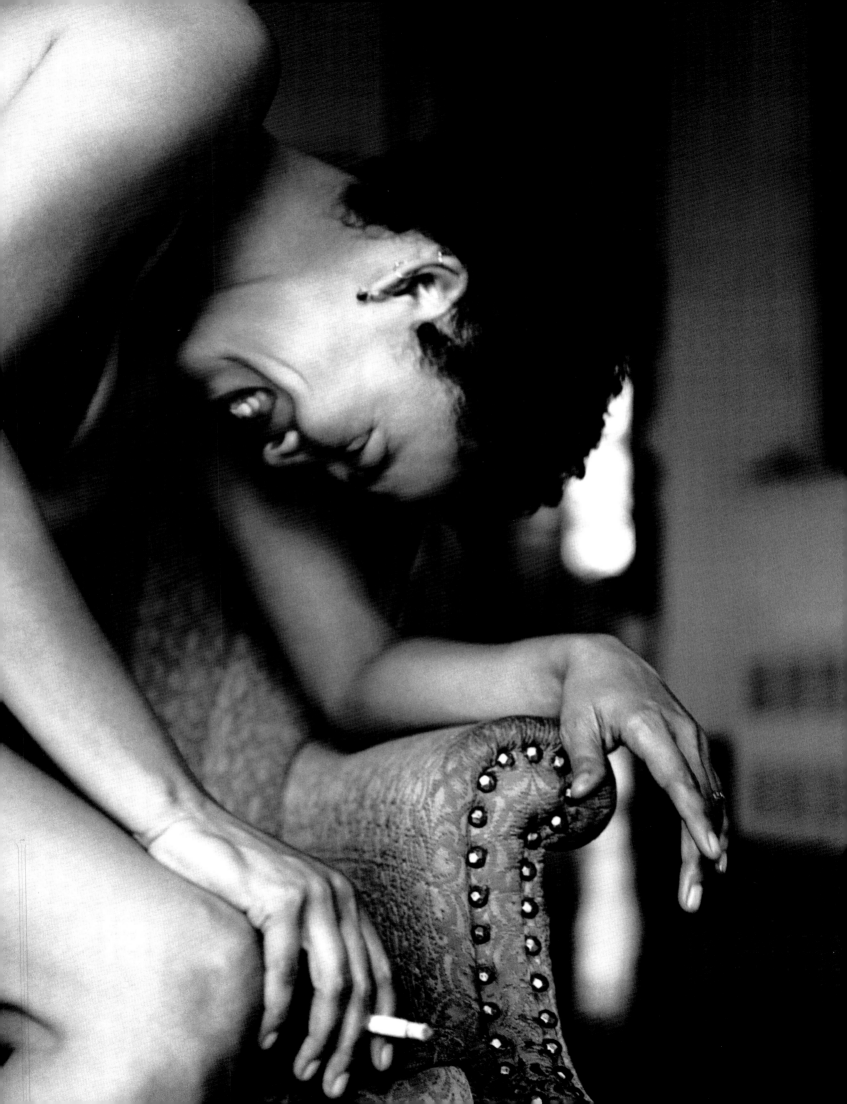

INTIMATE NUDES BY MARC BAPTISTE

THIS BOOK was extremely difficult to photograph, much more so than the previous book. Each subject had to have the utmost trust in me to reveal her most intimate and most exposed self, not only physically, but also mentally and emotionally.

WITH INTIMATE: NUDES I tried to capture what I believe to be the most undistorted moment of human emotion, a real feeling of intimacy. Intimacy is subjective for each individual. For some, intimacy means being alone, and for others it can mean being with another person or in a special place. In all cases, it has to be true to the moment. For me, intimacy is that revealing moment you share with another person. I asked each subject to express herself in whatever way felt real and right to her soul. Each sitting was unique and very involved. Sittings often included many talks prior to the shooting in order to create the right environment—particular to that subject—so that the openness and truth about them could be revealed. Most of the time, it was as if I wasn't there. As soon as I put the camera to my eye I wasn't part of that moment, but outside of it; the moment existed for that person alone.

MANY OF MY SUBJECTS looked forward to being a part of this project. They felt it was a unique concept, and an exciting way to express themselves. My interviews began with the same question: "What does intimacy mean to you?" Simply searching for an answer to that question forced each person to look deep inside herself. It takes a lot of strength for a person to let go of a perceived notion of self. I truly feel privileged to be the one whom people put their faith into, to be permitted to uncover an image behind their own concept of self and to have made the intangible tangible.

BEFORE I COULD even begin this project, I had to have the blessing of my wife. This was most important for me in order to go on this journey. She was enormously supportive of me during this project, and though at times it was tough on her, she showed great creativity and strength. For her to be by my side through this period exhibited the truest form of intimacy: it exhibited trust. I love her so much for that. Without her support I could not have done this book.

WE ALL LIVE in a world today where we can hide in and around technology; it is becoming harder and harder to reveal ourselves. I hope this book captures honest moments of revelation—moments free of race, creed, status, class, and nationality. *Intimate* embodies love and freedom.

SPECIAL THANKS to all the subjects for their trust, love, and support.

THANK YOU.

GOD BLESS.

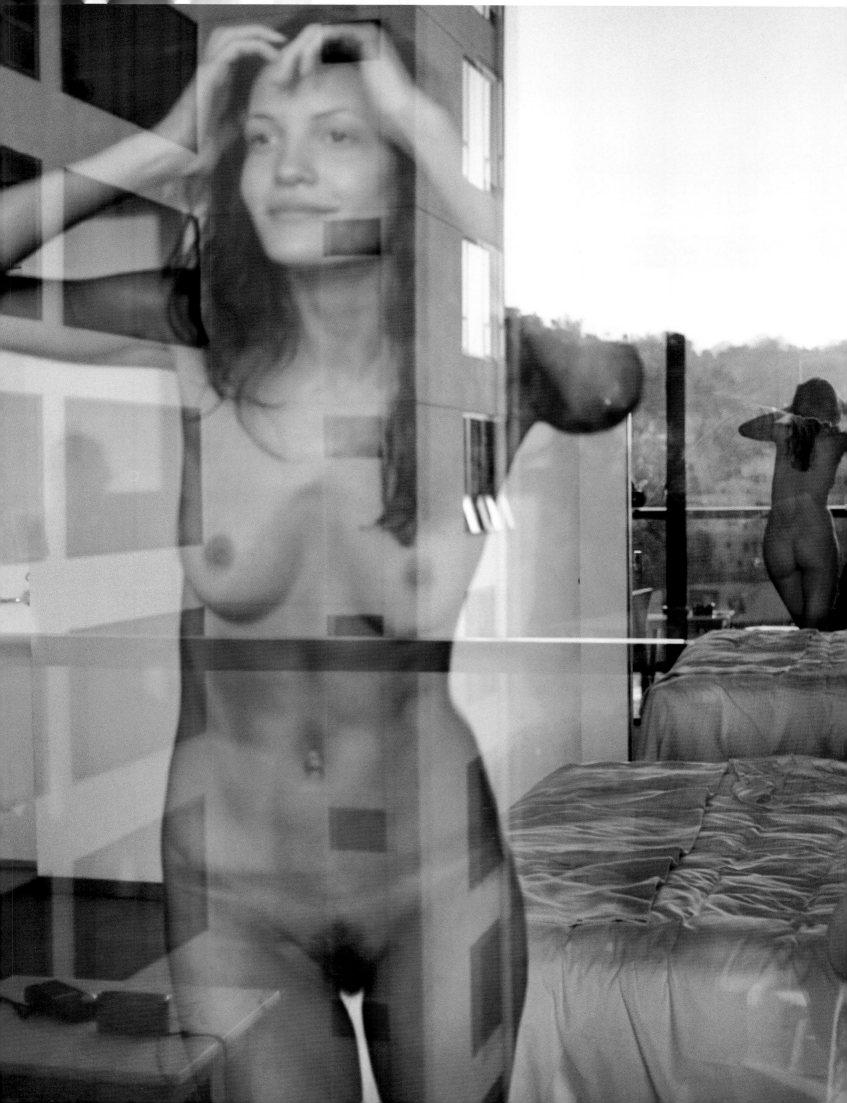

SPECIAL THANKS

To my wife Jenny Baptiste; my parents; my daughters, Brittany, Anais, & Skye
Bethann Hardison
Messfin Wolde-Mariam
Crawford Morgan
Bert Spangemacher
Adriano Fagundes
Veronique Roblin
Kythe Brewster
Justin Henry
Lysa Cooper
Patricia Morales
Andrew Dosumnu
Susan Sone
Vernon Jolly
James Hill
Siung Tjia
Tracy Nguyen
Sean Patrick Anderson
George Pitts
Donna de la Cruz
Brock Wylan
Melanie Harris
Leslie Zamore
Lauren Kunik
Tracy Murphy
Angie Parker
Mathieu Barelot
Anthony Dickie
Charles Miers
Jessica Fuller
Gena Pearson
Omar Alberto
Jesus
Amy Somlo
Julie Ragolia
Consuela Nance
Kim Porch Reed
Nate Bressler
Anoma Whittaker
Next Agency
Dana at NY Models
Miguel at Supreme Models
Paul Mohamed, Ali, And @ Women Model Management
Raja, Chia, Peter, John @ Color Edge
Vincent & Denise
Pic Digital, Puspa Lohemeyer, & Brenda Buck
All the hotels I've ever stayed in
Sun & Sun West Studios
Jeffrey & Michael at Lexington BTW

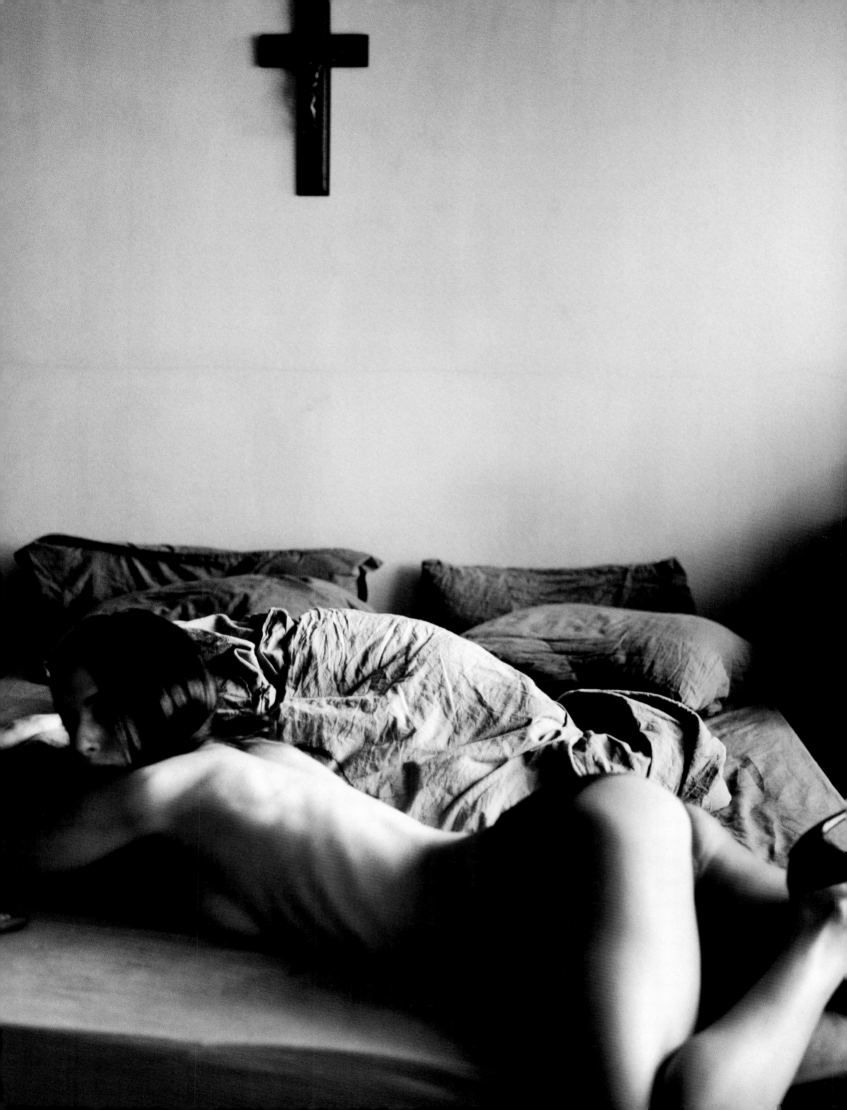

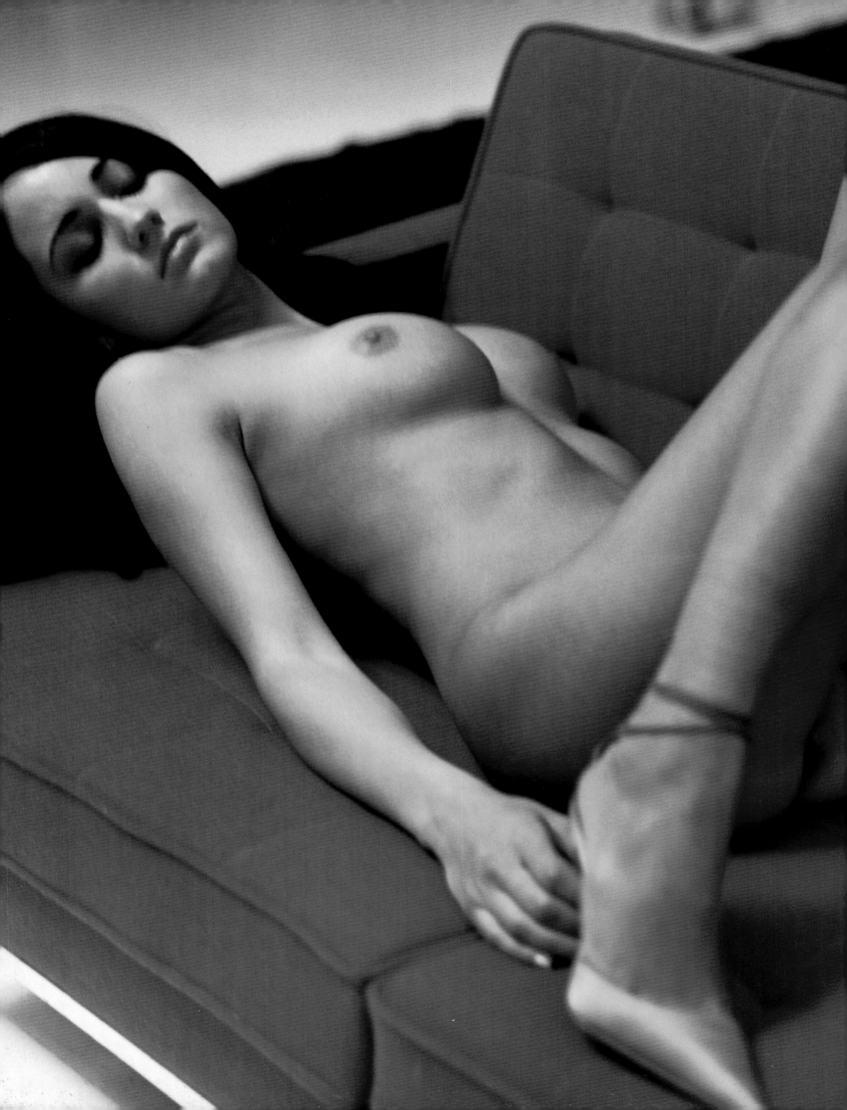

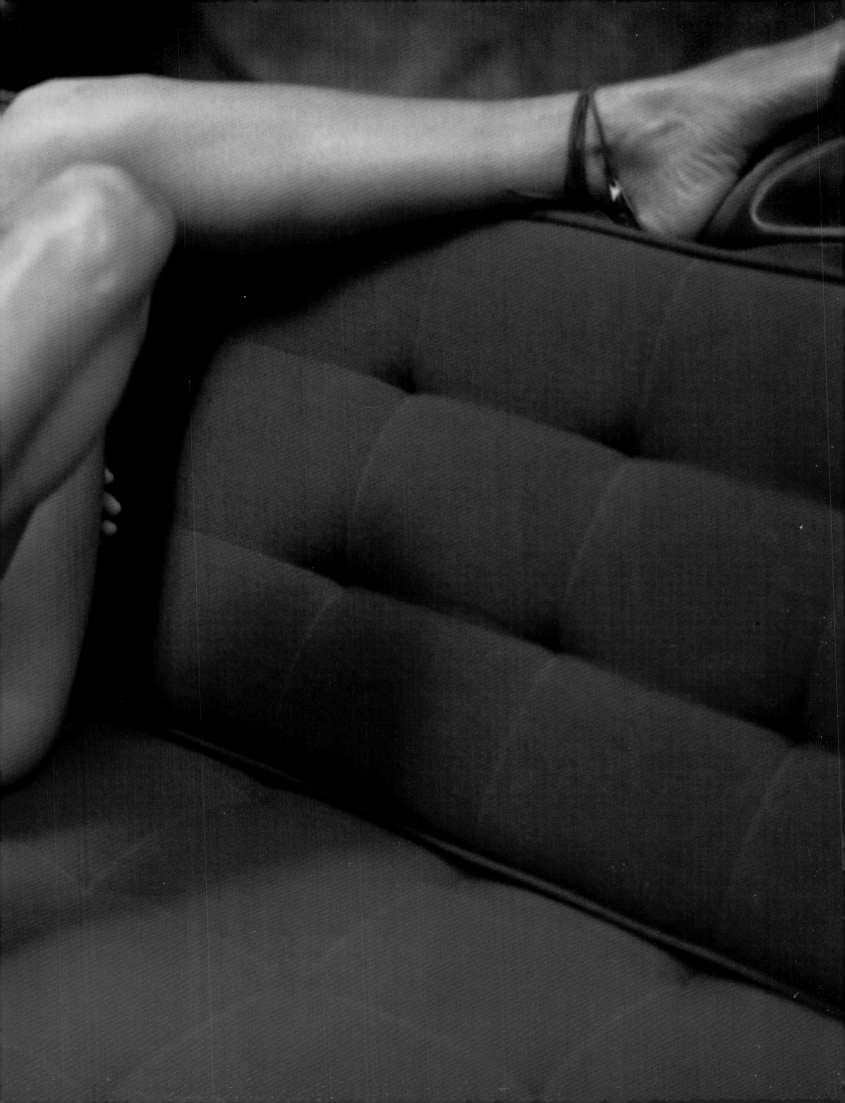

KIM PORTER BINTA GRIER KATIE RICHEY ANA BEATRIZ BARROS

 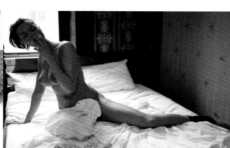 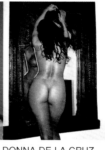 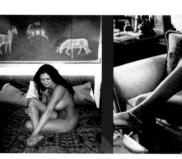

KELIS JAQUELINE NOVAC KIMBERLY MANN DONNA DE LA CRUZ KARA YOUNG

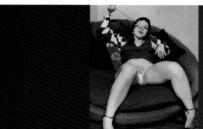 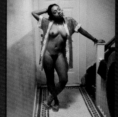 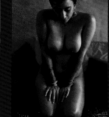 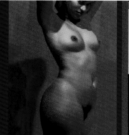 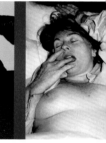

AMANDA-REY AMY ANDRIEUX GITA UNTITLED BLISS MARYBETH O'HAF
CLEGG-COOPER

 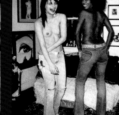 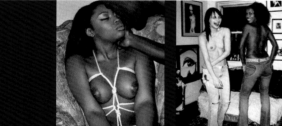 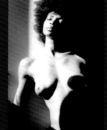 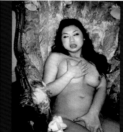 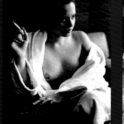

LIRIS CROSS LYSA COOPER & KAREN GIBSON-ROC TRACY NGUYEN LINDSEY MADIGAN BEATRICE MON CUR SHAWNA
 CAMELLIA CLOUSE CHRISTENS

 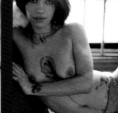 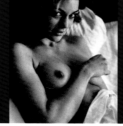 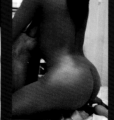 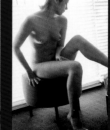 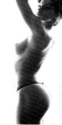

KISHA BATISTA KYLIE BAX ELIZA JIMENEZ KATIE RICHEY LIRIS CROSS & LINDSEY MADIGAN KATIE RICHEY
 DA' HILL

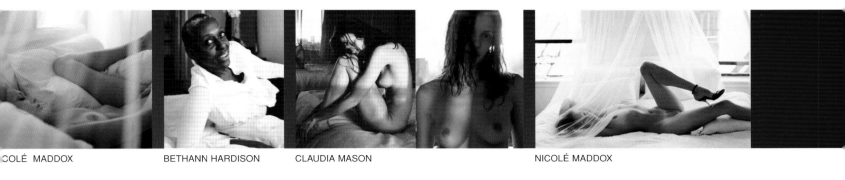
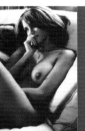
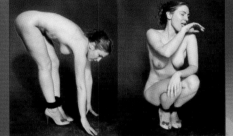
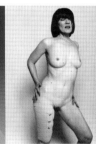
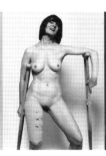
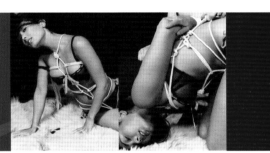

COLÉ MADDOX BETHANN HARDISON CLAUDIA MASON NICOLÉ MADDOX

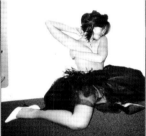
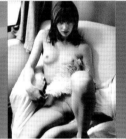
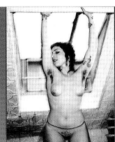
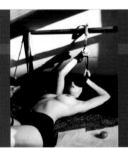
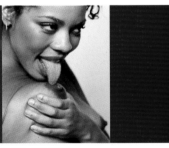

SERENA WALKER SABINE KARTEN SHAWNA CHRISTENSEN

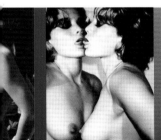
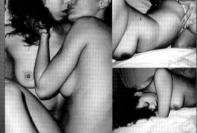
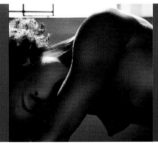
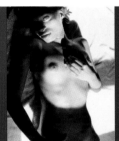
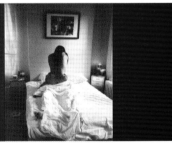

LINDSEY MADIGAN VANESSA GRECA AMANDA ADRIA LANG BINTA GRIER

KATIE RICHEY KATIE RICHEY & EWORSA OWENS ANOMA WHITTAKER IMANI GARDNER AUDREY QUOCK

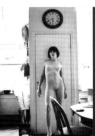
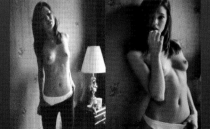

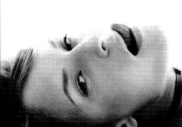
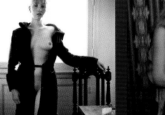
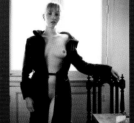
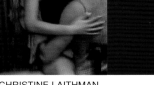

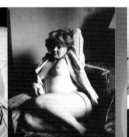

CECILIA LARSON CAMERON LLOYD REKA JANNE HJELTNES CHRISTINE LAITHMAN
& FRIEND

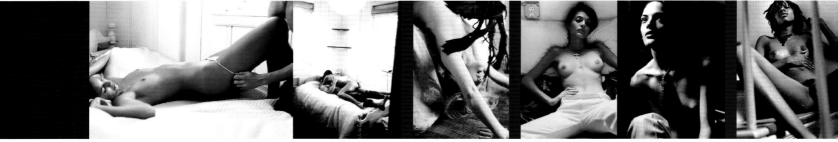

AMANDA & QUATZAR CARMINDY BRYN & LISA POMEREZ IMANI GARDNER
 JAMEL FREEMAN

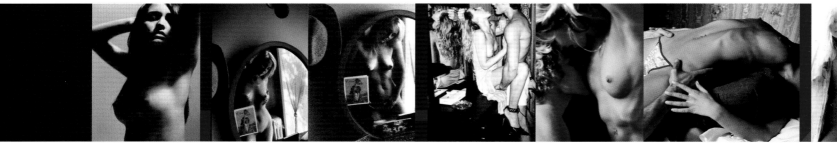

MARIEL CARMINDY BRYN CHRISTINE LAITHMAN & FRIEND CARMIN

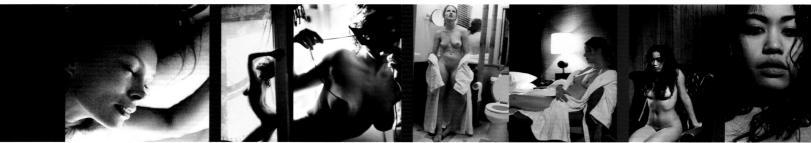

NICOLÉ MADDOX MARIA ALISON COHN TIFFANY LIMOS

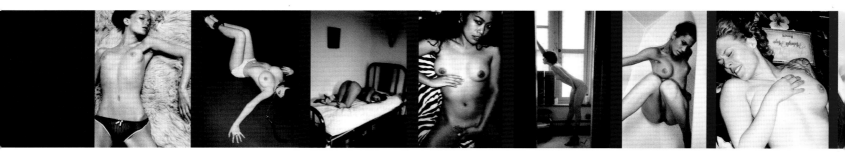

CAMERON LLOYD ADRIA LANG JENNIFER TIFFANY LIMOS CECILIA LARSON JAQUELINE BEATRICE MON CUR

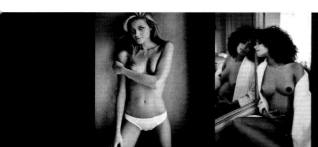

ANA BEATRIZ BARROS NATHALIE CHABLAT MELIDA PRADO, AGERA, AND ADER JENNY CLAUDIA MASON

 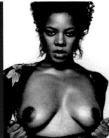 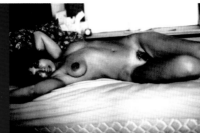 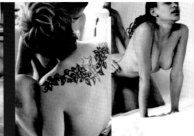 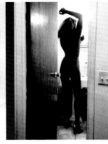

TANYA EDGERS BINTA GRIER SANTESSA MARC MCANDREWS & CHRISTINE RIDU KELIS
FRIEND

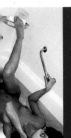 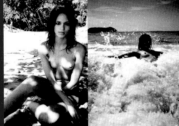 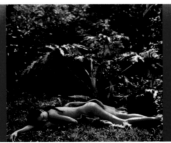 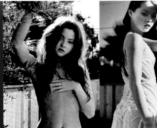 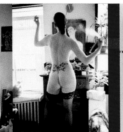

RYN REBECCA CARLSON UNTITLED MARIA ANNA CURTIS KIM PORTER

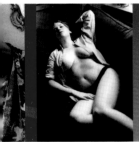 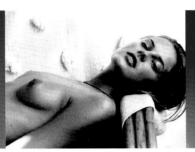 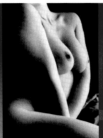 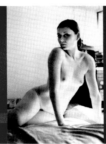 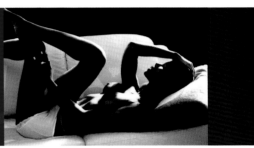

NTITLED SANTESSA ANNA CURTIS AMANDA SANTOS

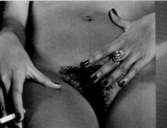 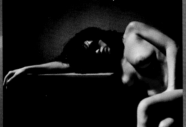 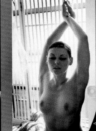 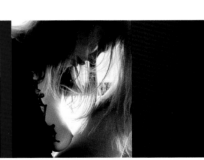

NTITLED LINDSEY FREEMONT LISA ANN CABASA DEVON AOKI NICOLÉ MADDOX

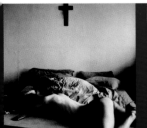 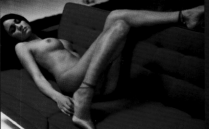 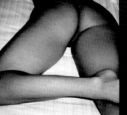 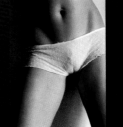

HELEN REYES MARIEL KIMBERLY MANN UNTITLED UNTITLED

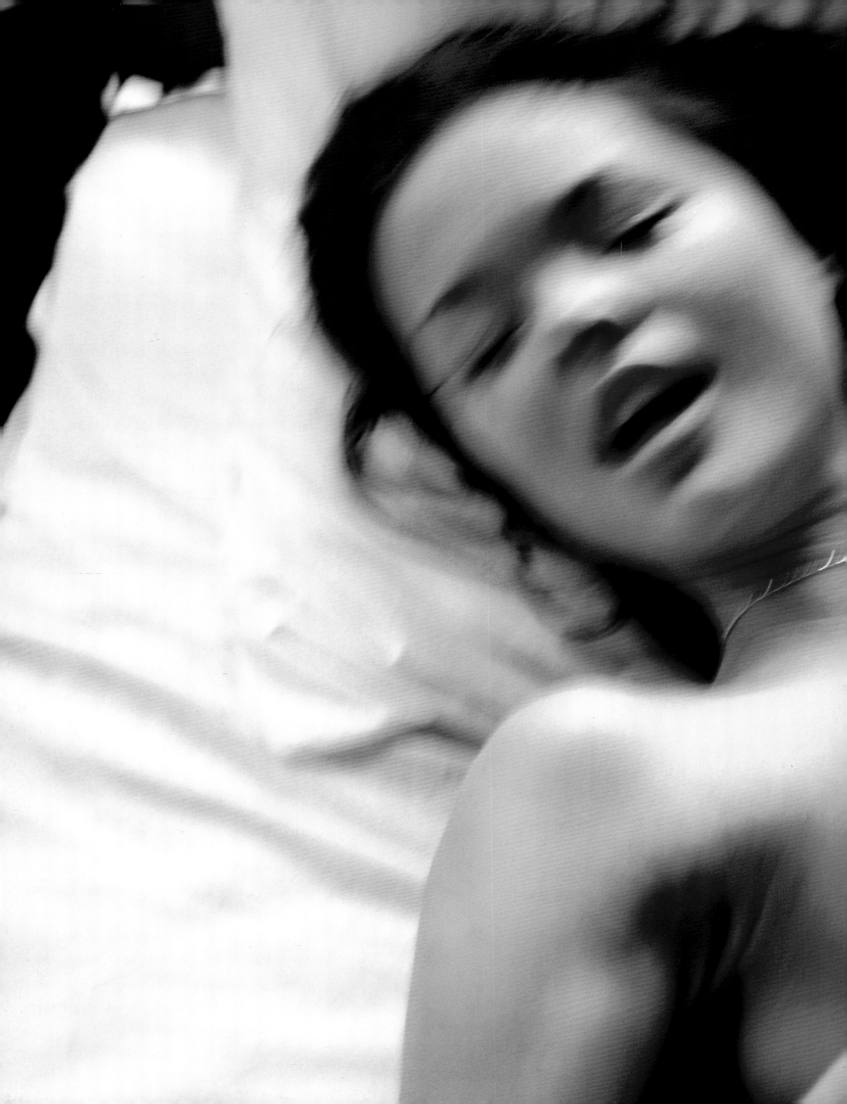

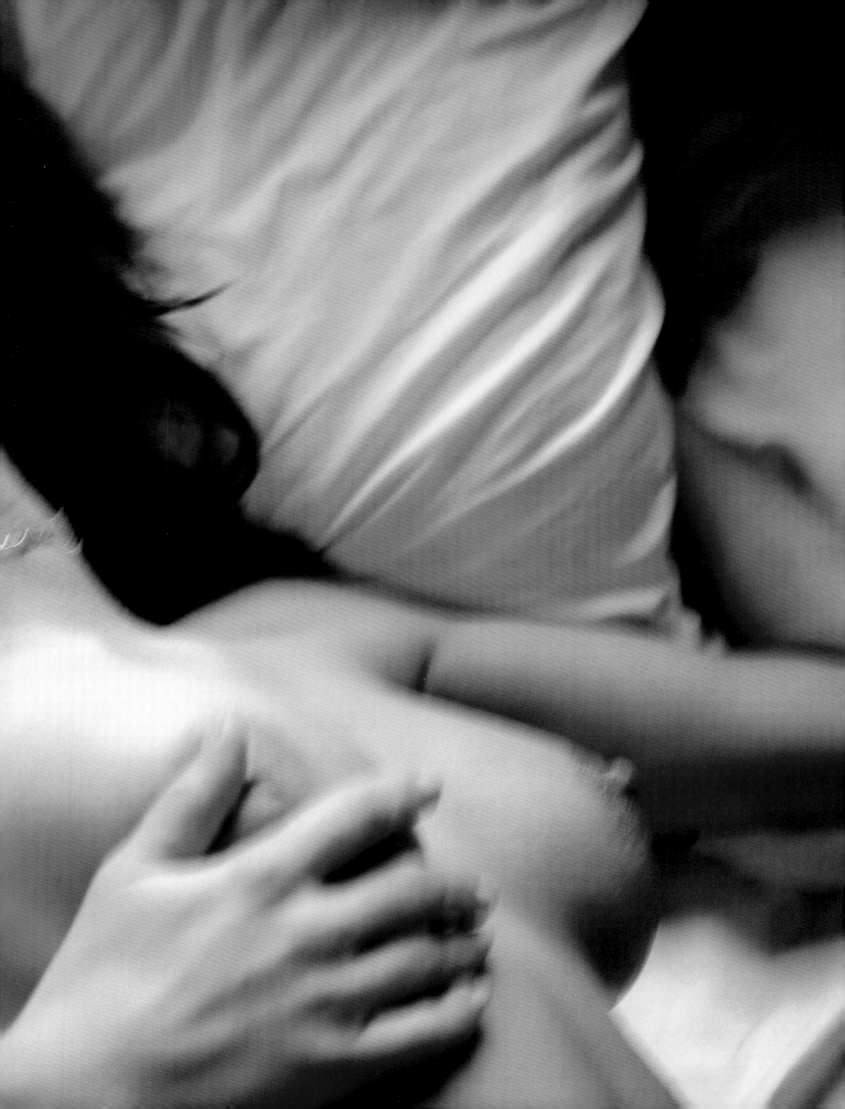

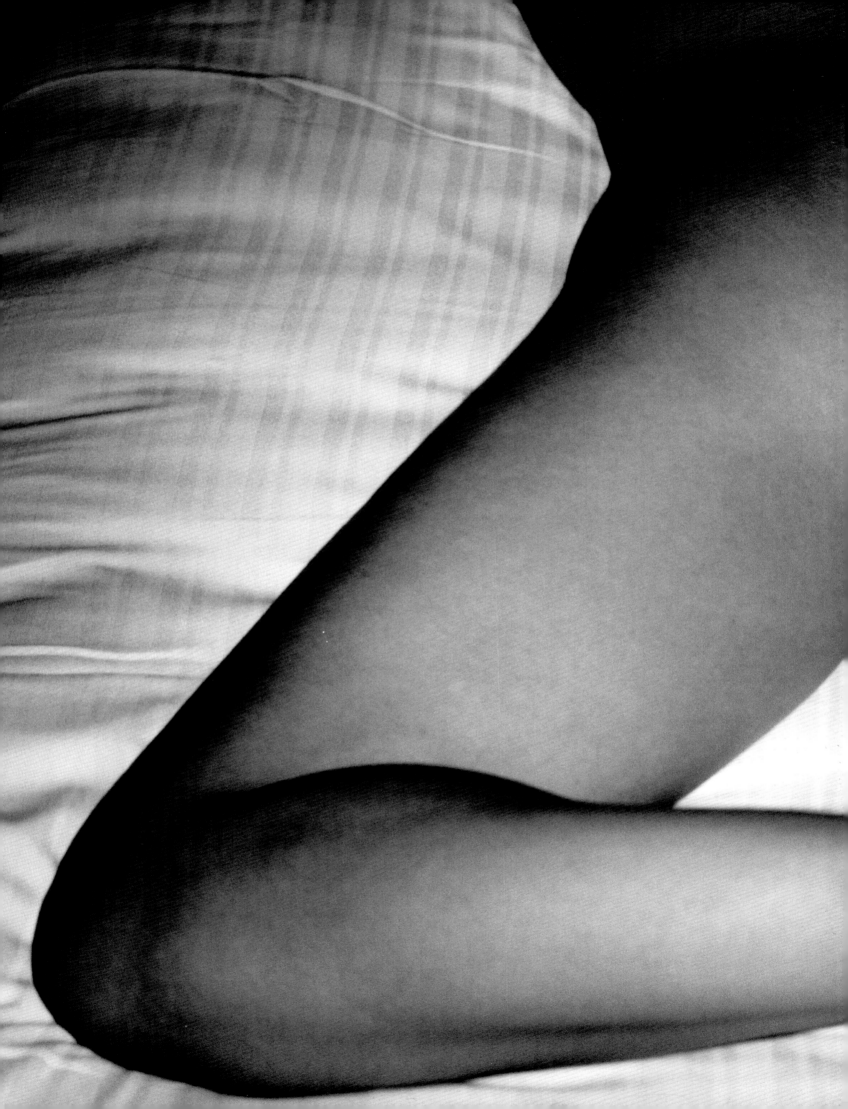

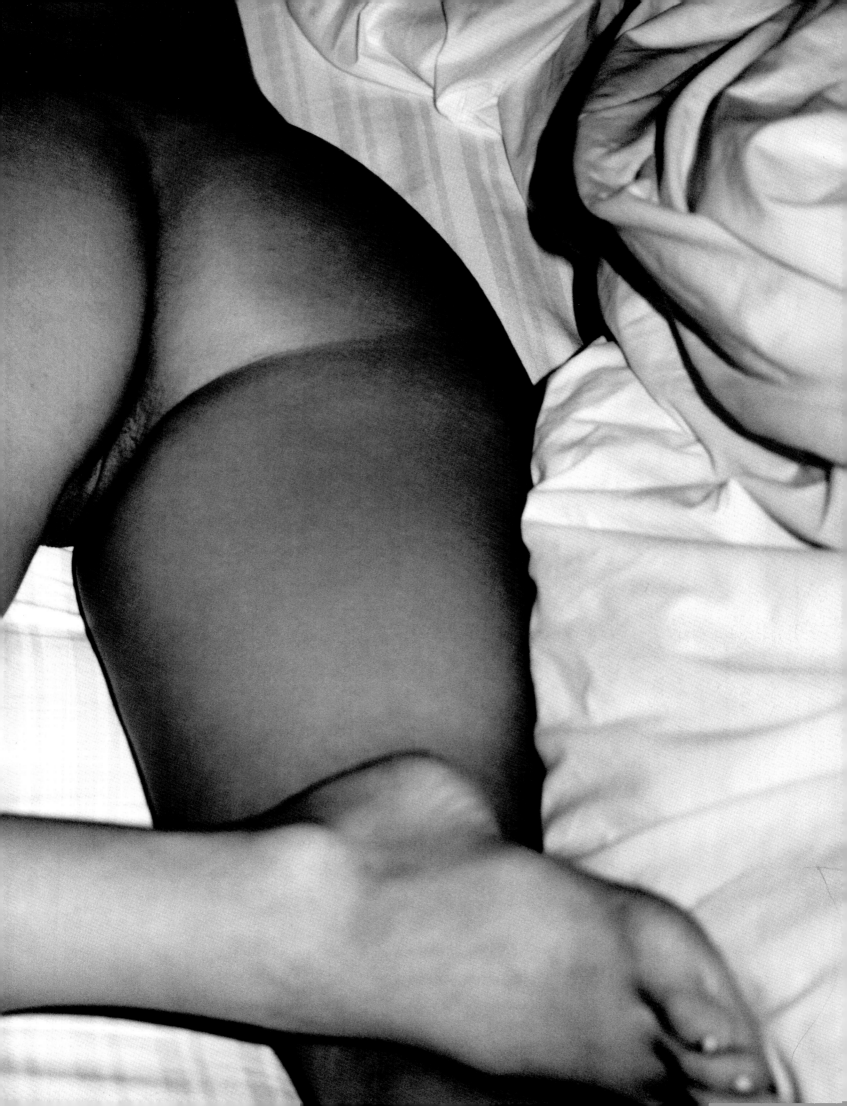

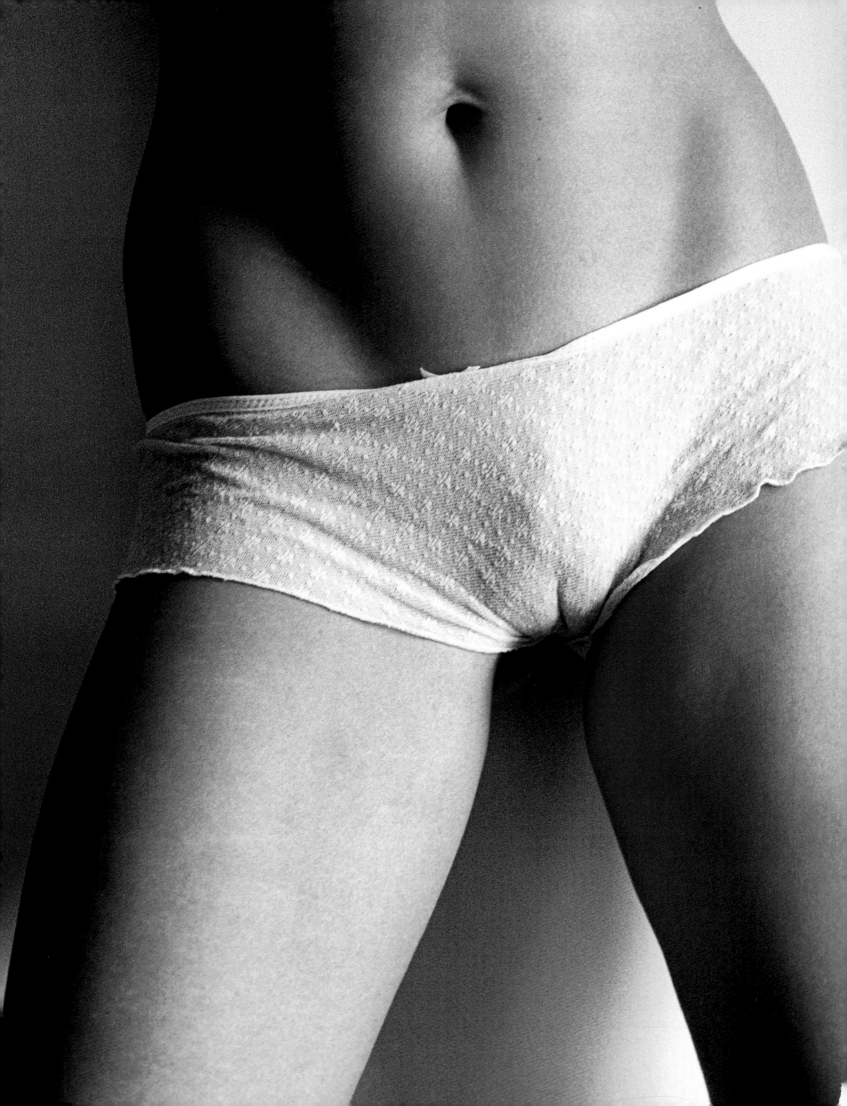